# TEXAS

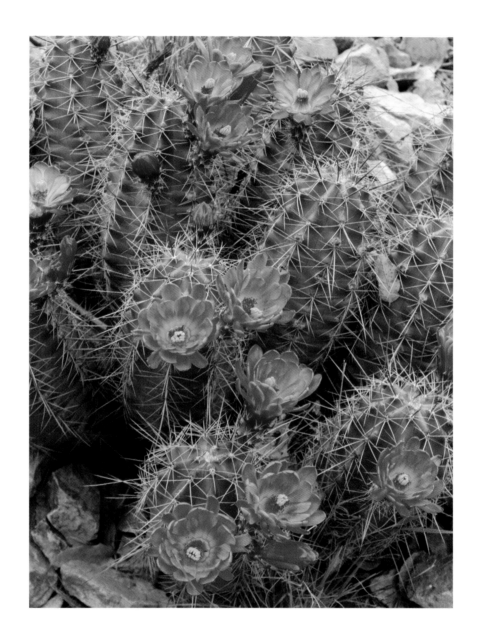

Just remember —
The Eyes Of Texas are Upon
You — All your
live - long days !
The Z's

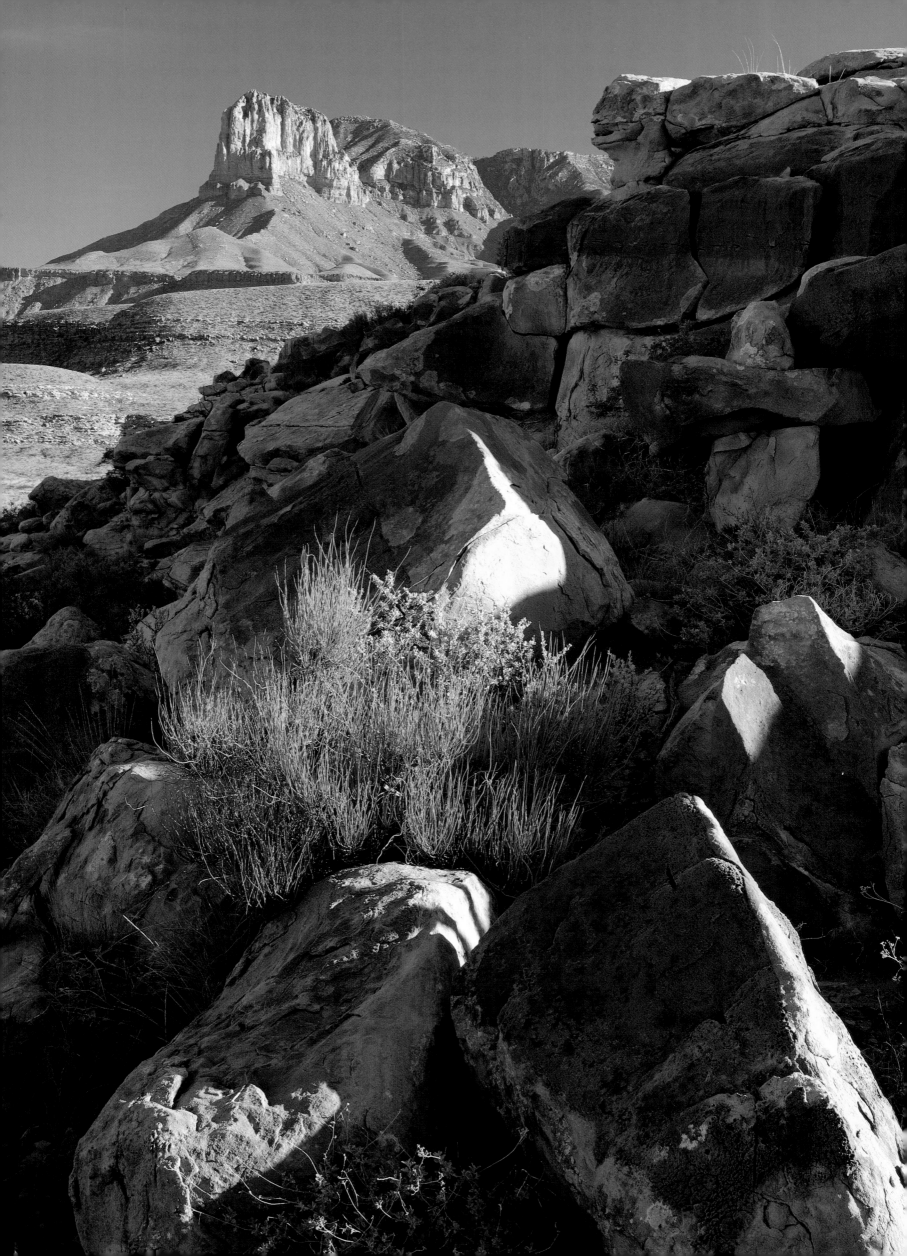

# TEXAS

BY LAURENCE PARENT

ESSAY BY ELMER KELTON

GRAPHIC ARTS CENTER PUBLISHING®

International Standard Book Number 1-55868-202-3
Library of Congress Catalog Number 94-73054
Photographs © MCMXCV by Laurence Parent
Text © MCMXCV by Graphic Arts Center Publishing Company
P.O. Box 10306 • Portland, Oregon 97296-0306
503/226-2402 • www.gacpc.com
President • Charles M. Hopkins
Editor-in-Chief • Douglas A. Pfeiffer
Managing Editor • Jean Andrews
Designer • Robert Reynolds
Production Manager • Richard L. Owsiany
Cartography • Thomas Patterson
Book Manufacturing • Lincoln & Allen Co.
Printed in the United States of America
Seventh Printing

*To my wife Patricia,
a true Texas patriot*

LAURENCE PARENT

*Half Title Page:* The claret cup cactus is found from the Hill Country west to El Paso and beyond. The Chisos Mountains of Big Bend National Park host many fine specimens such as this one.
*Frontispiece:* The massive bluff of El Capitan Peak is one of Texas' most prominent landmarks. The limestone that makes up most of the Guadalupe Mountains was formed as a reef in an ancient sea.
*Facing Page:* Spring brings splashes of color to Texas fields, especially in Central Texas. The bluebonnet and the Indian paintbrush are two of the most common and popular flowers.

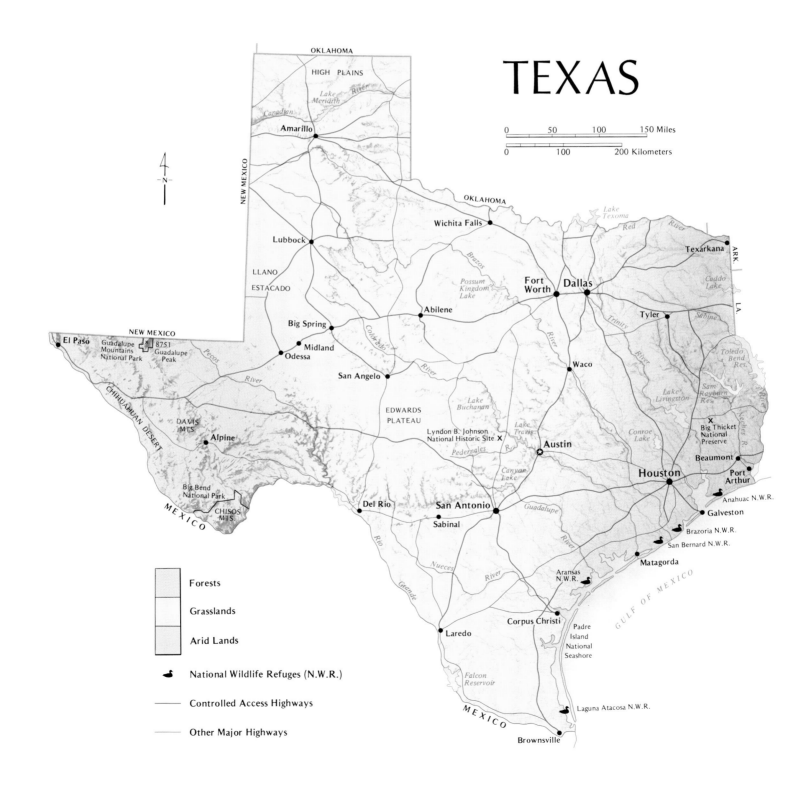

# TEXAS

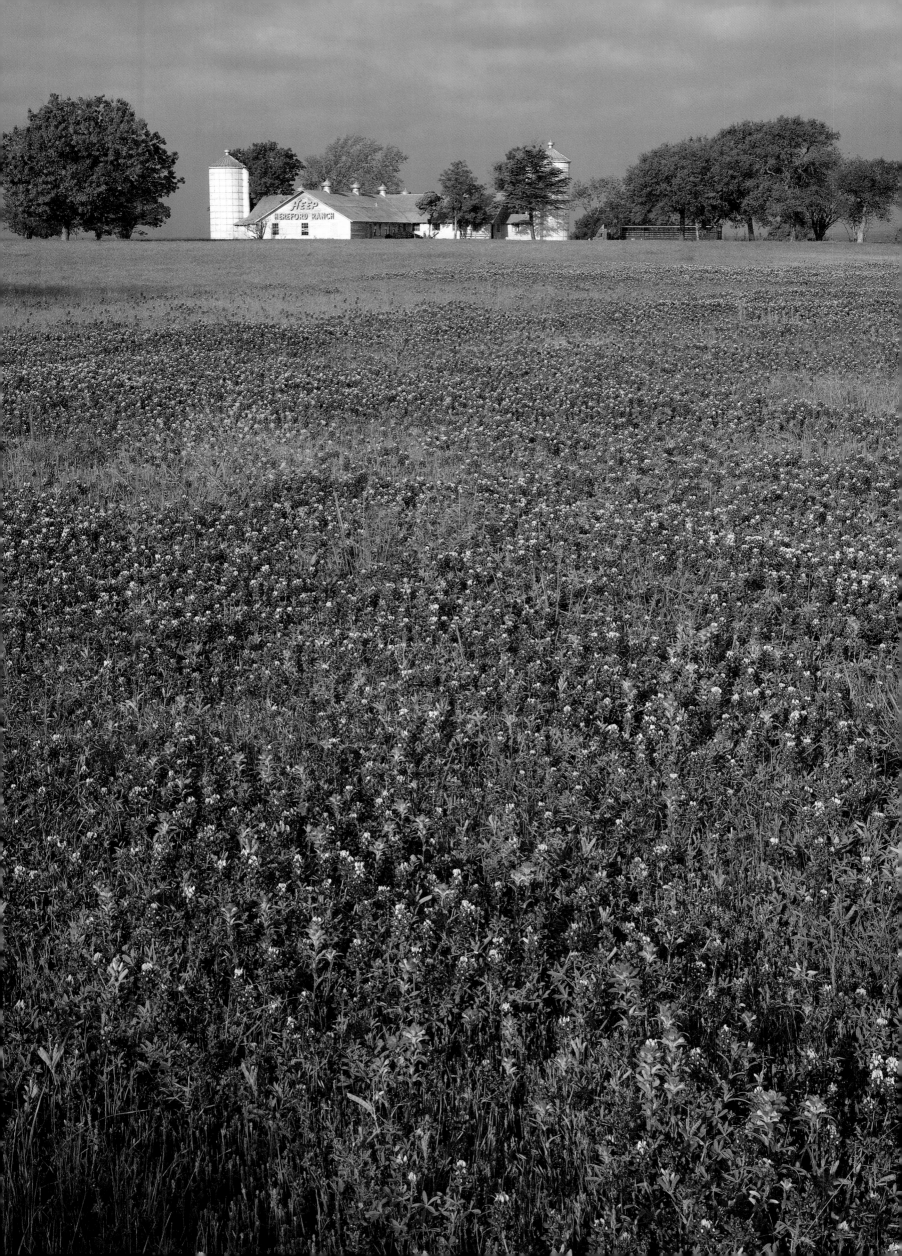

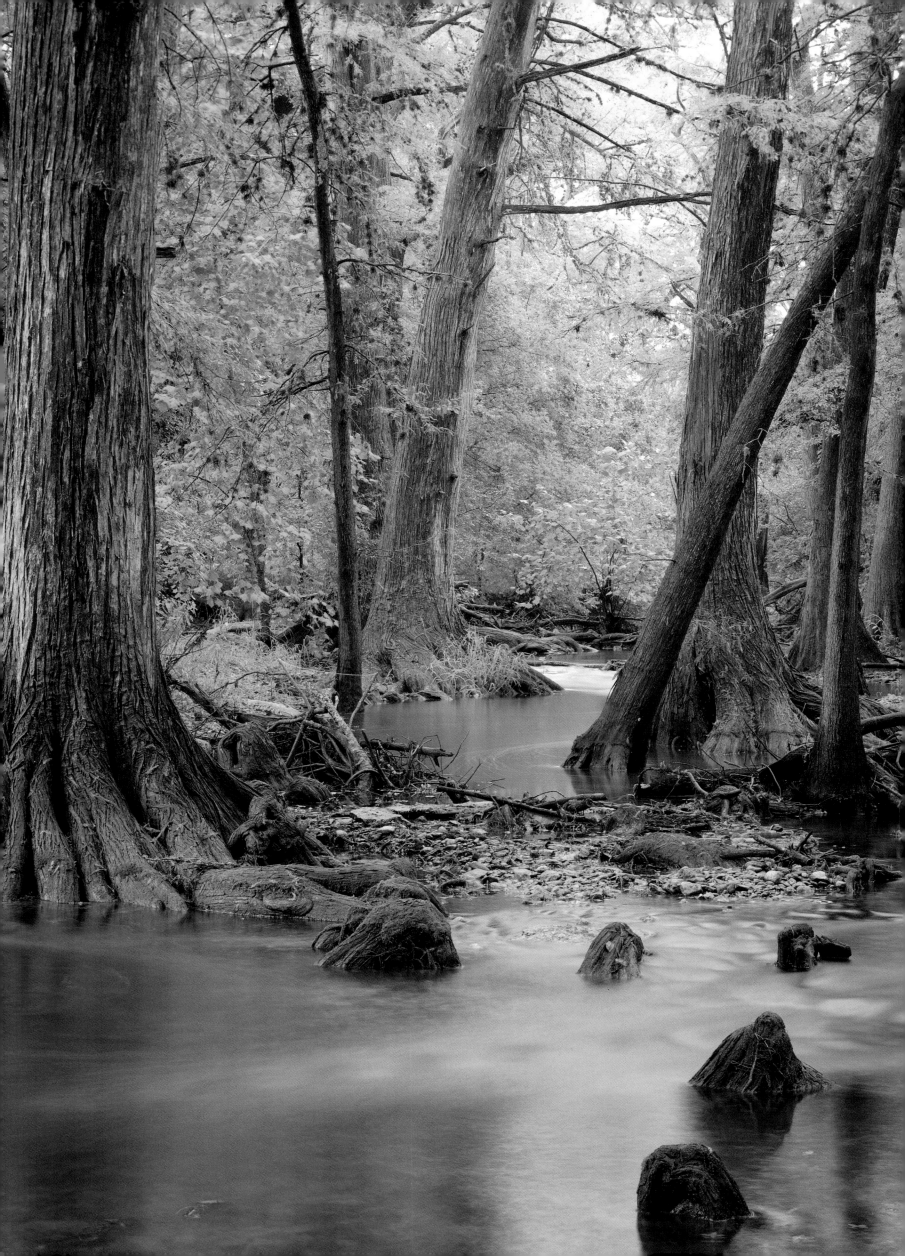

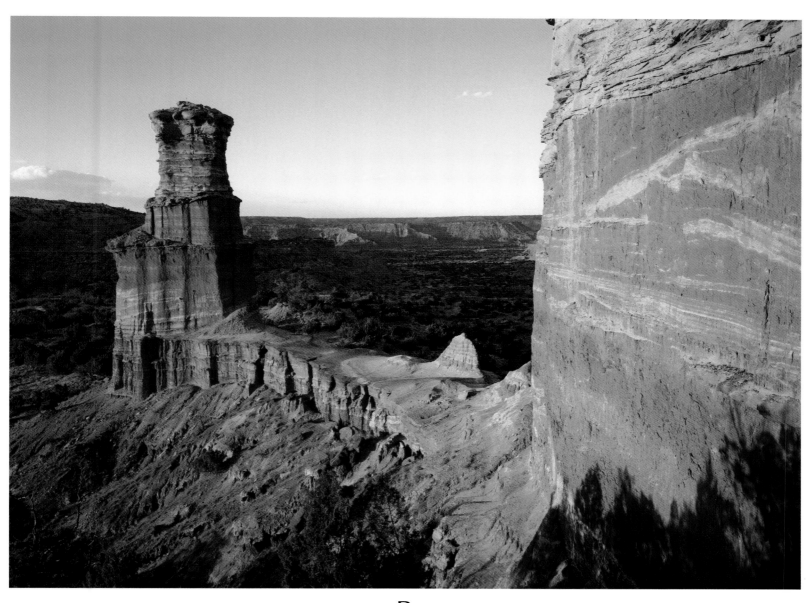

Bald cypresses thrive, fed by the waters of Cibolo Creek near Boerne. The trees are prolific in wet, swampy areas of East Texas, but also do well in the Hill Country. ◄ The Lighthouse is the best-known landmark of Palo Duro Canyon, which is an eight-hundred-foot-deep gash cut into the flat plains of the Panhandle by the Prairie Dog Town Fork of the Red River. ▲ A lone windmill seems lost in the vast prairies of the northern Panhandle. A broad sheet of debris that eroded from the Rocky Mountains of New Mexico and Colorado created the plain. ►►

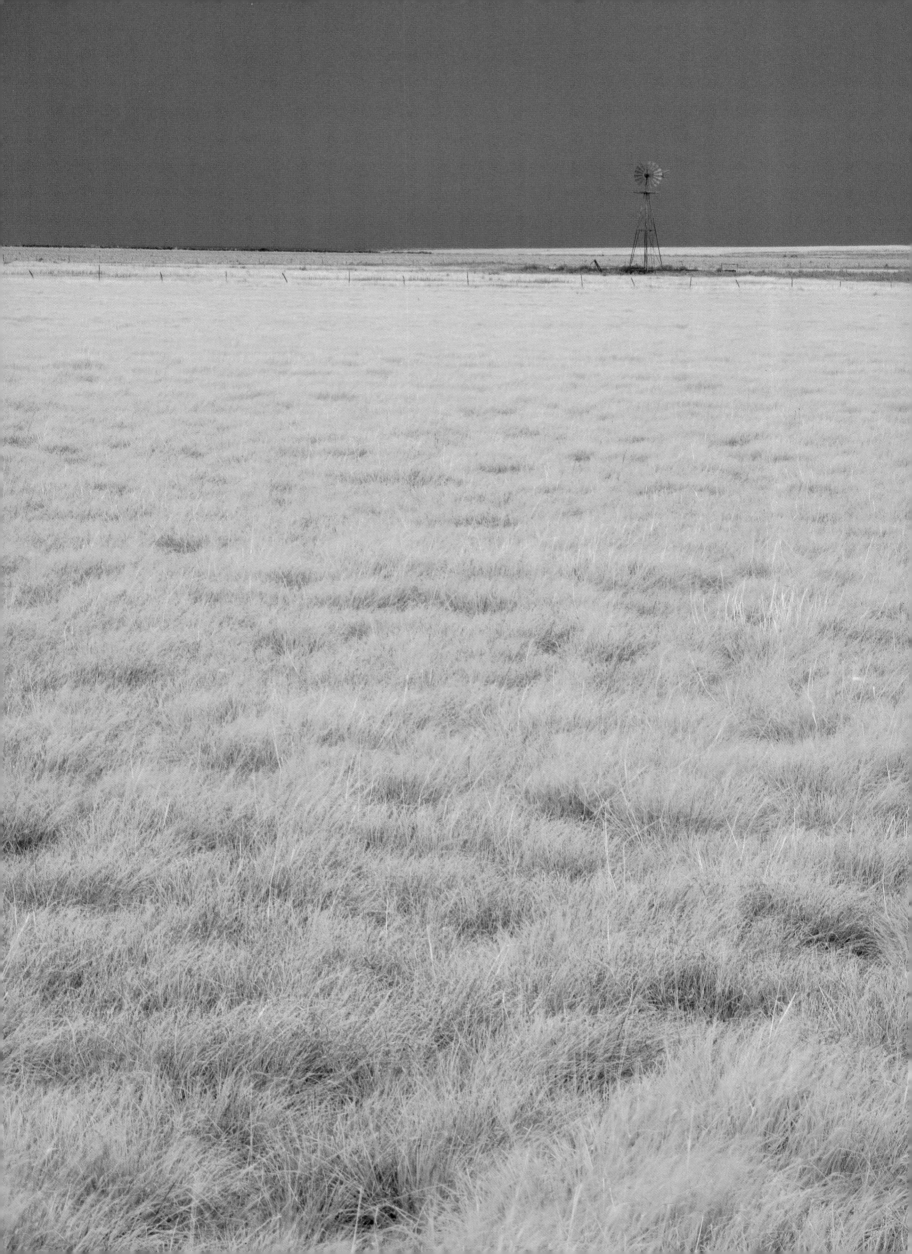

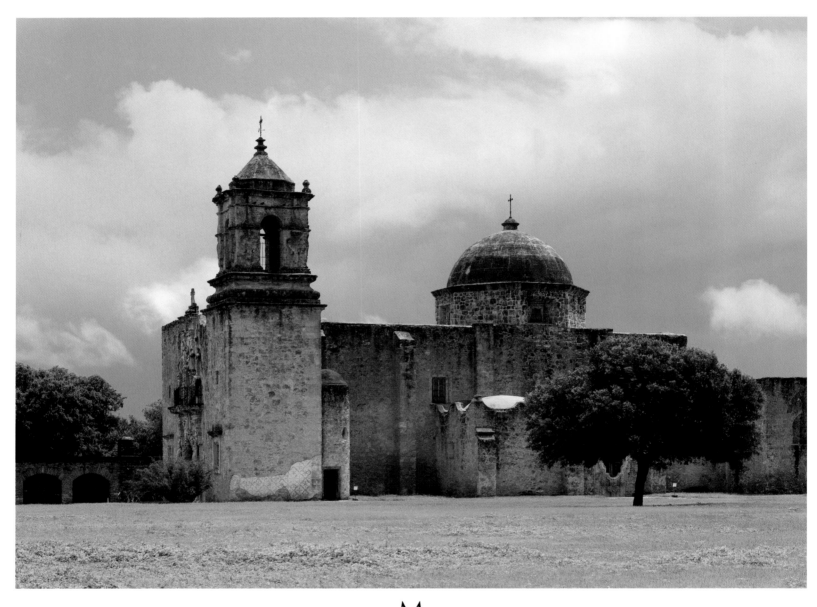

Mission San José was founded on the banks of the San Antonio River in 1720 by Franciscan priests as part of Spanish colonizing efforts in Texas. It was the second of five missions established in the area, the first being Mission San Antonio de Valero, better known as the Alamo. Because San José was the largest of the five San Antonio missions, it became known as the "Queen of the Missions." Today, San José is both an active church and part of San Antonio Missions National Historical Park. ▲ Tickseed and non-native crimson clover flourish in East Texas. ▶

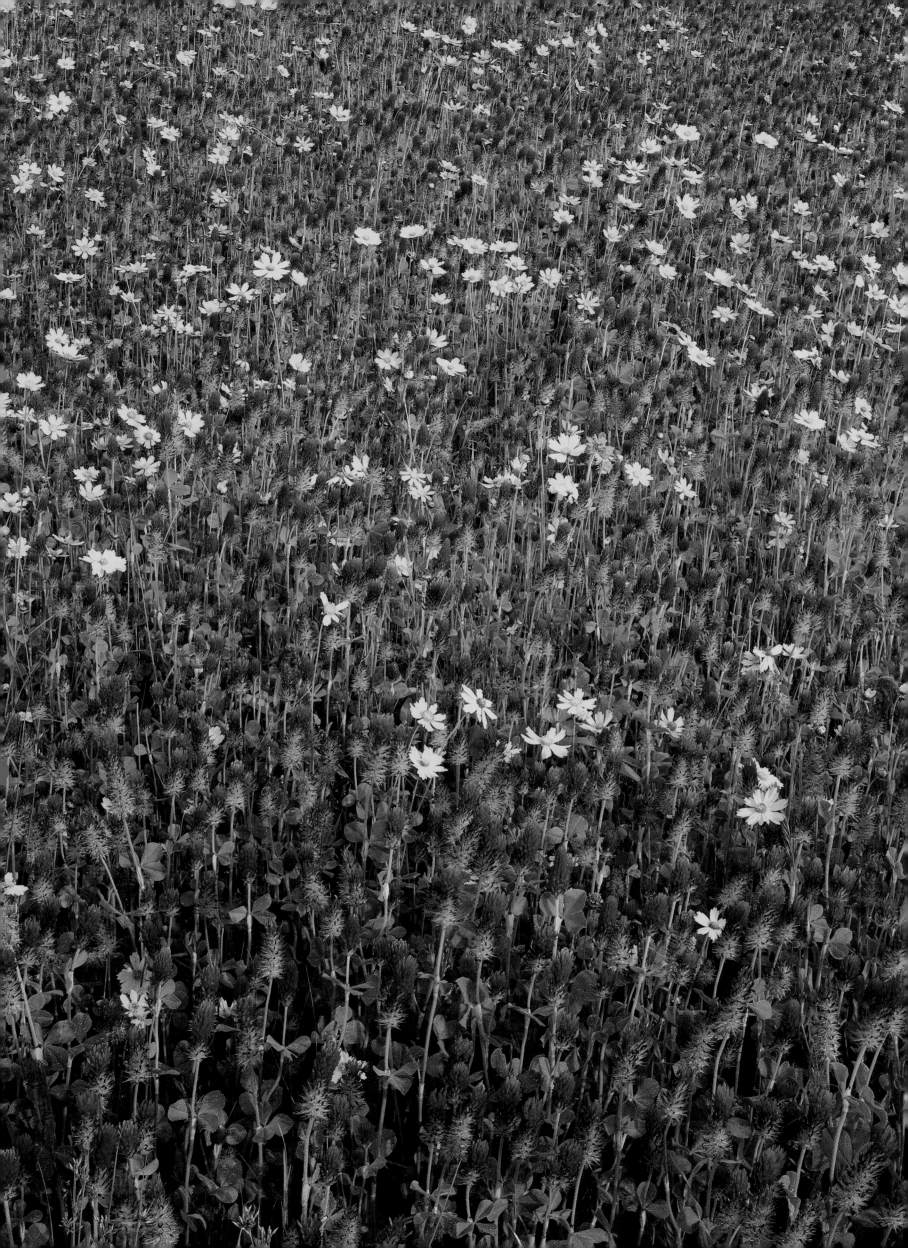

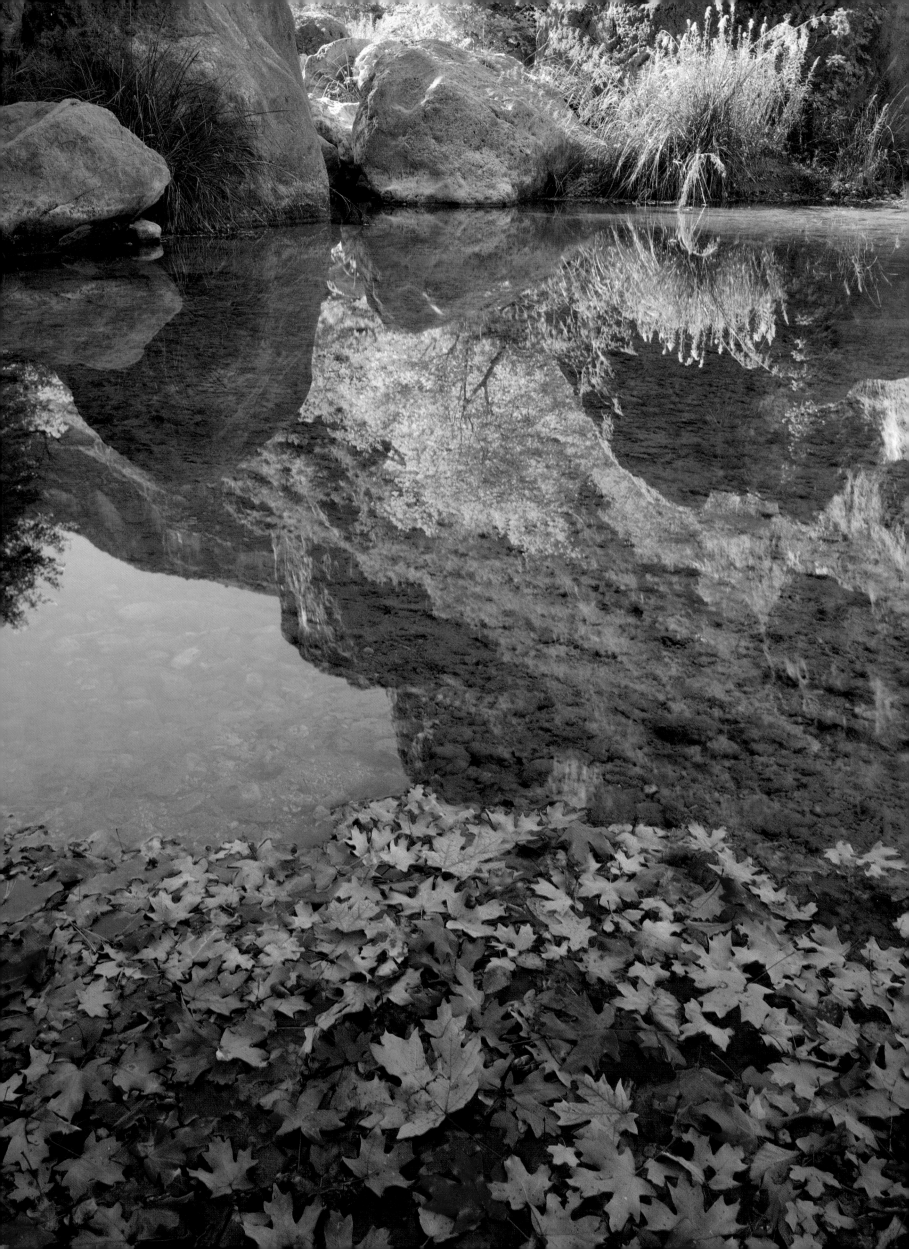

Bigtooth maple leaves dot pools in McKittrick Canyon in autumn. The permanent spring-fed stream flows through a rugged canyon hidden deep in the heart of the Guadalupe Mountains. Because of the mountain location, the waters remain cold enough year-round to support a reproducing trout population, the only one in Texas. When the stream reaches the mouth of the canyon at the edge of the mountains, it goes underground. ◄ A forest of mixed pine and hardwood, interspersed with scattered fields and farms, makes up most of the terrain of Northeast Texas. ▲

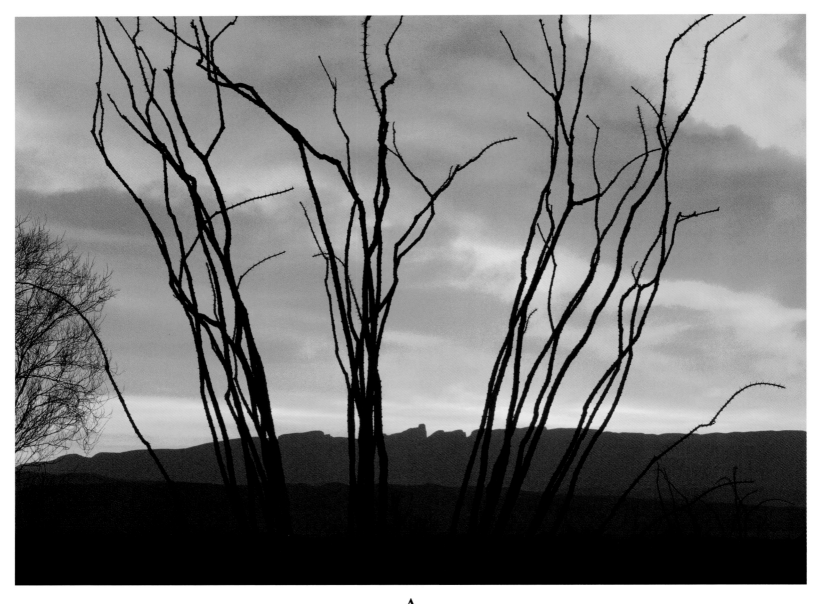

An ocotillo stands against the sunrise below the Sierra del Carmen of Mexico at Big Bend National Park. It is one of many plants adapted to the harsh environment of the Chihuahuan Desert. To survive the heat and dryness, plants have developed small, waxy leaves, thick skins, and other water conserving measures. The ocotillo sprouts tiny leaves along its spiny stalks only after a good rain and loses them when the weather turns dry. ▲ Aransas National Wildlife Refuge, famous as the whooping crane's winter home, is protected from Gulf storms by Matagorda Island. ▶

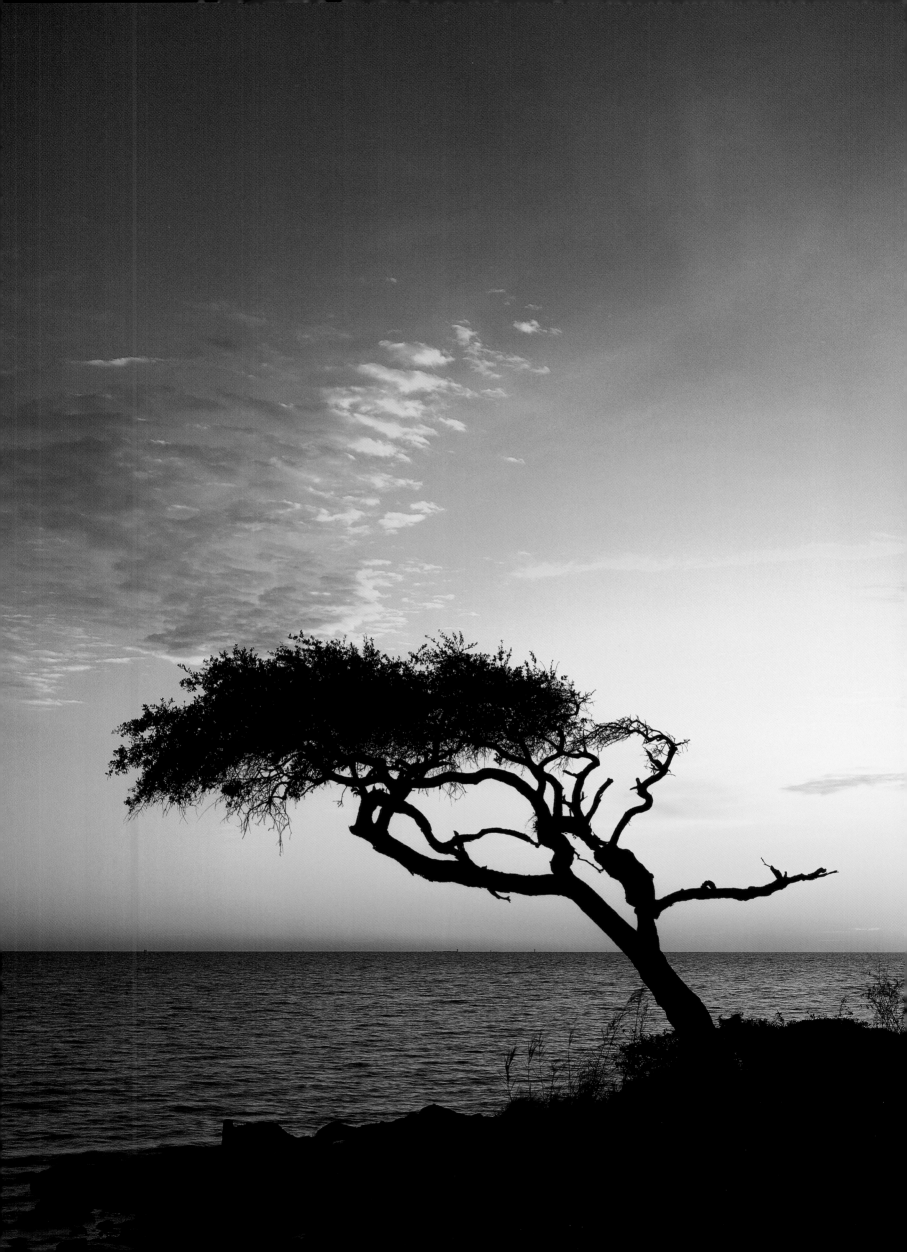

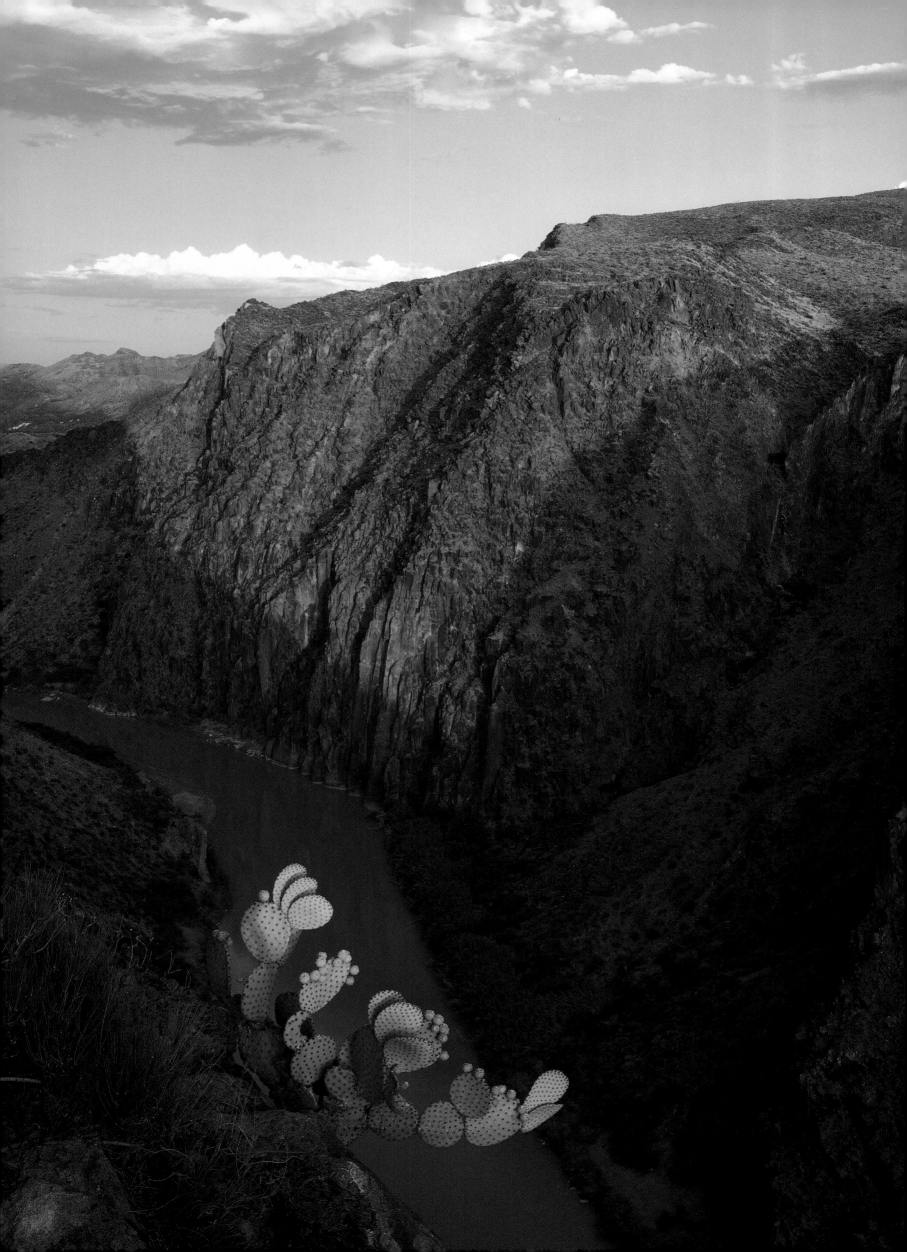

## The Many Faces of
# T E X A S

I was born in the mid-1920s on a West Texas ranch where my father was a working cowboy. When I was three years old, he became foreman on another ranch at the edge of a rapidly growing oil field. In my early years, I saw little except cattle, horses, cowboys, and oil wells. For all I knew, that was the whole world. The image would have conformed handily with the one many outsiders still have of Texas as a whole. It is valid as far as it goes, but it falls far short of the state's vast realities.

The reality that grew on me as I matured, studied, and traveled was one of tremendous diversity. No single image fits Texas; a dozen would not be enough. Texas has many faces and speaks with many voices. It is urban, it is rural. It is desert, it is seashore. It is mountains, it is plains. It is piney woods, and it is open grassland prairie. It is cowboys of the horseback kind, and it is Cowboys of the Dallas football variety. It is oil, it is cotton. It is cattle, it is sheep and goats. It is onions, and it is rice. It is fundamentalist religion, and it is down-and-dirty smoky-room politics. It is busy interstate highways. It is quiet farm-to-market roads. It is open-handed friendliness to strangers, yet it bristles with resistance to efforts by outsiders to control its actions and force it into conformity with someone else's notions. It is all these contrasting images and more. Just when you think you have it classified, it confounds you by revealing another face.

Many major rivers course across the land: the Canadian, the Red, the Trinity and Sabine, the Colorado, the Guadalupe and Brazos, the San Antonio, the Nueces, the Pecos, and the Rio Grande. Raindrops that fall in the short buffalo grass of the High Plains or on the alkali soil of the dry Chihuahuan Desert are carried hundreds of miles down to join the salt waters of the Gulf. Dozens of tributary rivers and streams like the Frio, the Concho, the Llano, and the San Saba drain the far reaches of the land, merging with larger rivers at their own deliberate pace and in their own good time.

Ecologists disagree on the number, names, and even the boundaries of distinct geographical regions contained within Texas' borders, such as the Gulf Coast, the coastal plain, the Rio Grande plain, the Northeast Texas blacklands, the East Texas piney woods, the Cross Timbers of Central Texas, the Hill Country and the Edwards Plateau, the lower and rolling plains, the High Plains and the Trans-Pecos. Each has a topography and a personality peculiarly its own. Within these classifications are deviations and subdivisions such as the Big Bend, the Guadalupe Mountains, and the Big Thicket, which some would argue should be considered separate and distinct.

Even the state's history is not easily defined. It too has many faces, many voices, subject to contradictory variations depending upon the ethnic, cultural, or political viewpoint of the interpreter. Six different national flags have flown over Texas soil: those of France, Spain, Mexico, the Republic of Texas, the Confederate States of America, and the Stars and Stripes of the United States. Each has left a mark upon the Texas character.

Texas was always the land of dreams, the home of dreamers. The lives of its original inhabitants were heavily influenced by visions and dreams, until invaders of European origin crushed those dreams in pursuit of their own. Early Spanish explorers labored across its mountains and its prairies in a vain search for golden cities, and the padres built their missions with the dream of converting Indian nations to the holy faith and securing their own place in heaven. American colonists came into a new land with hope of a fresh beginning where the soil was

*The Rio Grande has carved deep Colorado Canyon at Big Bend Ranch State Natural Area.* ◄

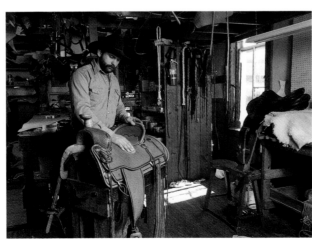

*Saddlemaking at Austin's Capitol Saddlery*

black and rich, the climate benign. Their descendants studied outcroppings of ancient rock and dreamed of black gushers, of boundless oil wealth hidden far beneath the earth.

Only a relative few ever saw their dreams transformed into full reality. But in life, the search is often more important than the finding. So long as the search continues, hope endures.

Though violence has been a prominent characteristic in Texas' past, its name is derived from the word *Tejas,* interpreted to mean "friend" in the language of the Hasinai. The Spanish explorers applied that name to many of the Indians they encountered. Some of the early contacts were anything but friendly, however.

In the timbered eastern part of the state, early Europeans found a Caddoan farming culture and a stable village-type lifestyle to which they would relate in considerable measure. By contrast, along the coast, they fell among more primitive and implacably hostile people such as the cannibalistic Karankawas, who grimly resisted intrusion. Farther inland, they faced the unforgiving Apache and Comanche.

Alvarez de Piñeda began in 1519—just twenty-seven years after Columbus—to map the Gulf Coast from Florida to Vera Cruz. He spent some forty days at the mouth of the Rio Grande, where Texas and Mexico meet.

Through a series of painful misfortunes, Alvar Nuñez Cabeza de Vaca became the first Spaniard to penetrate the interior of Texas and live to report upon it. Shipwrecked in 1528, he fell into the hands of coastal Indians, who enslaved him for several years. Eventually escaping, he began a long westward journey afoot with three surviving companions. Their wanderings brought them into contact with many Native tribes, among whom de Vaca gained a reputation as a wondrous healer.

Reaching Sonora, Mexico, in 1536, he returned to Spain with glorious tales that triggered a succession of bold, treasure-hunting expeditions into the New World. A godly man, he begged for justice and peaceful relations with the Indians. Ironically, the accounts of his travels led to the opposite: dispossession and enslavement, disease and slaughter.

Francisco Vásquez de Coronado swung across western Texas in his fabled but futile search for riches in 1541. Finding only sun-baked adobe villages where he had been promised seven cities of gold, he executed his Indian guide and went back to Mexico richer in knowledge but poor in purse.

Foreshadowing the state's twentieth-century prominence in petroleum, Luís de Moscoso in 1543 caulked his ships with seepage from oil springs near Sabine Pass, which three centuries later would be the scene of a remarkable Civil War confrontation. Moscoso had been part of Hernando de Soto's exploration of the Gulf Coast and had penetrated inland to the buffalo plains before turning back, discouraged by a land he found dry and inhospitable, devoid of its fabled wealth.

Hand-in-hand with the search for gold was the missionary padres' search for Indian souls. Missions were established, some successful, some failures. As early as 1632, a short-lived attempt was made to build a church on the Concho River near present San Angelo, where Spanish traders acquired river pearls from Jumano Indians.

A French soldier, Rène-Robert Cavelier, Sieur de La Salle, established a small fort near Matagorda Bay in 1685. Not far from present Navasota, he was killed by one of his own men. Indians destroyed his fort and most of its inhabitants. The French attempt stirred the Spaniards to more vigorous defense of their claim on Texas. They built more missions and encouraged permanent settlements. San Antonio's first mission would gain

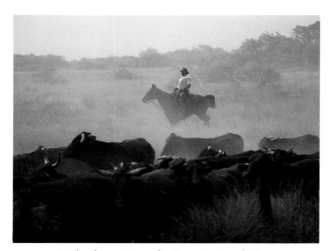

*Cattle drive, Kenedy County, South Texas*

immortality a century later as the Alamo. Some of today's San Antonio citizens can trace ancestry back to fifteen families of Spanish Canary Islanders who settled the newly founded San Fernando de Bexar village in 1731.

A tragic failure was the Mission San Sabá, established in 1757 near present-day Menard to minister to the Lipan Apaches. By this time, the Comanches had mastered the use of the horse as a weapon of war and swept down from the Rocky Mountains, conquering the plains and invading the prime hunting grounds of the Texas Hill Country. Blood enemies of the Apaches, they overwhelmed the mission and put it to the torch. Jim Bowie, fated to die in the Alamo, came across the ruins more than half a century later and carved his name on the gate. A replica built in Texas' centennial year still attracts visitors, though nothing tangible remains of the original mission.

Spanish rule over Mexico, which included Texas under the name Nuevo Santander, was arbitrary and erratic, leading to Mexican revolt and eventual independence from Spain in 1821. By this time, Mexican settlement in Texas was still confined mostly to the immediate areas of San Antonio, Goliad, and Nacogdoches, and some land-grant ranches along the Rio Grande that were hard-pressed to defend themselves against Indian attack. Even the sizeable village of San Antonio was not immune. Herdsmen were killed on its outskirts, and bold Comanche warriors occasionally rode through its streets, challenging the citizens to come out and fight.

In 1821, Mexican authorities gave Missourian Moses Austin permission to bring three hundred American families into Texas to help stabilize the Indian frontier. His untimely death dropped the responsibility on the thin but capable shoulders of his son, Stephen F. Austin, who would become known as the father of Texas. Austin's colonists were the first Americans to settle in

Texas legally, though many had squatted illegally west of the Sabine River. A state park near Sealy marks the site of the empresario's headquarters, San Felipe de Austin, on the south bank of the Brazos River amid venerable old oaks strewn with Spanish moss. The original stone-lined well remains much as it was when he drew water from it, near a replica of his office, a simple double log cabin with open dog-run in the center.

As Mexico had rebelled against Spain, Texas rebelled against Mexico in 1835 after President Santa Anna proclaimed himself dictator and nullified the Mexican constitution. A cannon shot on the Guadalupe River near Gonzales opened hostilities. A hastily organized Texan force laid siege to San Antonio and took the city after five days of bitter house-to-house, street-by-street combat. In an odd twist of history, Mexican General Cós regarded the Alamo as indefensible and did not try to hold it. His judgment was borne out the following March when the Alamo fell to Santa Anna after a thirteen-day siege.

Sam Houston, former governor of Tennessee, headed up the Texas volunteer army. After the fall of the Alamo and Santa Anna's massacre of prisoners at Goliad, alarmed Texas settlers began what became known as the Runaway Scrape in their haste to reach American soil ahead of the Mexican soldiers. Houston went into a long retreat. Many of his troops feared he was about to give up Texas and retire to the safety of Louisiana. But on the open plain of San Jacinto near modern-day Houston, his back to the waters of Buffalo Bayou, he suddenly turned about on April 21, 1836. Having lured the over-confident Santa Anna to divide his forces and stretch his supply lines, Houston led an assault that surprised the Mexican army at siesta. The result was a stunning rout, the capture of Santa Anna, and el presidente's reluctant acknowledgment of Texas independence.

*Alligators inhabit wet coastal areas and East Texas.*

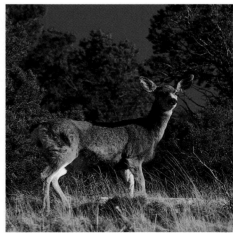

*Mule deer in West Texas*

For the next ten years, Texas was a republic, a nation unto itself. Though controversial even among the troops he had led to victory, war hero Sam Houston became its first president. For a time, the capital was the newly founded town of Houston, built on the ruins of old Harrisburg, which retreating Texans had burned to leave nothing for Santa Anna. The capital was moved in 1839 to a little settlement first known as Waterloo, on the Colorado River at the edge of the Indian frontier. The name was changed to Austin, in honor of the man who had brought the first American settlers into Texas. Houston had lived among the Cherokees and conducted a policy of conciliation toward the Native Americans. It was reversed under the second president, soldier and poet Mirabeau Lamar, who had a liberal attitude toward education but a deep hostility toward Indians.

Because a majority of the citizens were American in origin, most advocated attaching Texas to the United States. Anson Jones, last president of the republic, officiated over annexation ceremonies in 1846 at Washington-on-the-Brazos. It was there that the Texas declaration of independence had been signed even as the Alamo was under siege. He declared, "The Republic of Texas is no more."

Once one of Texas' most important towns, and for a time its capital, Washington-on-the-Brazos today is largely a state park where visitors may view the Anson Jones home and a museum devoted to the history of the town and early Texas.

An independent streak—a stubborn one, critics sometimes say—still runs through the Texas character as part of its strong pioneer heritage. Many attribute it at least partly to the fact that Texas, unlike any other state, was once a free and independent republic, in charge of its own destiny.

Though immigrants into early Texas came from all parts of the United States as well as from Europe, the dominant cultural heritage was from the American South. It stood to reason that as war clouds began to gather, a majority of Texans voted to cast their lot with the Southern Confederacy. Much of the state's male population was drawn away to distant battlefields in Virginia and elsewhere, but a few important Civil War battles were fought on Texas soil.

When the Texans thwarted the Union seaport blockade by freighting wagon trains of cotton across the Rio Grande into Mexico and bringing back war supplies, Union forces invaded at the mouth of the river and occupied Brownsville. Still, their patrols were unable to stop the movement of contraband, which simply shifted upriver out of reach, continuing on the Mexican side in plain sight but protected by Mexico's neutrality.

With a handful of volunteers, a few real cannons and several fake ones constructed of logs, an Irish saloonkeeper named Dick Dowling bluffed and outfought the commanders of a federal fleet, capturing several Union ships in the Battle of Sabine Pass. Confederate troops under John Salmon "Rip" Ford won the last battle of the war, defeating Union occupation forces at Palmito Ranch east of Brownsville May 13, 1865. Ironically, Lee had already surrendered to Grant at Appomattox, but the news had not reached Ford and his men.

Much of today's popular cowboy image of Texas dates back to the trail drives that began soon after the end of hostilities. Cash-poor but cattle-rich because of a huge buildup in unattended herds during the war, Texans began pushing longhorns north, seeking a market in Missouri and Kansas.

The Indian wars were winding down, brought to a head by commercial buffalo hunters invading southward from Kansas onto the Texas plains, decimating the great shaggy herds that for ages had been the Native Americans' walking commissary. Defeated in 1874 at the Battle of Adobe Walls, near present

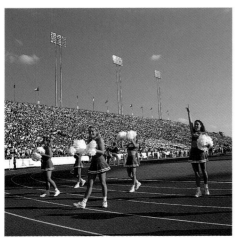
*Texas Pom Squad at UT game*

*University of Texas football game*

Stinnett, and in the Tule Canyon branch of the Palo Duro, east of Tulia, the Comanches and their Kiowa and Cheyenne allies were left little choice but a retreat to reservations set aside in Indian Territory. The Apaches held out a few years longer in far West Texas, where they fought several engagements with the army's black "buffalo soldiers."

Upon entering the Union, Texas had retained its public lands. It encouraged settlement of its sparsely populated regions through a more liberal homestead program than the federal government provided in other Western states. As would be expected, the last areas to settle were west of the 98th meridian, where rainfall is less than generous, rivers and streams fewer and farther apart.

It was said that the windmill did more for settlement of West Texas than the cavalry ever had, for it made dry regions habitable. The windmill remains an icon of West Texas ranches and farms today, standing tall against an open blue sky, offering its promise of relief in a land that seems always to thirst for cool, clear water.

It used to be said that West Texans had to climb for water and dig for wood. That is, they climbed windmills to service them and keep them pumping, and in an earlier time they often had to dig up roots and stumps for firewood on the open prairies. Invading brush, particularly mesquite, solved the wood problem, but has created larger problems of its own.

During the settlement period, new towns were born to great promise, only to die when by-passed by the advancing railroads or by highway builders who chose a different route. Railroads made bustling cities out of small, sleepy towns. Conversely, they brought decline to prosperous cities such as Jefferson, once a busy steamboat terminus, because its principal industry had been rendered obsolete by the convenience of the rails.

If any one feature can be considered constant in Texas history, it is change, recurring upheaval in the old and established, unsettling intrusion and triumph by the new, which then all too quickly becomes the old, the vulnerable.

Cattle and cotton were kings for a time; then came the oil age. It was ushered in by a spectacular gusher that blew out the crown block of a wooden derrick at Spindletop in East Texas January 10, 1901. It took nine days to bring the runaway flow of crude oil under control. Sparks from a passing locomotive set off a massive blaze that burned away much of the waste.

The Spindletop discovery set into motion a black-gold rush and launched explosive booms in such places as Kilgore, Ranger, and Borger. As oil excitement and exploration spread across the state, the boomtowns of Texas were much like earlier ones in California, Nevada, and the Yukon, except that now the boomers plied the rough terrain in trucks and automobiles.

On a lonely greasewood flat west of the quiet ranch town of Big Lake, driller Carl Cromwell lived in an unpainted shack on a University of Texas lease. His wife kept a garden and raised chickens for twenty-one monotonous months while an old and cantankerous cabletool rig slowly punched its way three thousand feet into the earth. On the morning of May 28, 1923, the ground trembled, and Santa Rita No. 1 erupted in a giant shower of mud and oil, ushering in the Permian Basin boom.

From a standpoint of population, Texas has become heavily urban like the rest of the nation. Yet, for those who venture beyond city limits, the atmosphere is still rural. Its huge landmass and its roughly 275,000 square miles of space challenge the endurance of any motorist who drives the eight hundred miles from Texarkana to El Paso, or from Brownsville at the lower end of the Rio Grande Valley to Dalhart in the Panhandle.

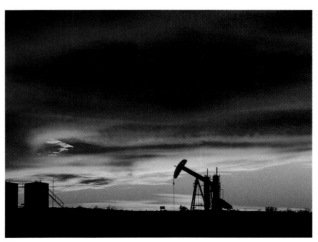

*Oil wells are common across much of Texas.*

Take a Texas highway map, as I have. Cut out the yellow sections that represent all the larger cities including Dallas, Houston, San Antonio, Fort Worth, Austin, and half a dozen others. Paste them down over the Big Bend region, and you will find that they do not even cover up all of Brewster County, largest of Texas' 254.

Urban? Yes, from the standpoint of where the majority of people live. Rural? Without question, from the standpoint of land area.

A tour of Texas can begin anywhere, but one logical place is where the first European adventurers saw it, along the Gulf Coast. The deep-soil prairies of the coastal plain, rising slowly and gently up from the marshes and beaches at water's edge, were the last part of Texas to emerge from receding ancient seas. The most prominent cities facing the water are Corpus Christi and Galveston, but smaller cities, fishing and shrimping towns, are scattered along the shoreline and inside the bays. Houston is serviced by a fifty-mile ship channel which gives it access to the sea, though it actually lies inland from Galveston Bay.

The coast's many long, narrow barrier islands, of which Padre Island is the largest, buffer the mainland from hurricanes that occasionally roar in from the warm salt waters of the Gulf. Such a hurricane in 1900 devastated Galveston Island and killed some six thousand people in the nation's worst natural disaster. Survivors rebuilt their historic town and constructed a granite seawall to help guard it against a repetition of that catastrophe.

Some historians contend that Cabeza de Vaca was shipwrecked on Galveston Island, setting in motion his overland odyssey across what would become Texas. Many other ships would die along the Texas coast in the next four centuries, sunk or driven ashore and battered to pieces by the treacherous storms which boil up almost without warning in the Gulf.

More than two hundred years after de Vaca, the Spanish built a garrison which they named for Bernardo de Gálvez, governor of Louisiana. After helping Andrew Jackson defeat the British in the battle of New Orleans, pirate Jean Laffite set up headquarters on Galveston Island, and legends persist about treasures buried in its sands. Other freebooters and filibusters used the island as a staging point.

Galveston became the leading seaport town for the new Republic of Texas. It was captured and held by Union troops for a time during the Civil War. As a major port of call for ships from all over the world, it was long considered the most cosmopolitan city in Texas, and in many ways the most beautiful. Large fortunes were amassed, manifested by the luxurious architecture of magnificent homes and business buildings. Most prominent of these is probably the 1886 Bishop's Palace, a splendid example of Victorian excess.

A leader in its heyday, Galveston was the first city in Texas to install electric lights. After construction of a ship channel between Houston and Trinity Bay siphoned away much of Galveston's import-export trade, the old city went into a long decline. In recent years, ambitious restoration projects have renewed much of its lost aura. It has become a magnet for tourists seeking the gilded splendor of a by-gone age.

Corpus Christi stands just off the tip of Padre Island at the mouth of the Nueces River, which traces its beginnings far to the west in the limestone hills of the Edwards Plateau. Alfonso Alvarez de Piñeda anchored his ship on the feast day of the Body of Christ in 1519 and named Corpus Christi Bay. The town was first a trading post in the early days of the republic but did not rival Galveston as a port until much later. Its position on the Gulf Intracoastal Waterway made it a natural after dredging of the bay and sea channel created its deep-water port in 1926.

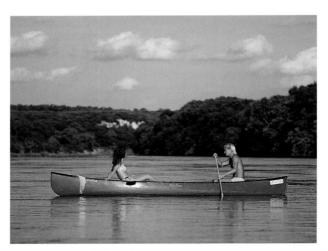

*Paddling down the Brazos River.*

Travelers from inland get their first good look at Corpus Christi from the heights of the Harbor Bridge. The city's sparkling clean appearance, its mild climate, its cultural offerings, deep-sea fishing, marina, and seaside recreational opportunities have made it another prime tourist attraction.

The rare whooping crane has its wintering ground in the Aransas National Wildlife Refuge near Rockport, just up the coast from Corpus Christi. The refuge is a haven to an estimated three hundred other bird species as well.

The upper part of the Gulf Coast nearest Louisiana is the most highly developed, largely because of the petroleum industry, pipeline facilities, and refineries at such points as Port Arthur and Texas City. From Galveston southwestward, development is more modest. Along the coastal bend from Corpus Christi to Port Mansfield, the inner shore remains much as it has always been, protected by long, narrow Padre Island, which serves as a natural seawall. Ranches extend to the sand dunes and beaches. Cattle wade belly-deep into coastal marshes to graze the salt grass. Pioneer cowman Shanghai Pierce called his hardy longhorns "sea lions" for their ability to thrive in this unlikely environment. Today, the region's cattle tend to be Brahman types or the red Santa Gertrudis developed by the King Ranch.

Though Padre Island has acquired much attention because of the college students who flock there during spring break, undeveloped sandy beaches stretching for more than a hundred miles are a year-round attraction to visitors. It is a unique environment for a wide variety of bird life such as gulls, terns, and snowy egrets, which hunt for food along the shore. Some are migratory, some permanent. Some mammals live among its shifting dunes. Many types of fish and crustaceans, some rare, are at home in the Laguna Madre or in the sea on the eastern side. Because most of the island remains undeveloped, much

without even a road, overnight visitors camp out, bringing their own provisions. This in itself makes it attractive to those seeking a getaway from urban traffic, city noise, and crowding.

Houston is an inland city, though its long ship canal makes it one of the nation's three largest seaports. For all its sprawling size, its far-stretching skyscraper skyline and its spaghetti-like elevated highway exchanges, Houston, in an odd way, retains some of the laid-back atmosphere of old-fashioned small-town Texas. It has a lackadaisical attitude toward such urban notions as zoning, building restrictions, and the like. Its close ties to the oil fields and their free-enterprise traditions have lent Houston an easy air of informality that shuns regulation and bureaucratic micromanagement. The prevailing spirit seems to be, "If you can afford it, do it. If you can't afford it, try anyway."

That attitude has helped make it a major medical center for the Southwest, not to mention its standing in such varied fields as aerospace, education, finance, and sports. Among its attractions are the Lyndon B. Johnson Space Center, the Astrodome, and the Texas Medical Center. Nearby are the moored battleship *Texas* and the San Jacinto Battleground State Historic Park. A needle-like white monument, topped by a huge lone star, stands 570 feet tall on the flat plain where Texas won its independence from Mexico in a blaze of cannon fire and musketry described as one of the world's most decisive battles.

Northeast of Houston lies the Big Thicket, of which enough remains to provide some idea about the physical obstacles early travelers faced as they struggled overland toward the Texas settlements through dense canebrakes; dark forests of pine, palmetto, and cypress; and deep marshes that threatened to swallow up men, mules, oxen, and wagons. The 84,550-acre Big Thicket National Preserve protects a sizeable remnant that has survived decades of timber cutting and land clearing.

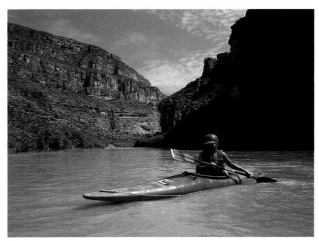

*Kayaking in the Lower Canyons, Rio Grande*

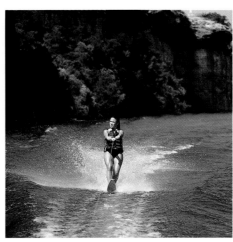

*Waterskiing at Lake Possum Kingdom*

Texas settlement began with Spanish land-grant ranches along the historic river that gave its name to the Rio Grande plain and today marks the Texas-Mexico boundary. The Spanish and Mexican heritage remains strong in the bicultural region of the state's far south, where a majority of the population is Hispanic. *Diez y Seis* and *Cinco de Mayo* holidays are celebrated with as much fervor as the Fourth of July. Export-import trade with Mexico is a vital part of the economy from Brownsville upriver to Laredo, Eagle Pass, and Del Rio.

The subtropical lower Rio Grande Valley, sloping gently toward the Gulf, has long been famous for its mile upon mile of ruby red grapefruit and orange groves, as well as its almost year-round harvest of spinach, carrots, lettuce, and cabbage. Mission is particularly known for its Christmas poinsettias. In recent decades, winter sunshine has attracted "snowbirds" who take up part-time residence to escape the bitter winds and deep snows of home states to the north. They park their mobile homes and RVs amid the palm trees and the brilliant bougainvillea in the benign climate of Harlingen and McAllen.

Ranching still occupies most of the land away from the river, as it did when the first Spanish cattlemen ventured into the region to take up the generous land grants given them for services to the king. Their major problem then was isolation and frequent harrassment by Indian raiders. Today's problems are more likely to involve rain and the lack of it, fluctuating markets, insects and disease, and a constantly changing myriad of government regulations. Early maps designated much of the region between the Rio Grande and the Nueces as Wild Horse Desert. The wild horses are gone, but ranchers and farmers still contend with the challenge of a land that always seems to need one more rain and is sometimes less compatible to grass than to mesquite, cactus, and chaparral. The manager of a huge King Ranch division once ventured out to inspect the range after a week or so of heavy rains had left water boot-top deep and pastures shimmering like a huge lake. He said to his son, "That rain was all right as far as it went. Now, if we can just get a follow-up like it in a couple weeks. . . ."

No city in Texas outranks San Antonio for history, for beauty and color, for diversity and unique personality. Long known as San Antonio de Bexar, it was for a century or more the largest town in Texas and became the Spanish, and later the Mexican, second capital for the combined states of Texas and Coahuila. Much of early Texas history revolves around it. Founded in 1718 around the San Antonio de Valero Mission, later called the Alamo, it was a principal point on the Camino Real, the royal road that led across Texas to a Spanish presidio far to the northeast at heavily forested Nacogdoches. Eventually, five missions were built in San Antonio's immediate area in an effort to convert and educate the Indians. Its oldest section, known as La Villita, or Little Village, still retains much of the original flavor of this Spanish outpost.

After the Texas revolution, American influence began to blend with San Antonio's original Hispanic culture. European immigrants, especially German and Polish, added other flavors to the mix. San Antonio became the nearest rival to Galveston for cosmopolitan atmosphere in the latter part of the nineteenth century. Annual celebrations such as the Fiesta San Antonio, the Battle of Flowers parade, the Texas Folklife Festival, and the Holiday River Festival help keep these mixed heritages alive.

San Antonio was a mustering point for hundreds of cattle herds as they began the long drive northward to Kansas. In the antebellum Menger Hotel, on whose ledger Robert E. Lee wrote his name while conducting courts-martial at army posts across

*Surfside Beach near Freeport*

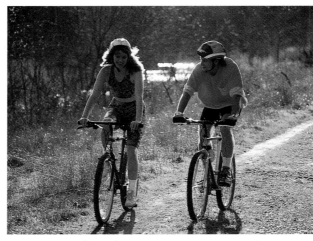

*Cycling along Austin's Barton Creek*

the state, tens of thousands of cattle changed ownership in a handshake over a cup of coffee or a jigger of whisky. In the Alamo plaza, John Warner "Bet-A-Million" Gates, a show-minded salesman, demonstrated that barbed wire could restrain wild longhorn cattle, in effect initiating the fencing of the West. San Antonio's annual livestock show and rodeo celebrates this tradition and stands second only to Houston's in size.

The historic San Antonio River meanders through the downtown area, flowing toward the old missions to the south. The popular River Walk is lined on both sides by shops and restaurants, where patrons may enjoy a leisurely meal outdoors, Parisian-style, or even take their dinner on a flat-bottomed boat as it gives them a slow and easy tour upriver and down.

From its days as a Spanish presidio, San Antonio has had a strong military presence. Since 1876, it has been home to Fort Sam Houston. The Apache Geronimo spent time at Fort Sam on his way to a Florida prison. Theodore Roosevelt recruited Rough Riders in the Menger Hotel bar and drilled them on the parade grounds. Army officers prominent in every war of the last hundred years have walked the quadrangle of Fort Sam.

Kelly Air Force Base trained such early-day flyers as Charles Lindbergh, Billy Mitchell, and Hap Arnold. Thousands of Air Force pilots have passed through Randolph, Lackland, and Brooks Air Force Bases. San Antonio is one of the nation's most popular cities for retired military personnel to call home.

To the Old Three Hundred who pushed their plowpoints into the rich virgin soil of Stephen F. Austin's colony, the frontier lay mysterious and forbidding, barely beyond sight to the west. It began just past the Austin grant and immediately west of San Antonio along the wooded limestone hills that marked the Balcones Escarpment. That rising prominence was the leading edge of the Edwards Plateau, which stretched westward toward

the Pecos River and south and southwestward to break away into the Rio Grande plain. The Comanches by that time had driven out or annihilated the Apaches and guarded their Hill-Country hunting grounds with fierce determination.

When Mirabeau Lamar first proposed building a new capital of the republic on the Colorado River and naming it for the Father of Texas, many citizens strongly opposed what they regarded as a reckless gamble. Among them was Sam Houston, who had personal reasons for wanting to leave the capital where it was, in the new town that bore his name. The suggested site was wide open to Indian raids, Houston and others argued. It would also be difficult to defend against re-invasion by Mexico. Indeed, Mexico did try in 1841 but penetrated only as far north as San Antonio.

Indian raids did occur, but those are less remembered than the international incident that arose when the French chargè d'affaires became involved in a squabble over an innkeeper's hogs invading the French legation. The building remains today the oldest structure in Austin, more than a century and a half after the infamous "pig war."

As the pig incident would indicate, Austin was a crude, muddy frontier village at first, but began taking on the appearance of permanence in the 1850s after Texas was annexed to the Union. Log cabins gave way to sturdy stone buildings. A fine three-story capitol building, topped with a cupola, served the state from 1856 until fire destroyed it in 1881.

Still short on money but long on land, the state of Texas traded three million acres of undeveloped range in the distant Panhandle to a Chicago syndicate for construction of a new capitol building. A narrow-gauge railroad was built to transport granite blocks for construction, and much of the labor force was made up of convicts. The Panhandle land became

*Pumpkins, Hill Country town of Comfort*

the fabled XIT Ranch, which at one time grazed 150,000 cattle in ten counties.

The University of Texas opened its first classes in Austin in 1883, though the republic's congress had provided for it as early as 1839. Large acreages of land in the western part of the state were set aside as an endowment. This proved particularly fortunate after the discovery of oil and gas, which vastly enriched the university system's permanent fund.

The university has branches in many cities across the state, but to former students the University of Texas is still in Austin. Here taught the famous Texas literary triumvirate, J. Frank Dobie, Walter Prescott Webb, and Roy Bedichek. The favorite student playground, aside perhaps from Memorial Stadium, is Zilker Park and its beautiful Barton Springs, where crystal-clear water gushes from the fractured layers of Balcones limestone.

The capitol building opened in 1888 still graces the Austin skyline, though from many vantage points it is dwarfed by skyscrapers built in the 1970s and 1980s. For a while it was joked that the state bird of Texas should be the crane because of heavy construction activity in the state's capital.

The region known as the Hill Country starts within today's city limits of both Austin and San Antonio and stretches westward through the old settlements of New Braunfels, San Marcos, and Fredericksburg, through Kerrville and Junction, Mason and Llano, Johnson City, Blanco, and tiny Luckenbach. It is traversed by the Guadalupe, the Frio, the Llano, and the San Saba Rivers, as well as dozens of creeks and streams. In contrast to the majestic scenery of the Big Bend or the Guadalupe Mountains, it has a quiet, restful beauty that touches the soul in a way uniquely its own. Those who know the Hill Country, though they may live far away, go back again and again. The Hill Country seems always fresh, always beckoning for a return.

Many of its towns, especially Fredericksburg but also New Braunfels and Boerne, still retain the German flavor that reflects their history. In the days of the Texas republic, the Adelsverein in Germany recruited potential immigrants to settle a large land grant it had acquired in Central Texas. The first wave arrived in 1845, only to find conditions more primitive and survival far chancier than promoters had led them to believe. Prince Carl of Solms-Braunfels founded New Braunfels that year but soon returned to Germany and left his charges to fend for themselves. Fortunately, leadership fell into the strong hands of John O. Meusebach, who among other things made a treaty with the Comanches and spared the Hill Country German settlers many of the Indian depredations suffered by others around them.

The Germans who survived the initial hardships found the hills similar in many ways to regions they had left behind in the Fatherland. Through hard work and thrift, they built a strong and conservative farming and ranching economy that remains today a model of responsible land stewardship and animal husbandry.

To walk the streets of Fredericksburg is to relive a segment of history, for its citizens have resisted the urge to tear down everything old and replace it with something "modern" of steel and glass and concrete. A majority of the downtown business buildings have stood for a century or more and reflect the flavor of their Old World heritage. A unique feature is the Sunday houses, small weekend homes built by past generations of farm and ranch families in a time when a trip to town for church a-horseback or by wagon meant an overnight stay.

Interstate 35 divides the state roughly in half, stretching generally northward from Laredo at the Mexican border, up through San Antonio, Austin, and Waco. It splits to intersect both Dallas and Fort Worth, then rejoins at Denton to cross

*Miradores overlook the bay in Corpus Christi.*

the Red River north of Gainesville and enter Oklahoma. To the east lie the dense piney woods and black gumbo soils of East Texas and such cities as Bryan-College Station—home of the Texas Aggies—and Huntsville, Lufkin, Longview, Tyler, and Sherman-Denison. At the extreme northeastern corner of the state sits Texarkana, where the main street forms the borderline between Texas and Arkansas and gives the city a split personality.

East of the interstate, rainfall is more generous, the grass greener, and croplands more productive than on the west side, for the highway roughly parallels the critical 98th meridian. There have been times when I have been almost certain I could see a difference the moment I drove through an underpass. It is easy to understand why early settlers took up the eastern part of the state first, and a majority of Texas' population today still lives east of I-35.

Dallas and Fort Worth, originally some thirty miles apart, have a rivalry that goes back a hundred years. However, they and their suburbs have grown so much that they all seem a single huge city. Many Texans lump them together as simply the D-FW Metroplex. Nevertheless, to those who know them, each has its own personality. Historically, Dallas was cotton; Fort Worth was cattle. In a strong sense Dallas looks eastward, while Fort Worth looks to the west. The Dallas image is sophisticated, conservative, well-to-do, and white collar. The Fort Worth image is that of the try-anything-once frontier mentality, of raw energy and blue-collar muscularity.

Fort Worth has proudly carried the nickname "Cowtown" for decades. When promotion-minded city leaders tried to abolish that title as outmoded and demeaning, they were ignored. The name still sticks, though the huge north-side stockyards that helped build Fort Worth have been converted

mainly into a sprawling entertainment center, strongly Western in theme.

Dallas began with a log cabin built by John Neely Bryan on the Trinity River in 1841. In two years it doubled in size to two log cabins. By 1849 it was large enough to have a newspaper, which in time became today's widely read *Dallas Morning News*. Dallas gradually evolved into an important center of the cotton trade. Though aging, Bryan was still around to greet the arrival of the first train in 1872 and partake of buffalo barbecue.

Dallas was a supply and marketing hub of the huge Northeast Texas farming area and, as such, became the major financial center which it remains today. Its State Fair of Texas, begun in 1886, is still one of the largest events of its kind in the Southwest. Dallas hosted plays, concerts, and operas, supporting its own Shakespeare Club as early as 1886 and building the city's reputation as a cultural leader for the state. The huge Dallas insurance industry was launched with the organization of the Praetorians in 1899. Southern Methodist University, one of the state's larger educational institutions, conducted its first classes in 1915. The Dallas skyline began to take on new dimensions with construction of the fifteen-story Praetorian Building in 1907 and the Adolphus Hotel in 1912. That skyline is world-famous today, thanks to the long-running television series bearing the city's name.

Fort Worth, like many other Texas cities and towns, owes its beginnings to the military, which established a post in 1849 on the Clear Fork of the Trinity River some thirty miles west of Bryan's fledgling community. The first business building was a tent on the riverbank. A stagecoach line began operation in 1850 from Fort Worth to Yuma, Arizona. After the Civil War, Fort Worth became an important supply point for trail herds on their way north to Kansas. The town's rivalry with Dallas

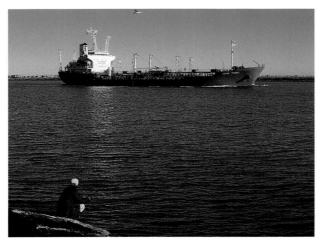

*Tanker enters Gulf from Freeport Ship Channel.*

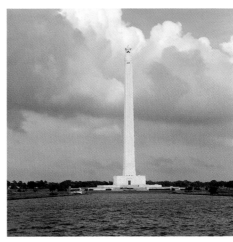

*San Jacinto Monument*

began early. Dallasites taunted their neighbor by nicknaming it Panther City, claiming it was so dull that a panther was seen sleeping peacefully on its streets.

The coming of the first railroad in 1876 pumped new life into Fort Worth. It became a major cattle-shipping point, leading to establishment of the stockyards that turned Panther City into Cowtown. For decades, those yards and several major meat-packing plants made Fort Worth the largest livestock market west of Chicago and St. Jo. This trade faded after World War II, as local auction markets shortened the haul for ranchers and farmers, and new, more efficient packing units were built closer to the supply of cattle and sheep.

Fort Worth profited from the discovery of oil in its western territory. Fort Worth and Dallas shared honors with Houston as headquarters for many major oil companies. Texas Christian University, which moved from Waco in 1910 and left that city to Baylor University, is Fort Worth's answer to Southern Methodist.

Despite their traditional rivalry, Fort Worth and Dallas joined forces to build the sprawling D-FW airport through which tens of thousands of passengers move daily. It is the hub of a vast commuter network. A common joke in many smaller cities that share that commuter service is that when you die you can only go to heaven or hell by way of D-FW.

West of Fort Worth, early settlers found Indian resistance stronger than what they had encountered in eastern areas of the state. The horseback Comanches and Kiowas used hit-and-run tactics to defend their hunting grounds and make life precarious for those whites bold enough to intrude upon them. Many times the frontier line pushed forward, then gave again under Indian pressure. It retreated as much as fifty to seventy-five miles during the Civil War, for the Indians soon became aware that defenses had been weakened by so many of the younger men being called away to fight other battles.

Gradually, however, settlements formed and survived from the Cross Timbers and the rolling plains to the broken caprock that marked the eastern edge of the great Staked Plains, the last stronghold of the free-roaming horse Indians. Military posts such as Forts Belknap, Richardson, Griffin, and Concho helped towns like Weatherford, Jacksboro, Comanche, and San Angelo gain a foothold. However, the dryness of the region west of Fort Worth presented an even greater challenge than the Indians for ranchers and farmers. It still does.

Extension of the Texas and Pacific Railroad west of Fort Worth toward El Paso helped speed settlement after the early 1880s, but that influx of new citizens created new problems. Early settlers came mostly from areas of higher rainfall, and all too often they overestimated the potential of the new land to which they had come. Farming methods that had worked well in the East or in Europe sometimes betrayed them. Stockmen saw a sea of grass that had grown up undisturbed after the buffalo were removed, and they were overoptimistic about its livestock-grazing capacity.

West of the 98th meridian, old rules failed, and new ones had to be established by trial and error. That learning process is not over, even today. A seven-year drought in the 1950s taught management lessons that are indelibly etched in the minds of contemporary ranchers and farmers, lessons incorporated into today's conservation-minded grazing and tillage practices.

The T&P railroad's westward advance established many towns where there had been none, and several grew into impor-tant cities, including Abilene, Sweetwater, Big Spring, Midland, and Odessa. Oil development in the early part of the twentieth century was a particular boon to Midland and Odessa, sparking

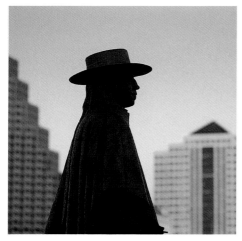

*Austin statue of Stevie Ray Vaughan*

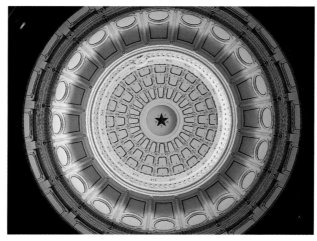

*Ornate dome atop Texas Capitol rotunda in Austin*

a rivalry that on a smaller scale resembles the one between Dallas and Fort Worth. In a general way, Midland became the white-collar center of the Permian Basin oil industry; Odessa, its blue-collar counterpart.

Midland's first skyscraper, a twelve-story structure originally named the Hogan Building, was known at first as Hogan's Folly because much of it stood empty. However, as petroleum development proceeded, its presence encouraged many oil companies to establish headquarters in Midland, filling the building's spaces. Odessa, by contrast, housed many of the equipment companies and became home to thousands of the workers who lent their strong backs and arms to the industry's field operations.

Oil fields developed all over the broad Permian Basin, so named because it was once an inland sea. The waters at its western edge lapped against a great barrier reef that in later geologic times was uplifted to become Guadalupe Peak, highest point in Texas. Early fields bristled with steel and wooden derricks so thick one author described them as an "iron orchard." In recent decades the derricks have come down, replaced by the simple and much less obtrusive pump jack. It looks for all the world like the praying mantis, its heavy steel head rising and falling. From thousands of feet down, each stroke brings up the black oil that helps keep the nation on wheels. Casual visitors sometimes complain about crude oil's pungent odor. Natives say it never smells if you make your living in the oil patch.

Today the Permian Basin Petroleum Museum in Midland pays tribute to those industry pioneers who thought there must be something of value beneath the ground because it seemed to offer so little on top. The East Texas Oil Museum in Kilgore provides a similar tribute to oil pioneers in the eastern part of the state, where development preceded that of the Permian Basin.

The Panhandle-Plains Historical Museum in Canyon devotes space to the high-plains oil and gas industry as well as to the plains Indians and pioneer ranchers and farmers.

After the Civil War, several short-lived Mexican settlements were established in the western Panhandle by sheepmen from eastern New Mexico. Some of these, called Comancheros, knew the plains country well from having traded with the Indians. They grazed their flocks on the public domain. However, once cattlemen began moving into the Panhandle in the wake of the Indians and the buffalo, the sheepmen drew back across the New Mexico line.

High-Plains settlement had to await defeat of the Comanches and their allies, who staunchly defended their homeland until a relentless army forced their yielding in the mid-1870s. Some of the earliest towns showed a great initial potential but did not prosper in the long run. Tascosa, in the western Panhandle, survives today only as headquarters of Cal Farley's Boys Ranch, though its notorious Boot Hill cemetery still reminds visitors of a sometimes-violent past.

An hour's drive to the southeast, Amarillo managed to grow from a railroad camp of buffalo-hide tents in 1887 to a thriving city, center of the huge plains cattle feedlot industry and site of one of the nation's largest cattle auction markets. North of Amarillo is the ancient Alibates quarry where generations of Native Americans chipped away chunks of the raw flint they would shape into arrowheads and spearpoints. A vast Indian trading network scattered this quarry's flint all the way from the Mexican border to Canada.

Southwest of Amarillo lies the long, rugged, and beautiful rainbow-colored gash known as Palo Duro Canyon. In a branch called Tule Canyon, Colonel Ranald Mackenzie and his cavalry

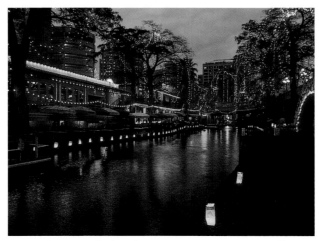

*Christmas lights dot San Antonio's Riverwalk*

troops surprised a Native American winter encampment, captured most of its horses, and for practical purposes ended the long-fought Plains Indian war.

Two hours south of Amarillo is Lubbock, since 1891 center of a huge cotton- and grain-farming area and site of Texas Tech University and its Red Raiders. It boasts a unique musical heritage, having at one time been home to Buddy Holly, Waylon Jennings, Mac Davis, and Jimmy Dean. A classic battle was fought in its Yellow House Canyon in 1877 between buffalo hunters and Comanche Indians. A city park named for Colonel Mackenzie features a popular prairie-dog town.

One of Lubbock's best-known attractions is the Ranching Heritage Center, to which more than twenty authentic historic ranch buildings from around the state were moved and placed on a fourteen-acre site to be preserved as a monument to the ranching industry. To walk among them and let the imagination run free is to relive a bit of the Old West.

My own city is San Angelo, nearly four hours' drive southeast of Lubbock. It began with the military. An army scouting expedition in 1867 decided upon the junction of the three Concho Rivers as the site for an army post, first named Camp Hatch and then Fort Concho. It was on an immigrant trail used as early as the 1849 gold rush, and near the route of the pre-Civil War Overland Mail, the Butterfield stagecoach line. A farming community quickly began, providing food and livestock feed for the post. A village sprang up just off post grounds, selling whisky and sin to the soldiers. A stagecoach station was established at nearby Ben Ficklin, but that town was destroyed by a massive flood in 1882. First known as Saint Angela, the village nearest the fort became San Angela and finally San Angelo as it grew. For a couple of years, it was a hub of the buffalo-hide trade. It was and still is the trade center for a large ranching, farming, and oil-producing region. It features the nation's largest sheep auction and one of the state's largest cattle markets.

Its main tourist attraction is Fort Concho, often cited as the best-preserved frontier military post in the West. Much of what the visitor sees is still the original buildings, augmented by several reconstructions. The post serves as the focal point for two big annual celebrations: Fiesta Del Concho in June and Christmas at Old Fort Concho in early December.

After the army decommissioned the post in 1889, the military was absent from San Angelo for more than fifty years. It returned during World War II to establish Goodfellow Air Base and Mathis Field. Goodfellow remains an active base; Mathis is a civilian airport.

San Angelo is at the juncture of several distinct geographic areas. Immediately to the south begins the Edwards Plateau, a limestone-based live oak and cedar range, center of the state's sheep and Angora goat industry. The plateau extends a hundred or so miles southward, breaking off between Sonora and Del Rio, and some two hundred miles southeastward across the Hill Country, to the edge of San Antonio. To the east lies deep-soil Lipan Flat, which became a prime farming area after arrival of German and Czech farmers in the 1920s. To the north lie the rolling plains, prime cattle-ranching country. Not far to the west begins the semi-desert region regarded as the Trans-Pecos, an arid mesquite and greasewood range starting east of the Pecos River and stretching beyond it to the Davis Mountains.

History, some bright and some tragic, has played itself out along and near the Pecos River. Desolate-looking greasewood-lined Horsehead Crossing, north and a little west of oil-town McCamey, was a favorite fording place for Comanche warriors on their way to Mexico and back with horses, mules, captives, and scalps. It was used by the Forty-Niners, the Butterfield

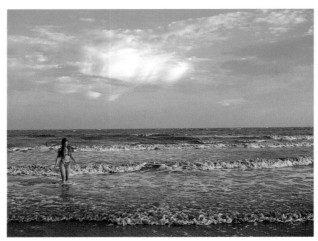

*Sea Rim State Park near Port Arthur*

stage, a west-bound Texas Confederate invasion force, and thousands of covered-wagon emigrants.

After a disaster involving his trail herd, pioneer cowman Charles Goodnight declared the Pecos "the grave of a cowman's hopes." In nearby Castle Gap, legend says, a treasure belonging to Maximilian, late emperor of Mexico, was buried by outlaws who had murdered its escort, then were killed by Indians.

West of Horsehead was Comanche Spring, long a watering place on the Comanche War Trail for raiding parties on their way to and from forays into Mexico. A true oasis, it was a stopping point on early emigrant trails. There, in 1859, the military built Fort Stockton. Using water from the huge spring, an irrigated farming district grew up, reaching eight thousand acres by 1877. Recently, deep-well pumping for more distant farm operations has dried up the spring and idled most of the original irrigation district. A portion of the old military post remains intact, and some of the rest has been reconstructed.

One of the big first-time surprises for travelers moving west across the Trans-Pecos mesquite and greasewood desert is the sight of the Davis Mountains rising tall and blue out of the heat waves that snake along the horizon. Like the Guadalupes to their northwest, they are a southern extension of the Rockies. Early westbound emigrant and military trails led up through Wild Rose Pass and down along the cottonwood-lined Limpia Creek to the army garrison that was set against a huge natural rock wall at Fort Davis. A scenic loop of about seventy-five miles takes a visitor past the two white domes of Mount Locke's McDonald Observatory and through some of the most splendid scenery in the entire Davis Mountain chain, including the ragged Sawtooth Mountain, Adobe House Canyon, and the slick boulders that make up the Rock Pile. Visible for many miles and from many directions is Mount Livermore, 8,382 feet high.

To the southeast, its south boundary the Rio Grande, lies Big Bend National Park, by far the largest in Texas at more than 800,000 acres. A geological wonder and a microcosm of Texas diversity, it rises from its cactus-studded Chihuahuan Desert floor to the pine-forested heights of the Chisos Basin and 7,825-foot Emory Peak. Where the river makes the bend that long ago gave the region its name, the scenery is as varied as in the rest of the park. At Santa Elena Canyon, a sheer rock wall rises up about fifteen hundred feet on the Mexican side. The ground then evens out, looking almost flat for a time before the river once again winds through the depths of Mariscal and Boquillas Canyons.

As diverse as the scenery, wildlife ranges from jackrabbits and ground squirrels to deer, coyotes, mountain lions, and javelinas. The Big Bend is said to host more than 430 species of birds, the widest variety found in any national park.

From Presidio, the park is reached by way of the winding Camino del Rio, the river road that rises over mountains and drops down through deep canyons as it follows the Rio Grande southeastward to the village of Lajitas, and then through the ghost town Terlingua (famous for its annual chili cook-offs) to the western park entrance. Other routes to the park are through Marathon and Alpine, home of Sul Ross State University, where deer sometimes graze at the edge of the campus.

Although the 86,416-acre Guadalupe Mountains National Park is not as large as the Big Bend park, it is no less spectacular. Four of the highest peaks in the state are within its borders, including Guadalupe Peak at 8,749 feet. Ponderosa pine forests stand in vivid contrast to the dryness of the desert environment around them, and high mountain meadows furnish lush grazing to deer and elk. Hiking trails traverse beautiful McKittrick Canyon, which slices through a fossil reef once formed in the western edge of the ancient Permian Sea.

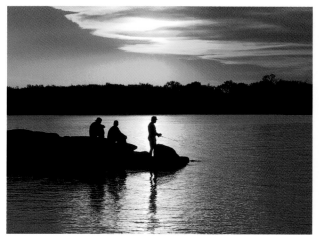

*Anglers at Lake Colorado City State Park*

*The Devil's Sinkhole*

The state's westernmost city, El Paso, in many ways seems an accident of geography, so far removed from the state's other major population centers that its citizens often feel more affinity to New Mexico. It was so long isolated from other parts of Texas during Spanish colonial times that its early history bears little relationship to the rest of the state.

Like San Antonio, it was Spanish, then Mexican, before it was American. Juan de Oñate passed that way as early as 1598.

Historically, it was one and the same with its Mexican twin city, Juárez, originally known as El Paso del Norte, the Pass of the North. Situated on the Rio Grande, it was an important stopping point on the old ox-cart and wagon trail from Chihuahua City to Santa Fe and other early Spanish settlements in New Mexico. Missions were established nearby in 1681 and 1682. The San Elizario Presidio chapel was built in 1777 to serve a military garrison and is still used for daily worship.

The military presence has been an integral part of El Paso life since Spanish times. Fort Bliss was established soon after the end of the Mexican War in 1848, its principal mission being defense against the Apaches. It was a stopping place for Texas Confederate troops in 1862 as they marched westward with a grand plan to capture New Mexico and Arizona and finally the gold fields of California. After a California-based Union column defeated them at Glorieta, they straggled back through Bliss on their way home.

In frontier times, El Paso had a wild-and-woolly reputation, its board sidewalks frequently trod by outlaws from both sides of the border. Famous gunfighter John Wesley Hardin was killed in an El Paso saloon by the aging John Selman, who in earlier times had ridden the outlaw trail himself but in his later years wore a city marshal's badge. Pancho Villa took refuge in El Paso while plotting to overthrow the Mexican government.

My recollections of Fort Bliss go back to World War II, when I was sent there for anti-aircraft training. We often drilled amid sand dunes and patches of goat-head stickers between Bliss and Biggs Army Airfield. One of my most trying days involved a blistering July climb up the west side of boulder-strewn Mount Franklin to conduct a communications exercise on top, then a descent down the east side and a long march back to barracks. There, I just had time to wash up before I was due my turn at KP. I decided if that day didn't kill me, nothing was likely to.

We maneuvered on a firing range out in the Hueco Tanks area, where natural catch basins in the rocks stored precious rainwater for Indians and for early travelers crossing the desert.

The Rio Grande has always been fickle, changing course from time to time so that land once in Mexico became a part of Texas. That did not matter so long as Mexico and Texas were one, but it came to matter a great deal after Texas independence. One long-disputed area known as the Chamizal was given back to Mexico in 1963 and the river artificially but permanently rechanneled into an older course.

The sandy El Paso Valley is a rich, irrigated farming area in the midst of a desert. The city is important as a supply center for a large area of western Texas and southeastern New Mexico. Interstate 10 channels heavy traffic on its way west to Arizona and California, or east toward Dallas-Fort Worth or San Antonio and Houston. El Paso is an important gateway to Chihuahua City and western Mexico, just as Eagle Pass, Laredo, and Brownsville far downriver are entry points to eastern Mexico.

Even those of us who have lived a lifetime in the state continue to discover unexpected hidden corners, fresh and exciting turns in the road. Texas is old, yet it is constantly changing, renewing itself, surprising us with its many faces.

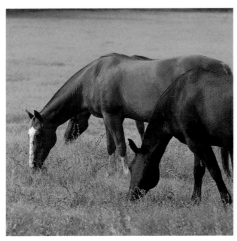

Horses, Travis County Hill Country

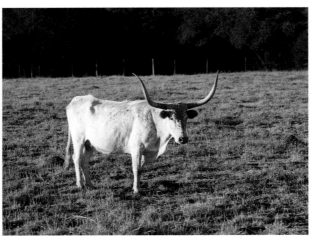

Hardy longhorns, well suited to early Texas ranches

*In wet years, bluebonnets can surround blind prickly pear cactus in the Big Bend desert.* ▶

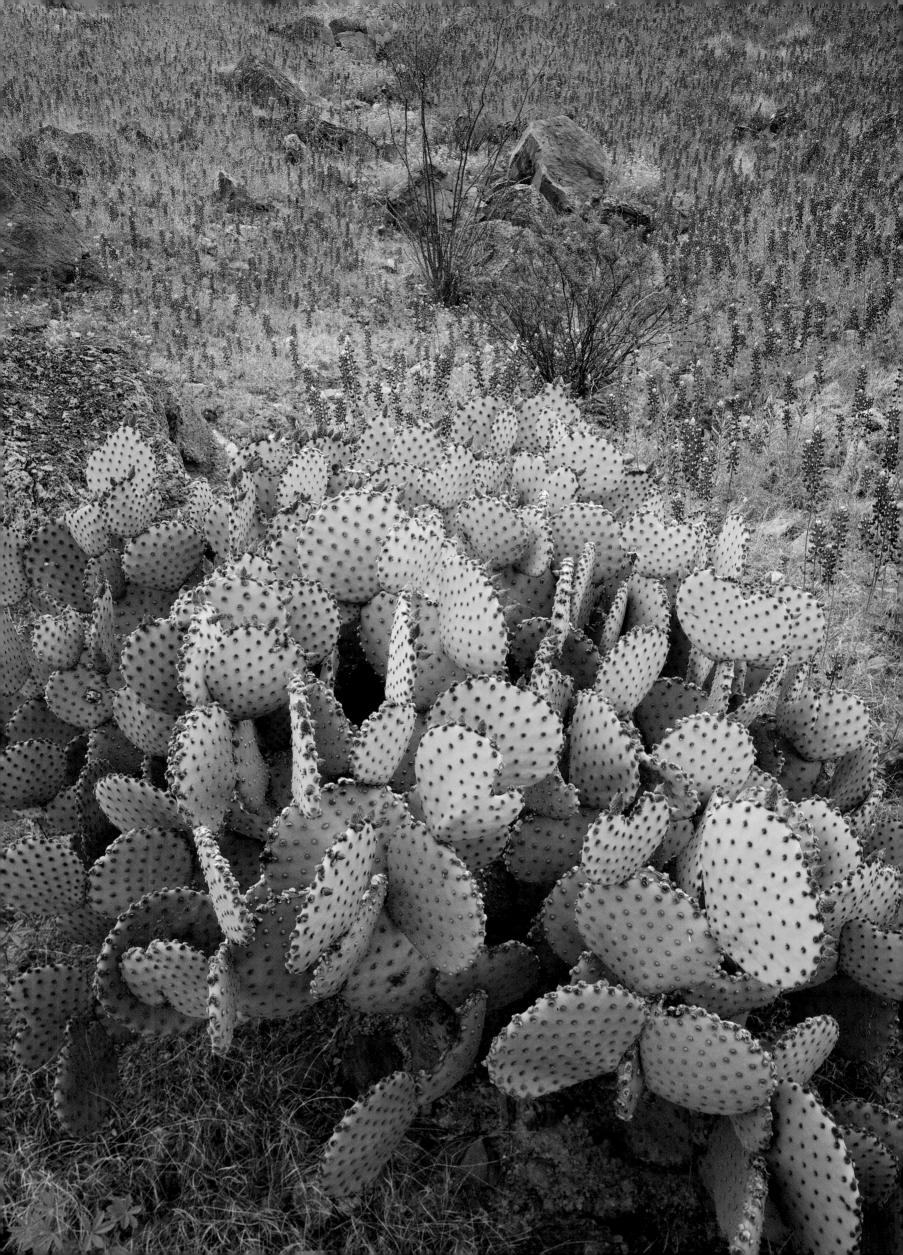

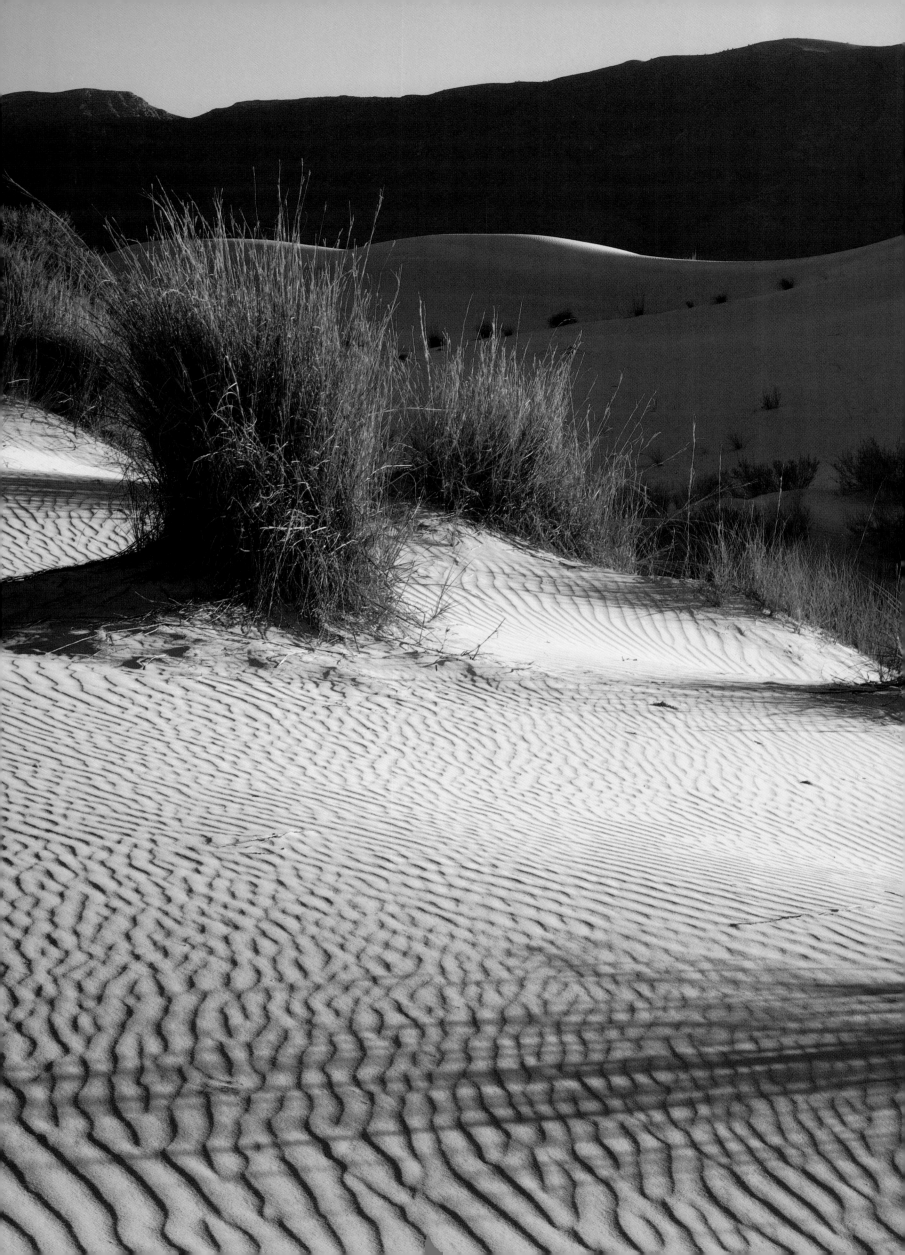

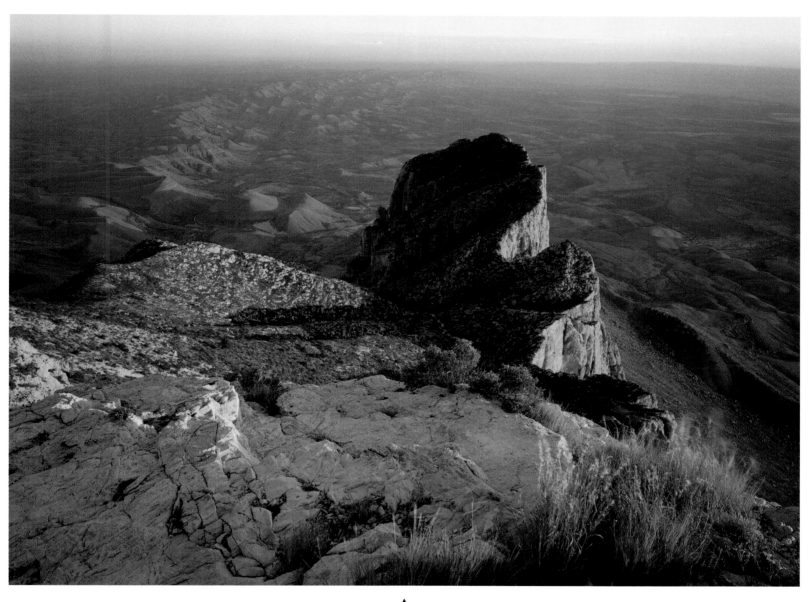

A small field of gypsum dunes lies just west of the Guadalupe Mountains. Like the bigger dune field at White Sands National Monument in New Mexico, the dunes formed when rain dissolved gypsum from surrounding mountains, washing it into lakes. As the climate became dryer and lakes evaporated, the gypsum weathered into sand and was blown into dunes. ◄ El Capitan Peak rises above the desert like the bow of a massive ship. The limestone that forms the Guadalupe Mountains is known for its many caves, including Carlsbad Cavern in New Mexico. ▲

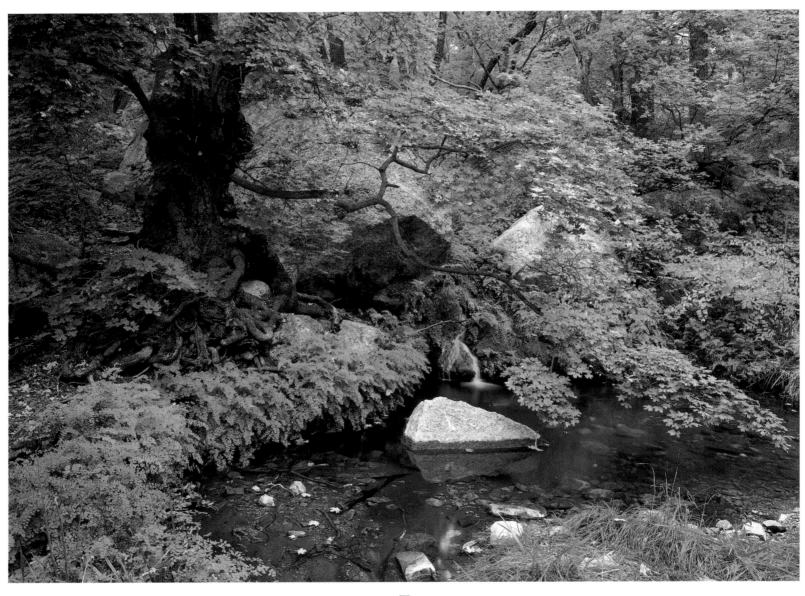

From a distance, the Guadalupe Mountains appear stark and waterless, but places such as Smith Spring belie first impressions. Springs and small streams are hidden in the rugged moutains, usually in canyons along the base of the range. Mountaintops have no permanent sources of water, but do harbor woodlands of ponderosa pine, Douglas fir, and even a few aspens. ▲ A century plant, or agave, provides a contrast to the fall colors of a bigtooth maple in Guadalupe Mountains National Park. The maples of the Guadalupes display some of the best fall color in Texas. ▶

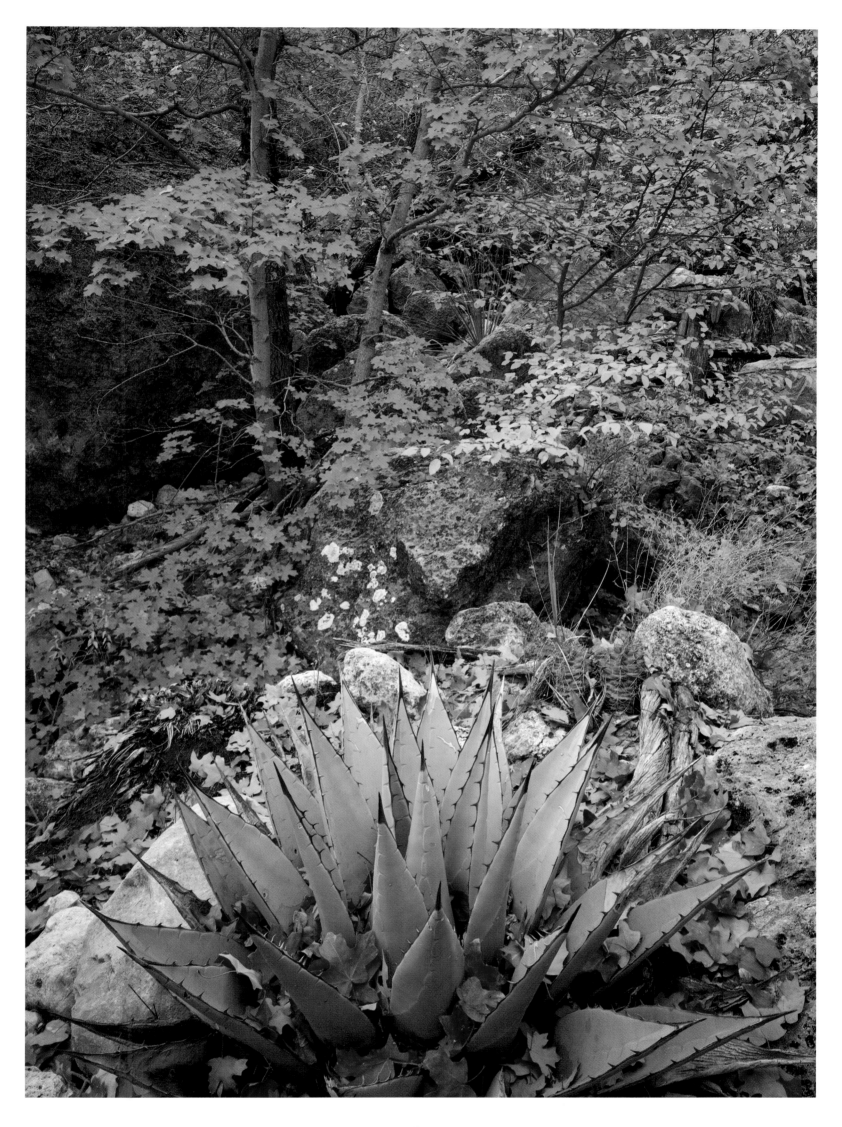

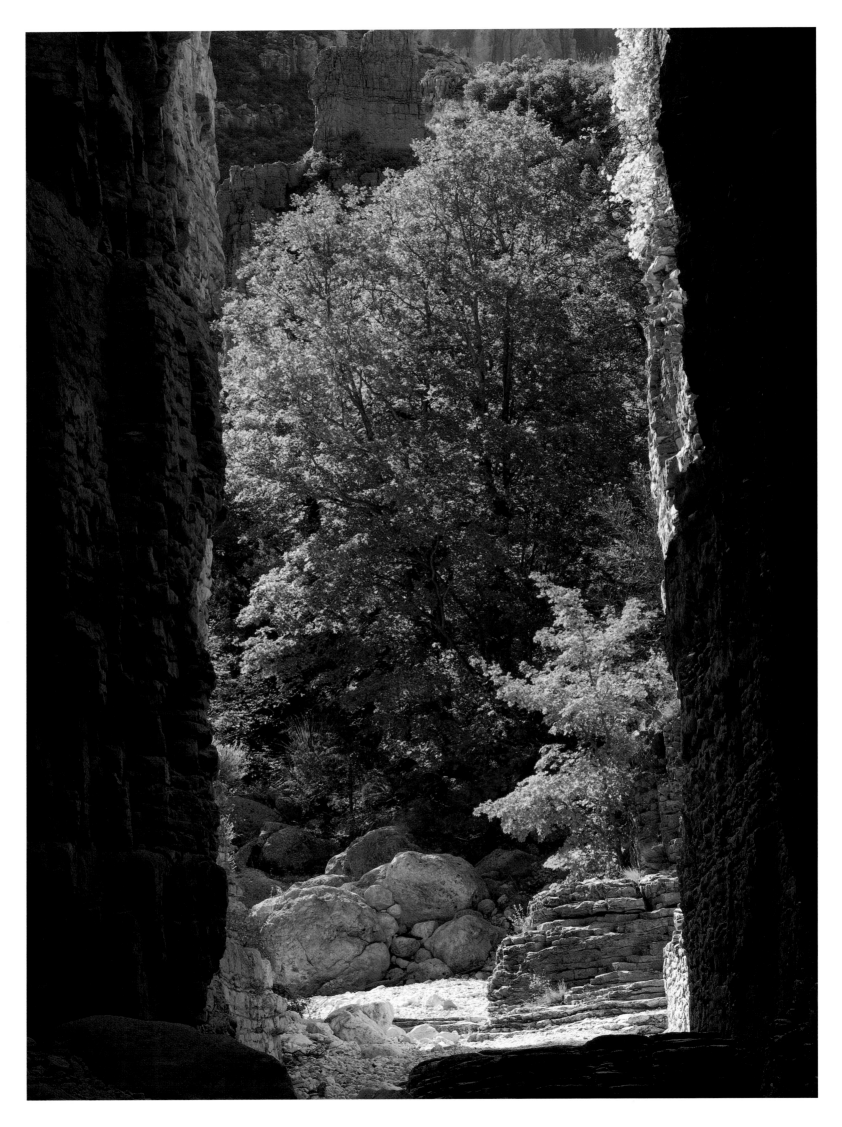

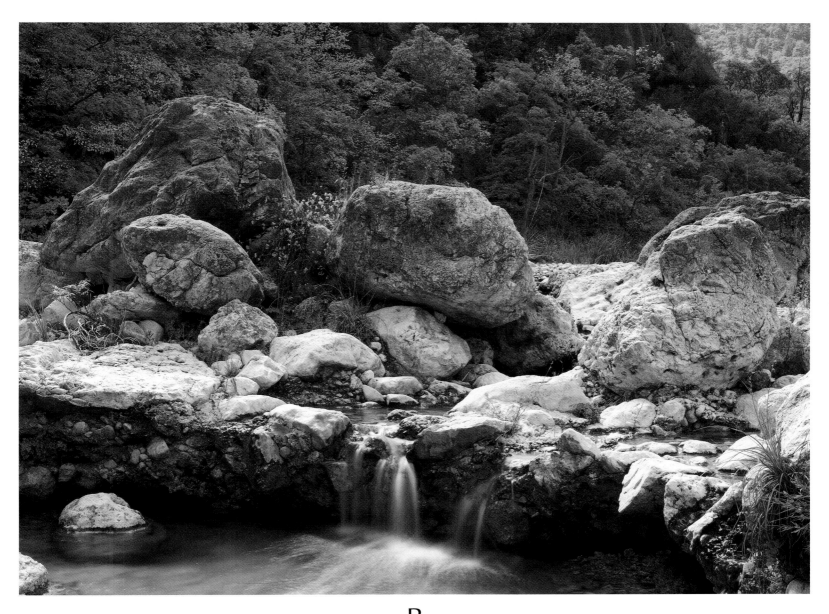

Bigtooth maples add color to the rocky defile of Devil's Hall. The narrow slot lies just a short hike up Pine Spring Canyon in the Guadalupe Mountains. When flooding occurs in rainy weather, the canyon can be hazardous. ◄ Water, quite a rare commodity in dry West Texas, tumbles over a cascade in McKittrick Canyon in the Guadalupe Mountains. ▲ Snow cloaks the Guadalupe Mountains at sunrise. Because Texas is a southern state and mostly lies at low elevations, snow is a fleeting phenomenon to be enjoyed. Only the Panhandle and the mountains of West Texas receive snow with any regularity. ► ►

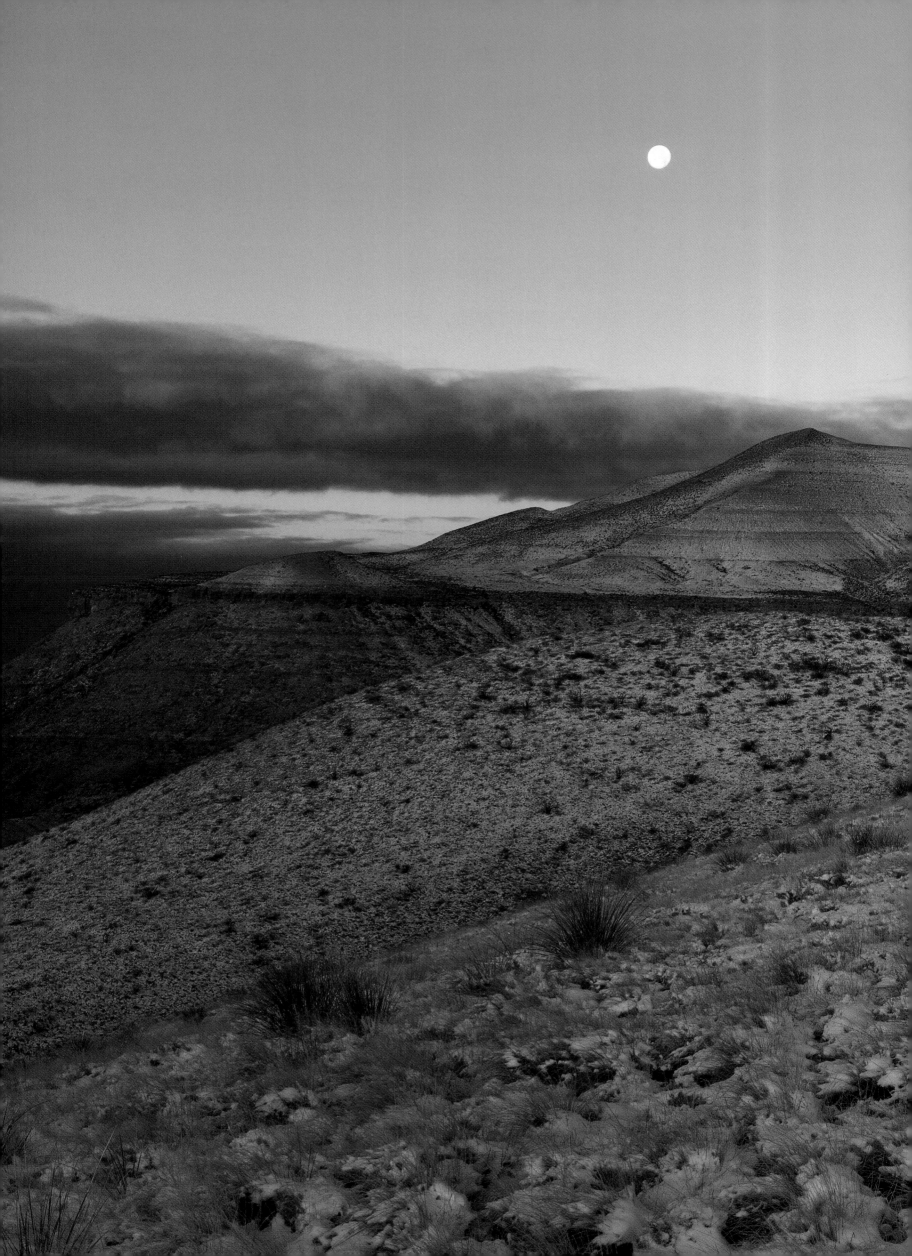

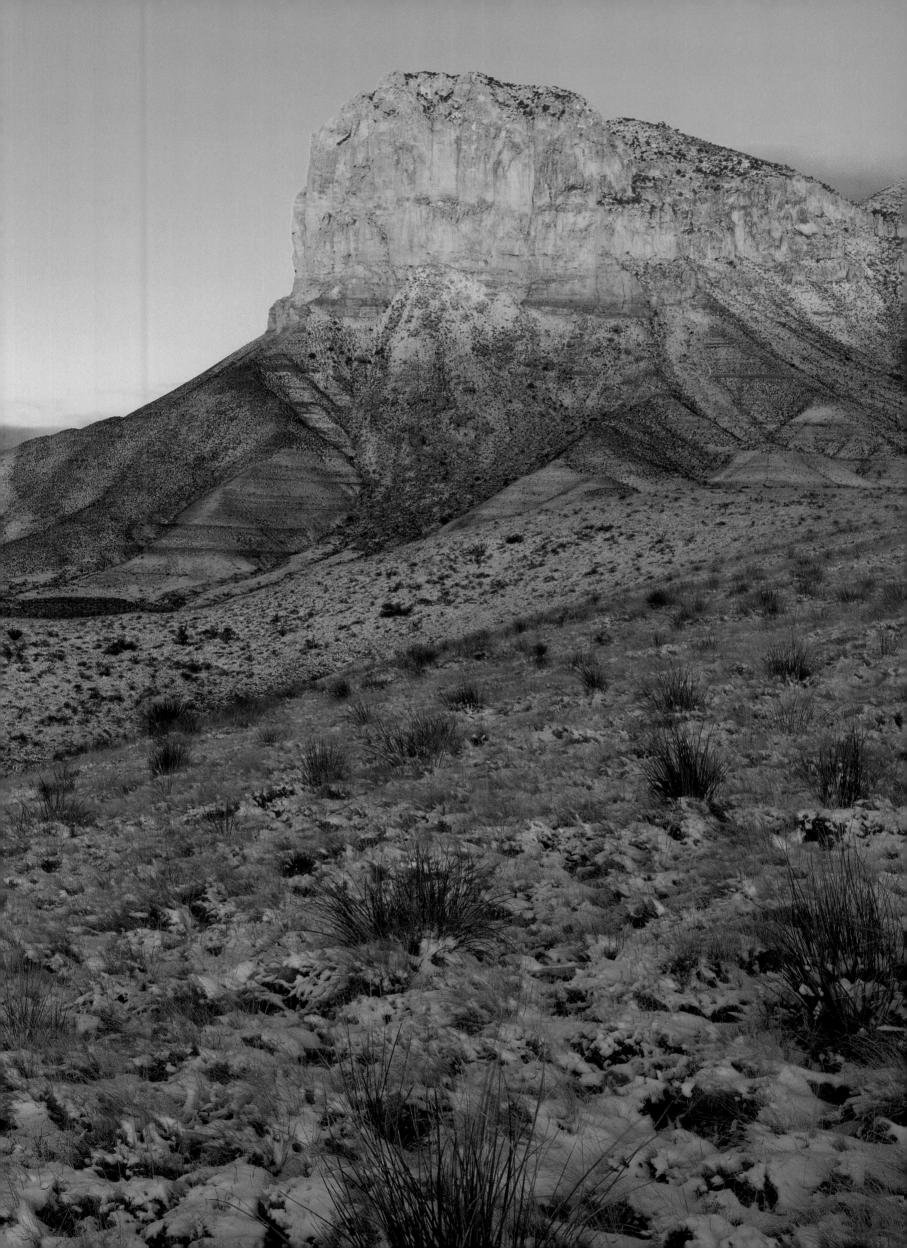

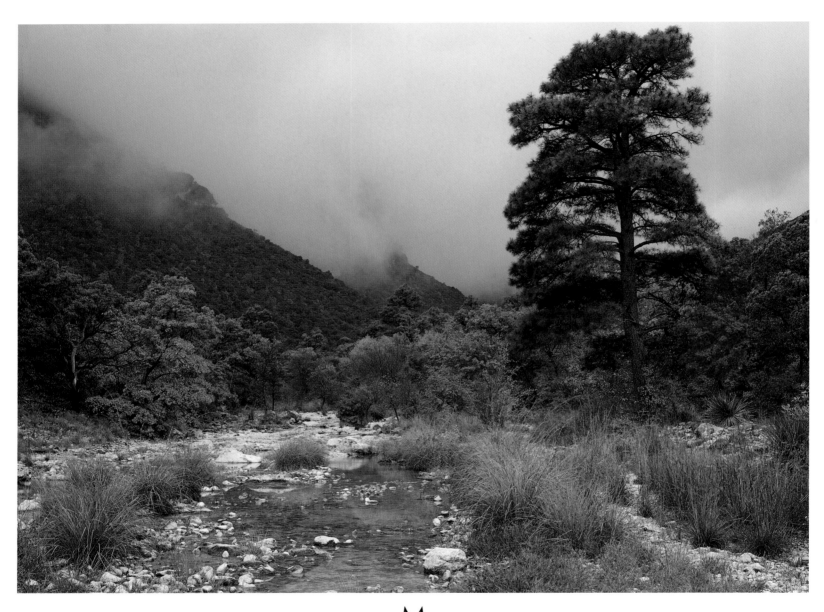

Mist hides the rim of McKittrick Canyon at Guadalupe Mountains National Park. The mouth of the canyon is dry and sparse, but hikers will find running water and lush vegetation only a mile or so upstream. Geologist Wallace Pratt thought that McKittrick Canyon was the prettiest spot in Texas and donated the part he owned to the National Park Service. ▲ Wind ripples the gypsum dunes west of the Guadalupe Mountains. The gypsum sand comes from an ancient lake bed called Salt Flat. In the 1800s, battles were fought over the salt deposits, which were valuable for seasoning, meat preservation, and silver smelting. ▶

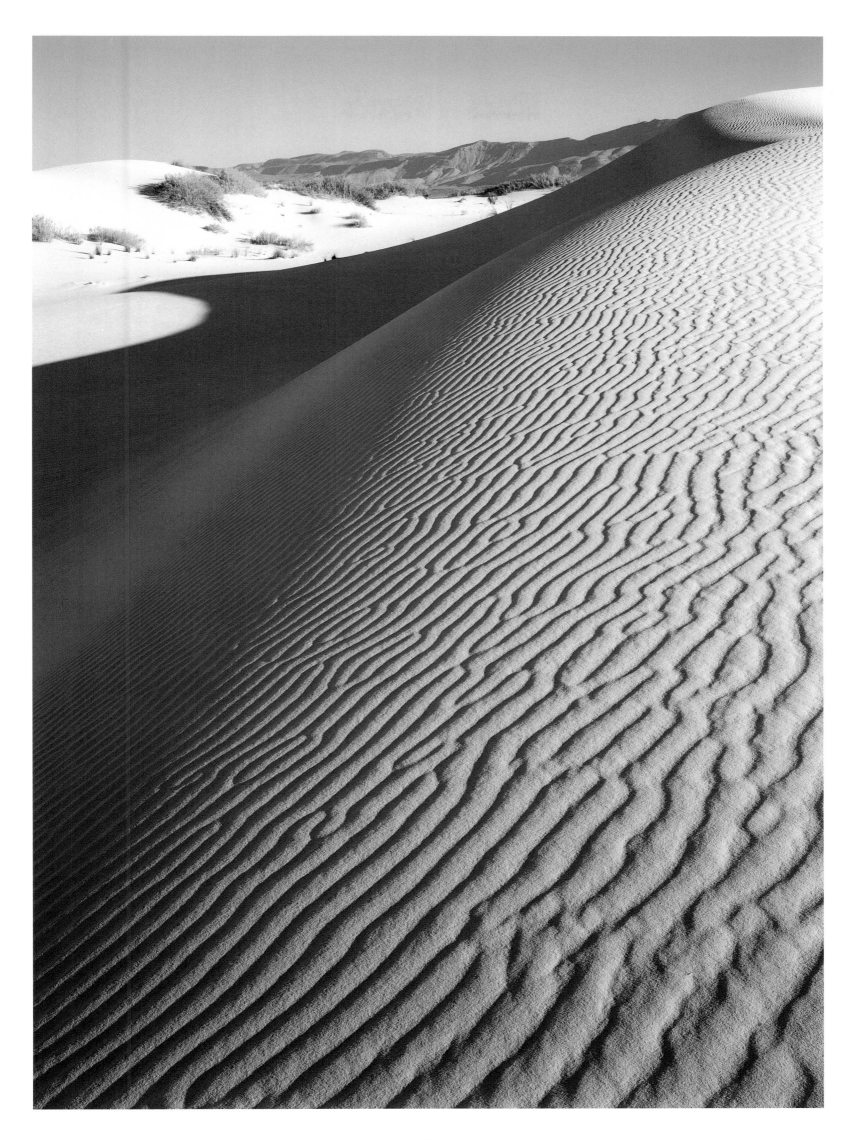

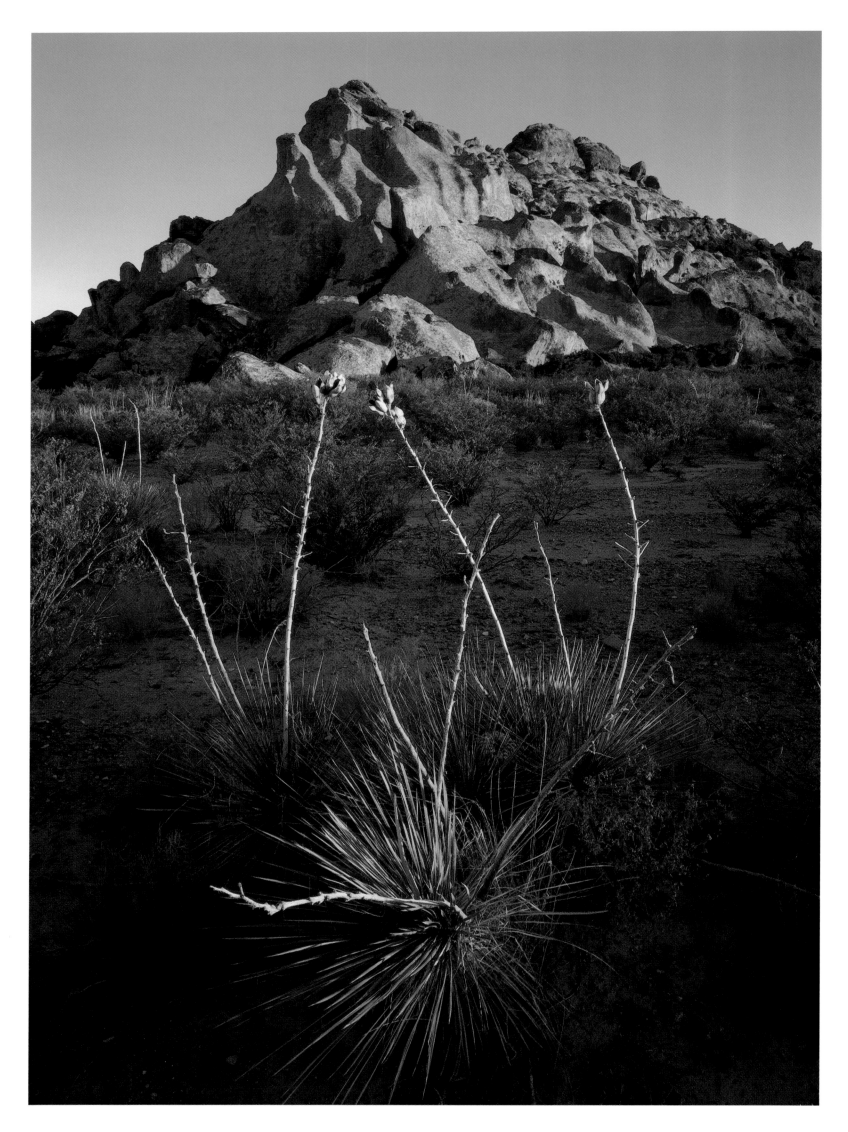

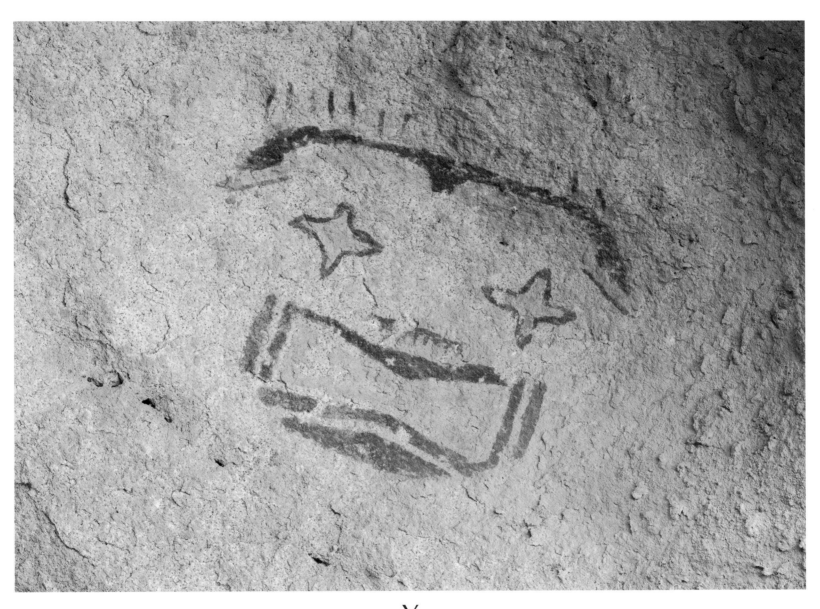

Yuccas eke out a living in the desert below the rocks of Hueco Tanks State Historical Park. The park's rocky hills formed when molten rock, or magma, intruded into sedimentary rocks and hardened. The softer sedimentary rocks then eroded away, leaving islands of granite called *syenite porphyry.* Today, the rocks are famous as a winter rock climbing haven. ◄ Between about A.D. 1000 and 1500, the Jornada branch of the Mogollon people left large numbers of pictographs at Hueco Tanks. Water, which collects in rock depressions, or tanks, has attracted people to the area of the desert park for at least ten thousand years. ▲

The Rio Grande divides the twin cities of El Paso, Texas, and Juárez, Mexico. El Paso is named for the pass cut by the Rio Grande that separates the Franklin Mountains of Texas from mountains in Mexico. The area was first visited by Spanish explorers in 1581, but the first mission was not established in what is now Juárez until about eighty years later. El Paso and Juárez are now the largest border cities in the United States and Mexico. ▲ The San Elizario church was originally built nearby in 1774 as part of a Spanish presidio, or fort. It was moved to its present site in about 1777, but had to be rebuilt after floods in 1877. ►

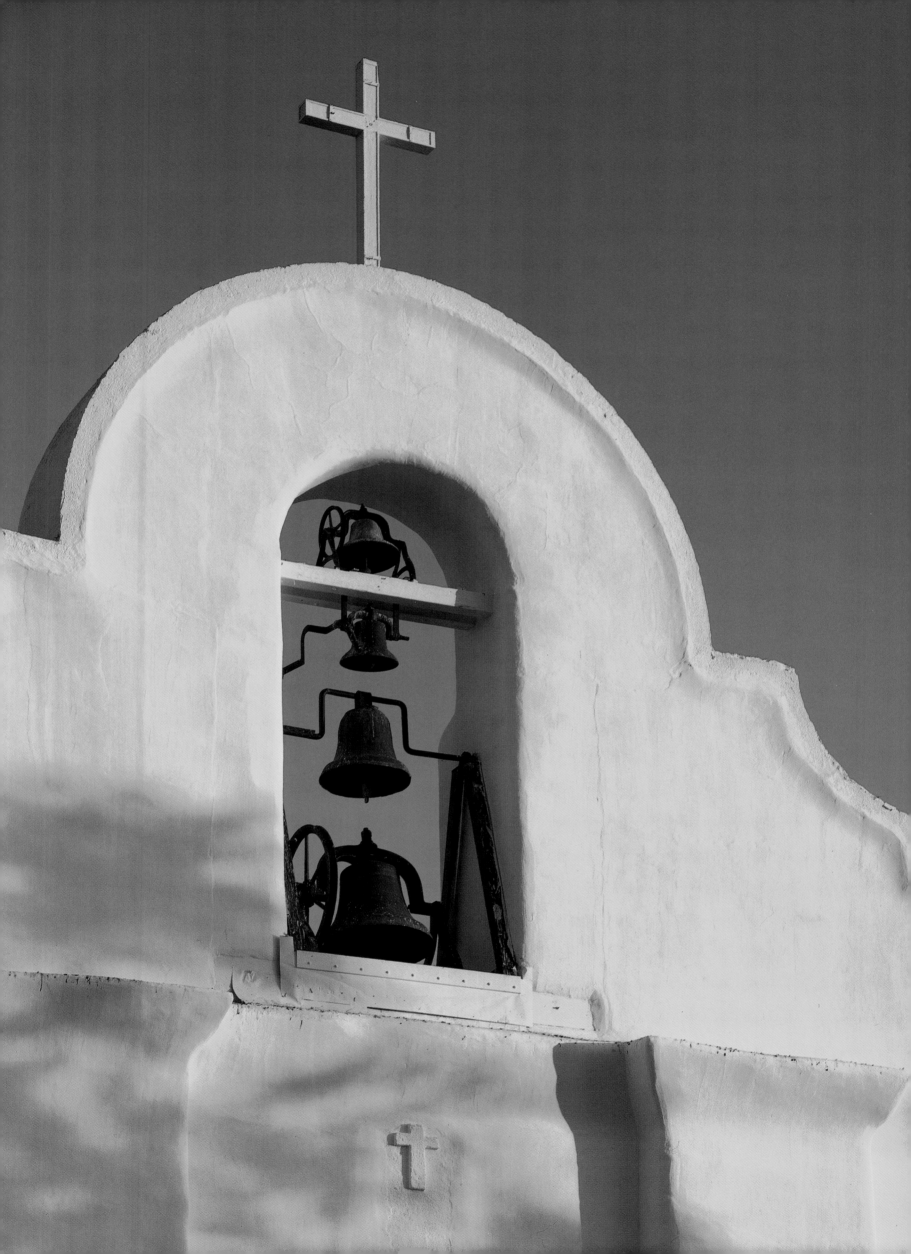

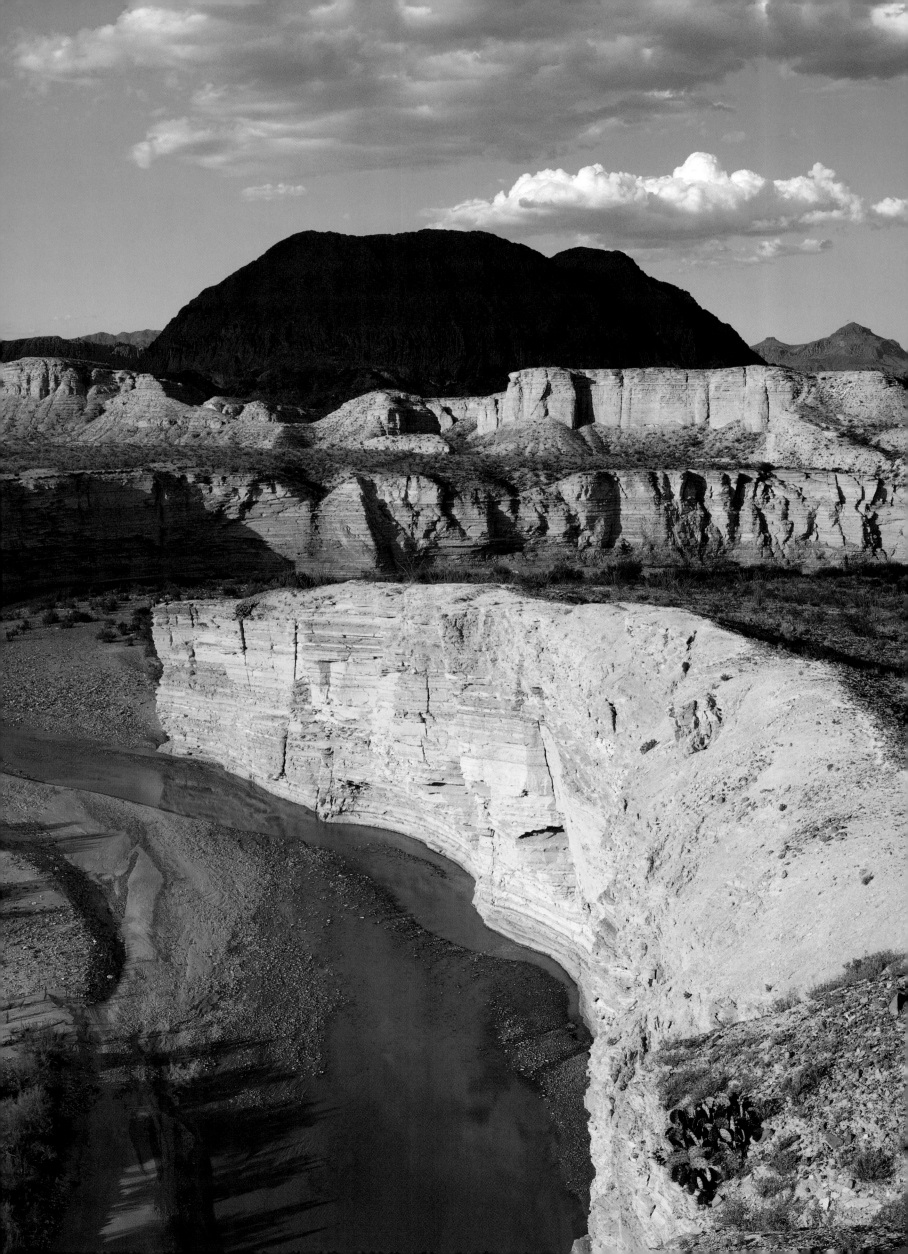

Terlingua Creek drains a large area near Big Bend National Park before joining the Rio Grande at the mouth of Santa Elena Canyon. Along the way it passes by the former ghost town of Terlingua. The town developed in the 1890s with the onset of quicksilver mining. The mines became the second-largest mercury-producing district in the nation before closing in 1941. ◄ The officers' quarters at Fort Davis National Historic Site are a well-preserved reminder of the frontier era in Texas. The fort, built to protect travelers from Indian attack, was established in 1854, temporarily abandoned during the Civil War, and finally closed in 1891. ▲

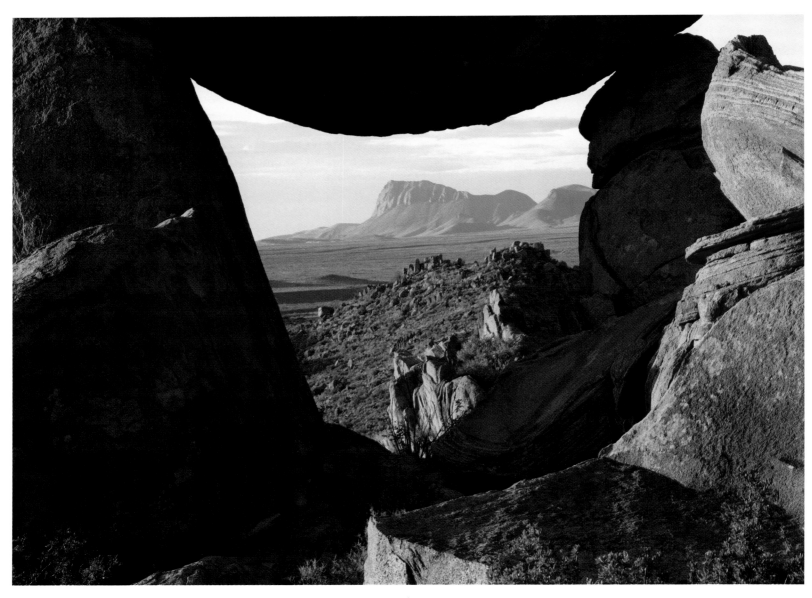

A stone arch lies at the end of a short hiking trail in the Grapevine Hills of Big Bend National Park. The rocky hills are a laccolith formed when molten rock intruded into other rock layers. The molten rock hardened into granite that was exposed to the surface when the other rocks eroded away. ▲ The Rio Grande has cut deep Boquillas Canyon between the Dead Horse Mountains of Big Bend and the towering cliffs of the Sierra del Carmen of Coahuila, Mexico, which is visible across the river. Surprisingly, ponderosa pines, Douglas firs, and aspens blanket the high country of the nine-thousand-foot Sierra del Carmen. ▶

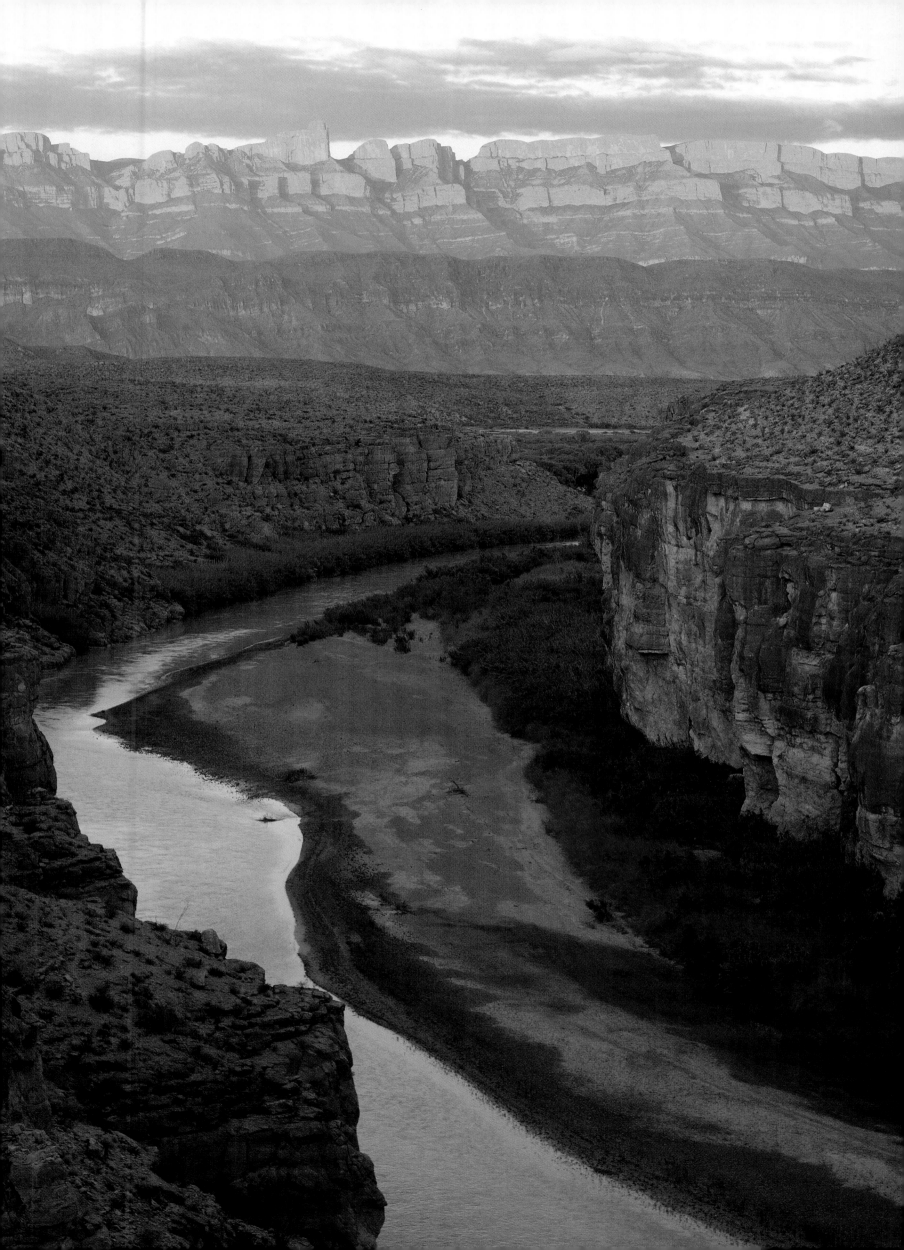

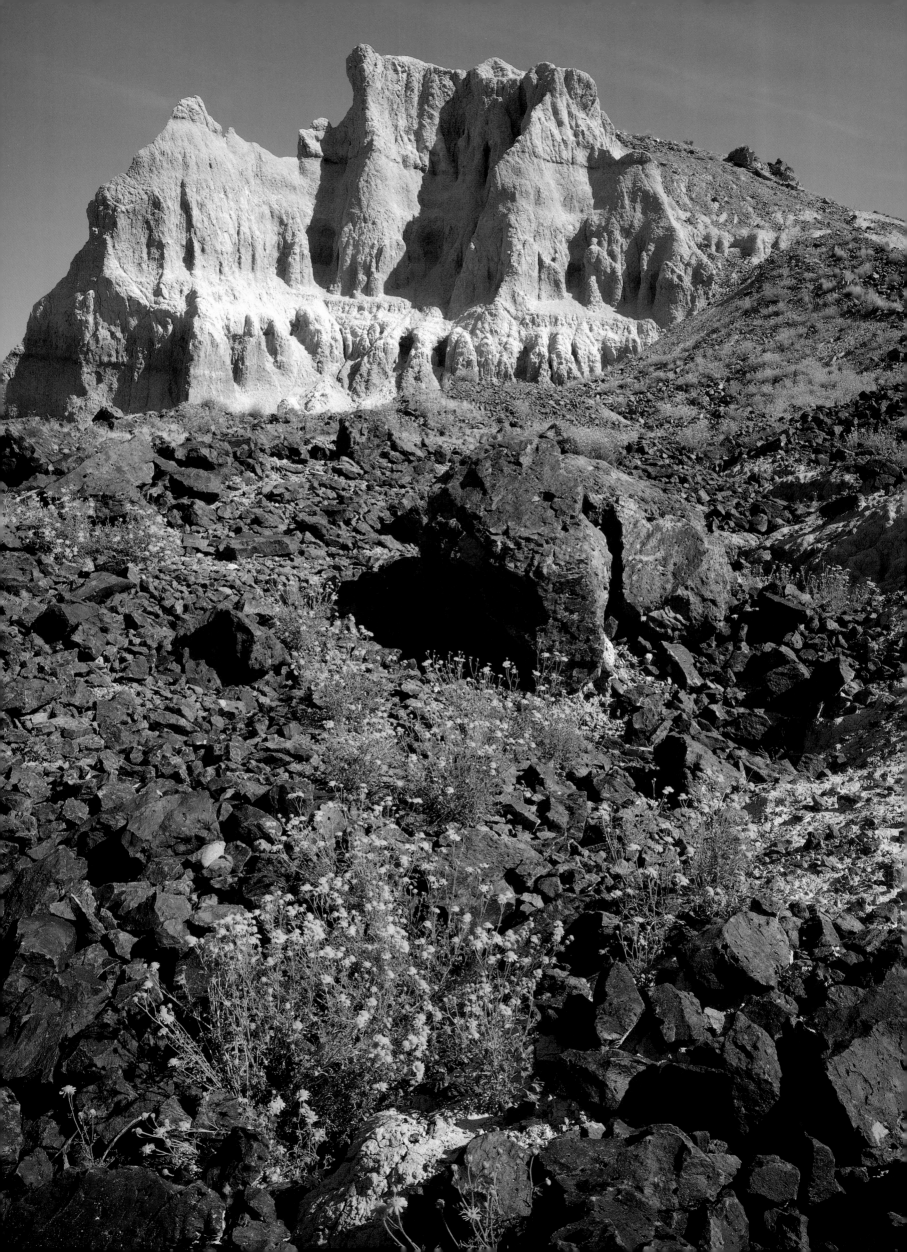

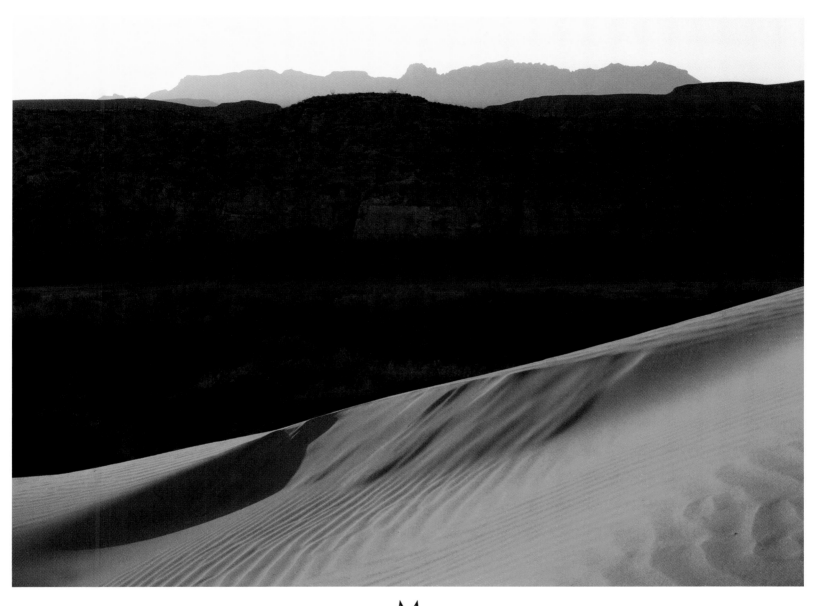

Margined perityle dots an area of white volcanic ash and dark lava. Much of the terrain near Castolon at Big Bend National Park was formed by ancient volcanoes and is still rough and bare today. With enough rain, however, flowers do bloom even in this stark, seemingly barren landscape. ◀ The Chisos Mountains of Big Bend National Park loom above the Rio Grande. The sand dunes in the foreground lie in Coahuila, Mexico, across the river from Texas. For years, international efforts have been made to create a sister Mexican park to Big Bend in Coahuila. ▲

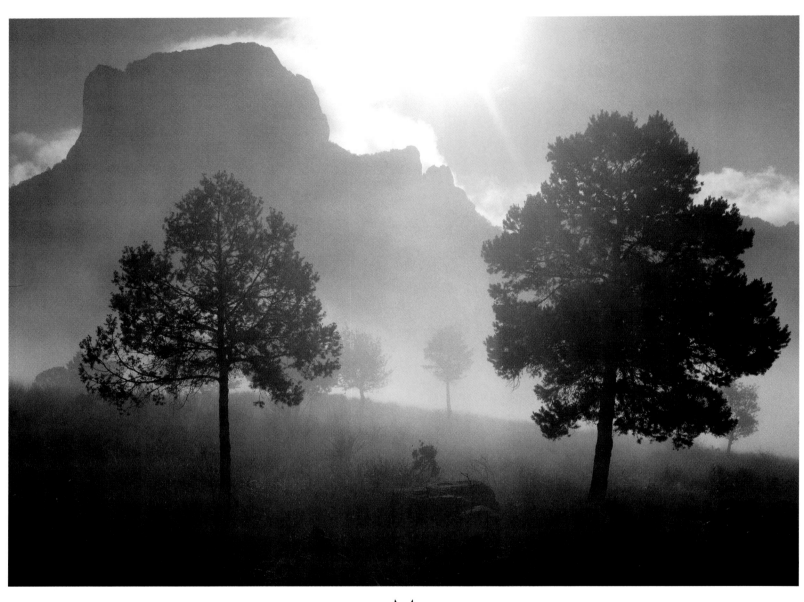

Morning fog shrouds rugged Casa Grande Peak and the Basin in the Chisos Mountains of Big Bend National Park. A mountain valley partly wooded with pinyon pine, juniper, and oak, the Basin is largely hidden from the desert below. ▲

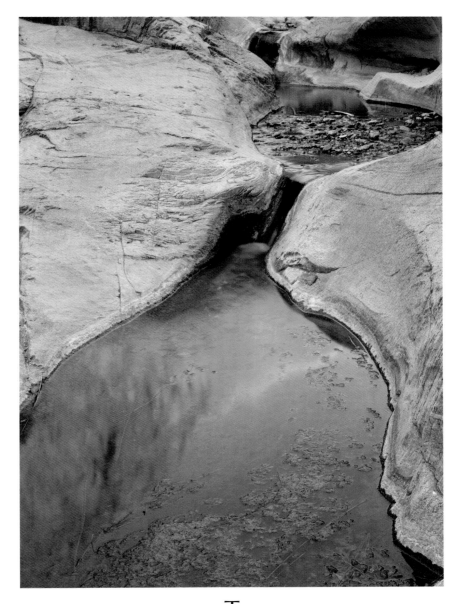

Tiny Oak Creek drains the Basin
through a narrow gap in the Chisos Mountains called the Window. ▲
Rafts float through Mariscal Canyon, one of three major canyons
carved by the Rio Grande at Big Bend National Park. The park gets its
name from the large bend the river makes at Mariscal Canyon. ▶ ▶

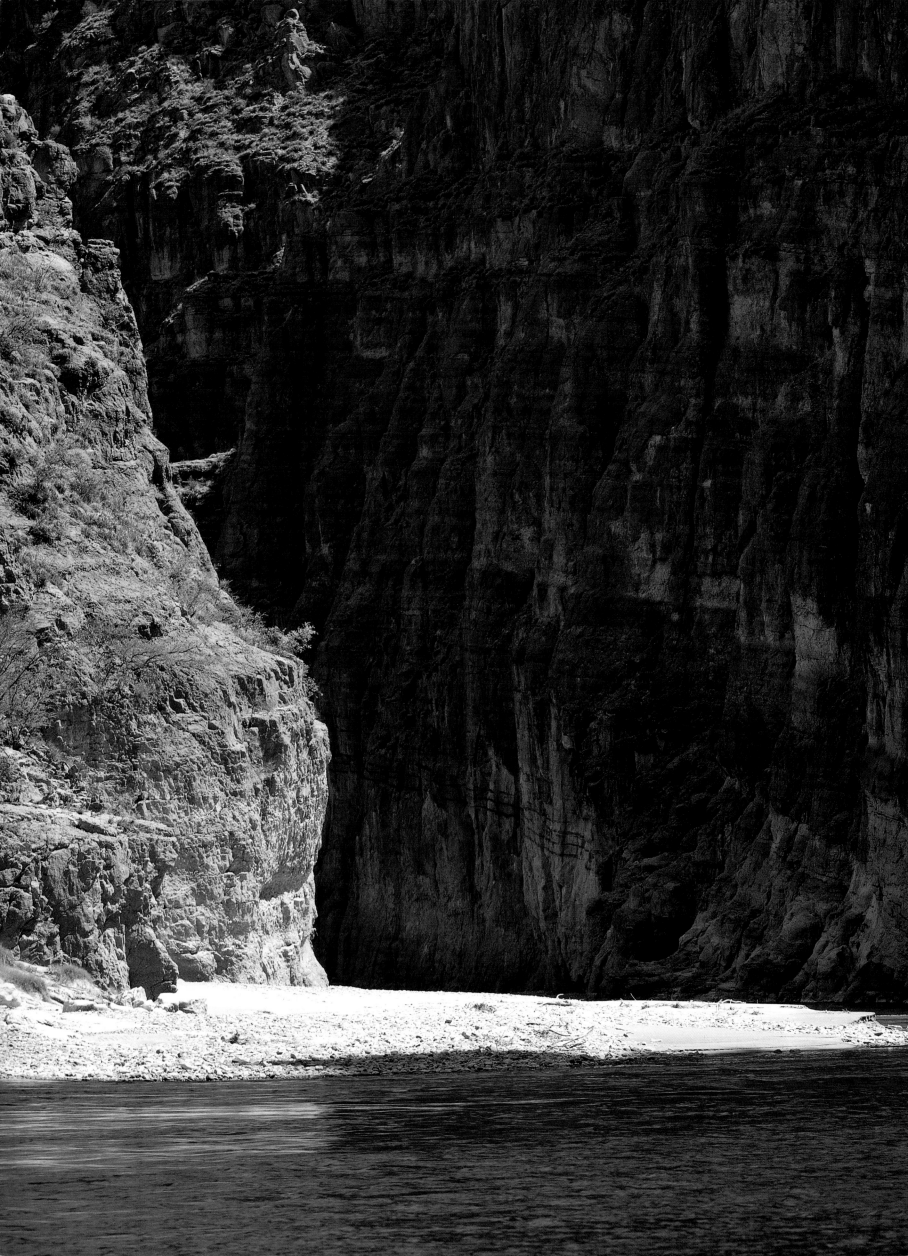

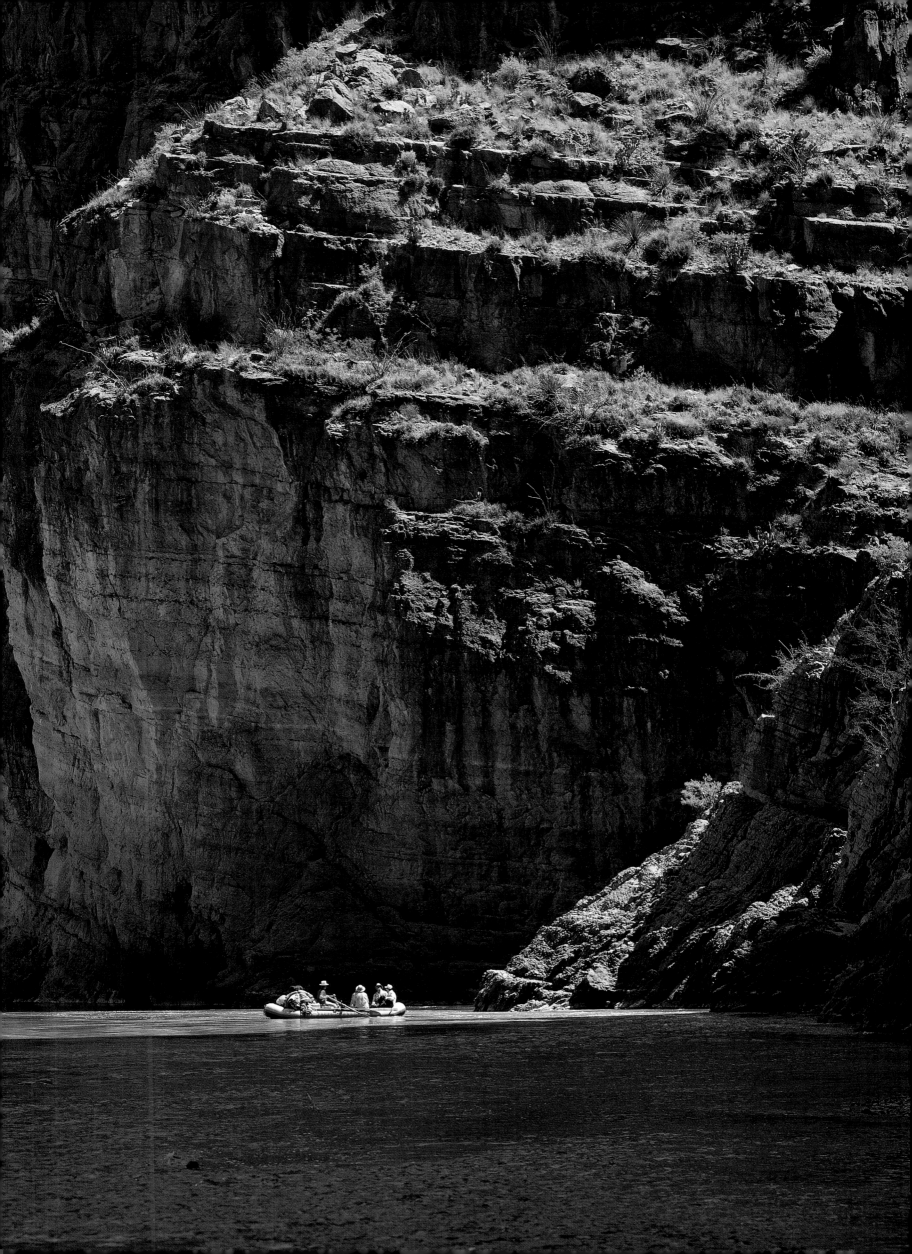

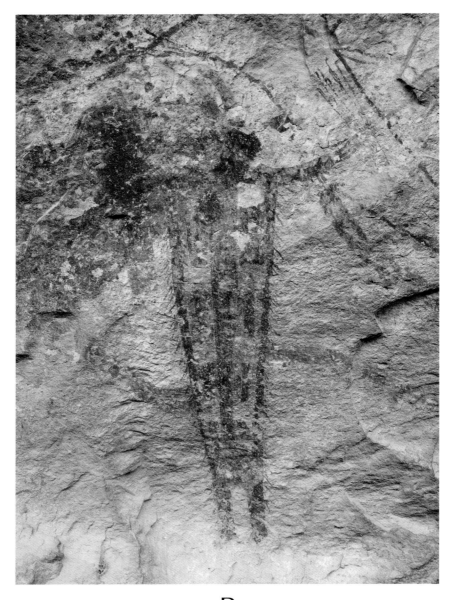

Pictographs were painted on the canyon walls in Seminole Canyon State Historical Park thousands of years ago. The dry desert climate and protection from sun and weather have preserved the rock art, some of the nation's oldest. ▲

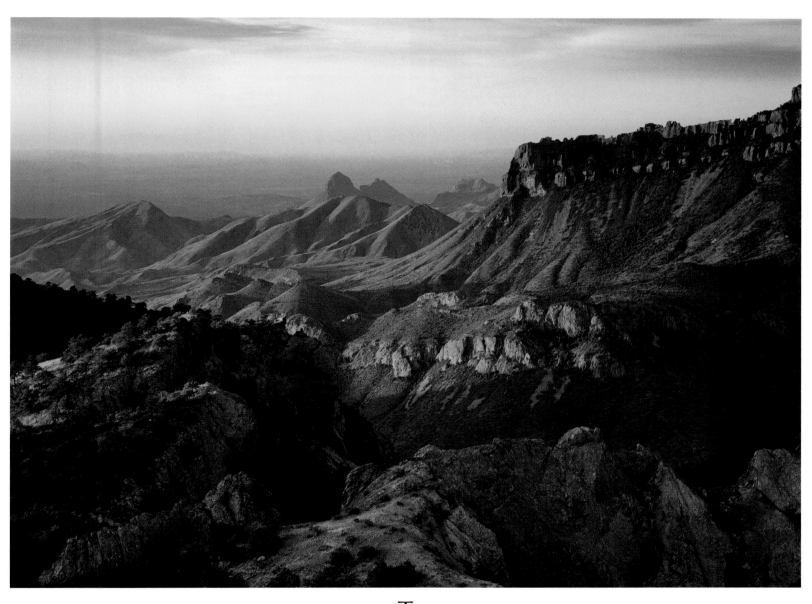

The rugged Chisos Mountains of Big Bend National Park sprawl southward from the Lost Mine Trail. The mountains rise about six thousand feet above the Rio Grande to the south. The extra elevation creates cooler temperatures and attracts more rain than the hot desert below. The more moist climate allows a scrub forest of pinyon pine, oak, and juniper to survive. ▲

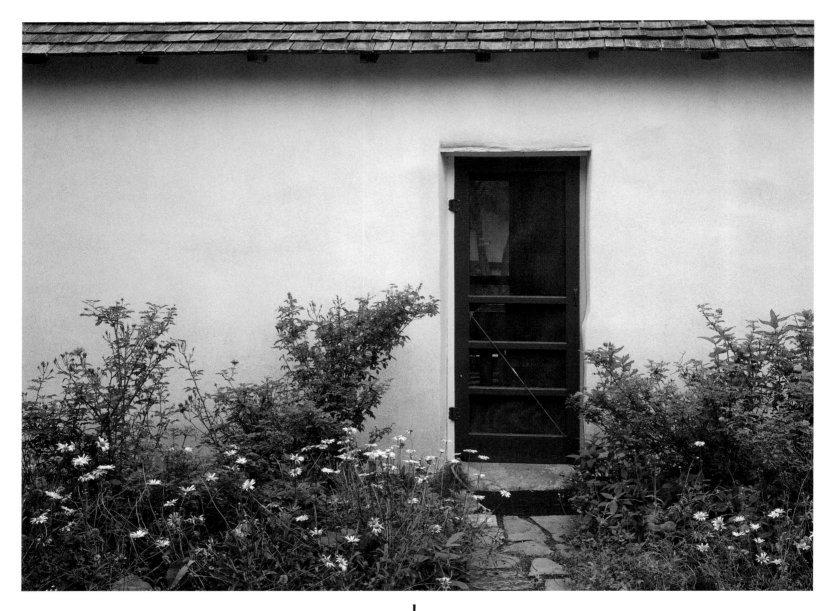

Landmark Inn State Historical Park had its beginnings in 1842 when Henri Castro obtained a colonization contract and founded Castroville. Cesar Monod built the first part of the inn in 1849, and over the following years, he and other owners added to it. For most of its history, it has been a hotel; today, it continues the tradition as a bed-and-breakfast. ▲ Mission Espada, both an active parish and part of San Antonio Missions National Historical Park, was founded in 1731 by Spanish priests after they had abandoned previous missions in East Texas. ▶

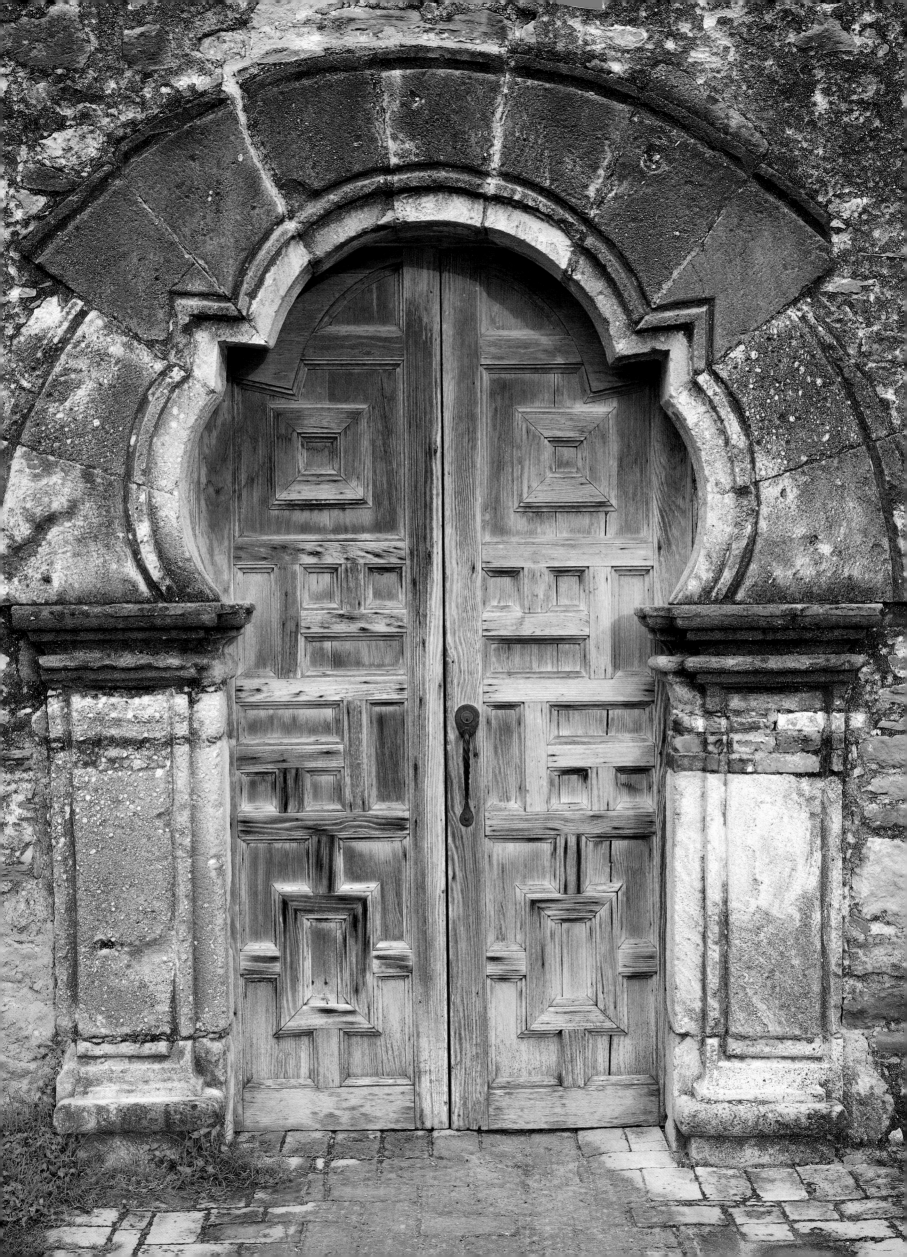

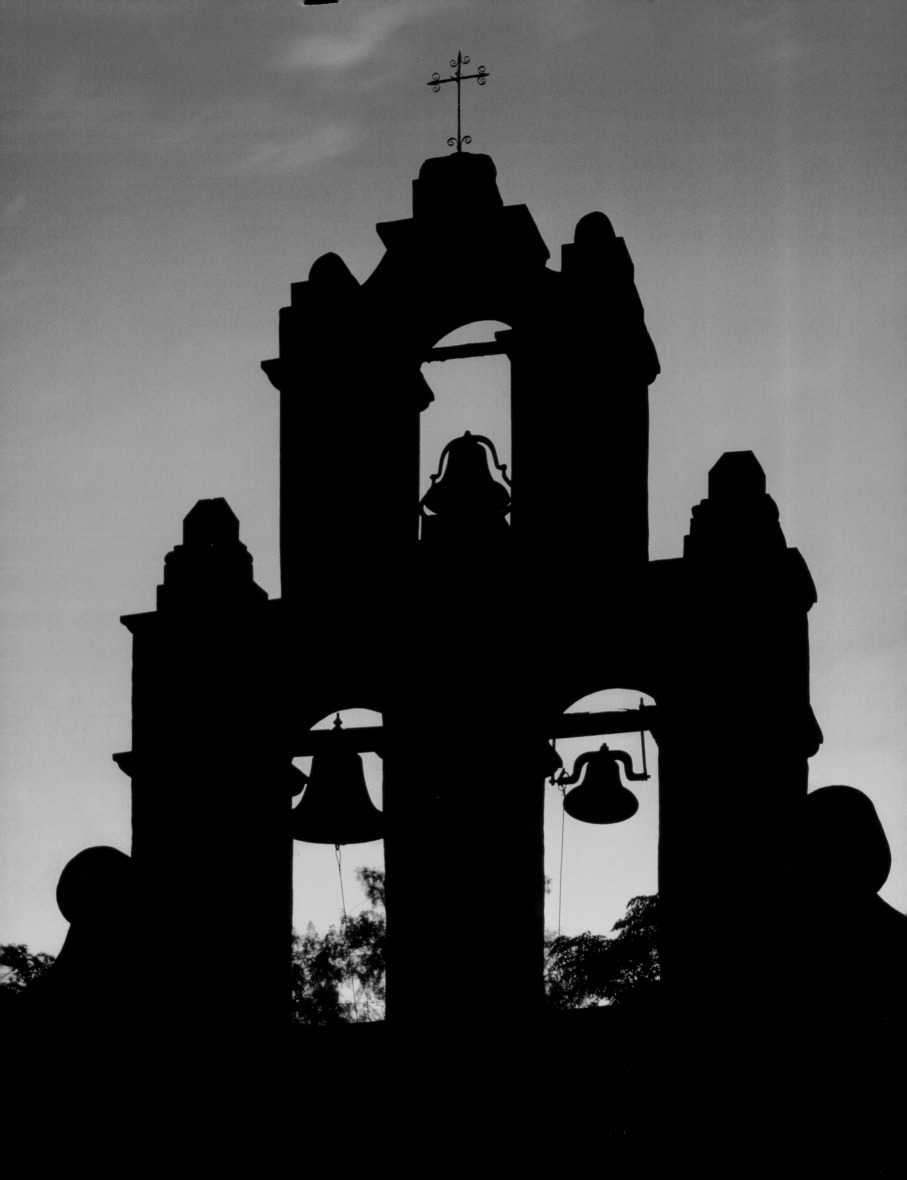

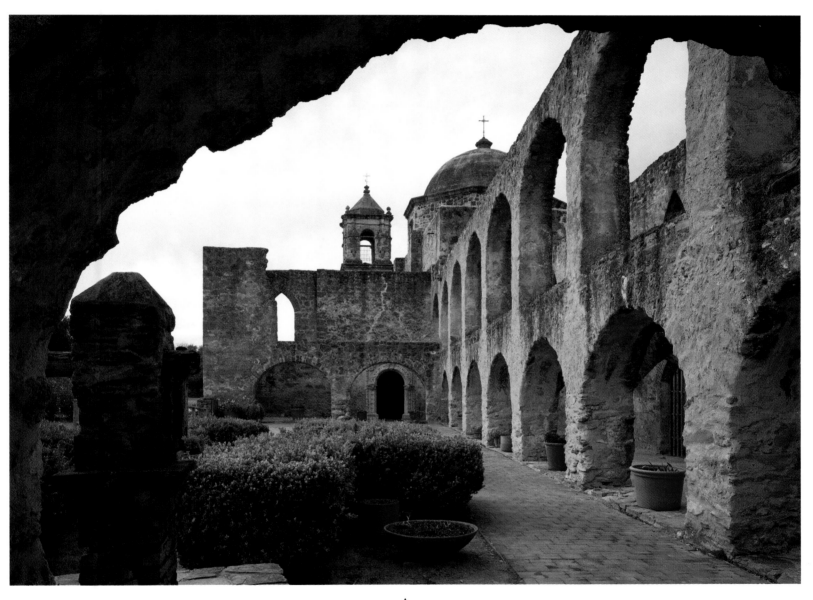

Along with two of the other San
Antonio missions, Mission San Juan was relocated to the San Antonio
River from East Texas in 1731. To limit French encroachment from
Louisiana, Spain had begun colonizing East Texas in 1690 by estab-
lishing six missions. Disease, crop failures, and Indian hostilities
eventually forced their abandonment and a retreat to San Antonio. ◄
Mission San José is the largest of five missions founded along the San
Antonio River by the Spaniards. The missions along the river were the
greatest concentration of Catholic missions in North America. ▲

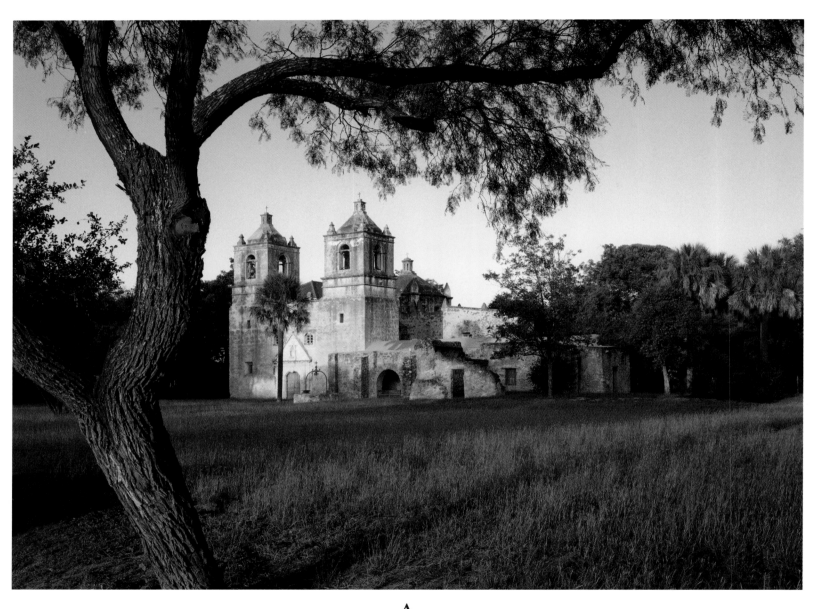

Although its colorful exterior paint has faded away, the Mission Concepción church looks much as it did more than two hundred years ago when it was the busy center of the mission's religious life. Inside, some original paintings still survive. Concepción and her four sister missions were some of Spain's most successful efforts to extend dominion north of Mexico. ▲ Prickly pear thrives at Bentsen-Rio Grande Valley State Park. The park, along with other areas in the Rio Grande Valley, has a subtropical climate that is noted for its many rare birds and animals. ▶

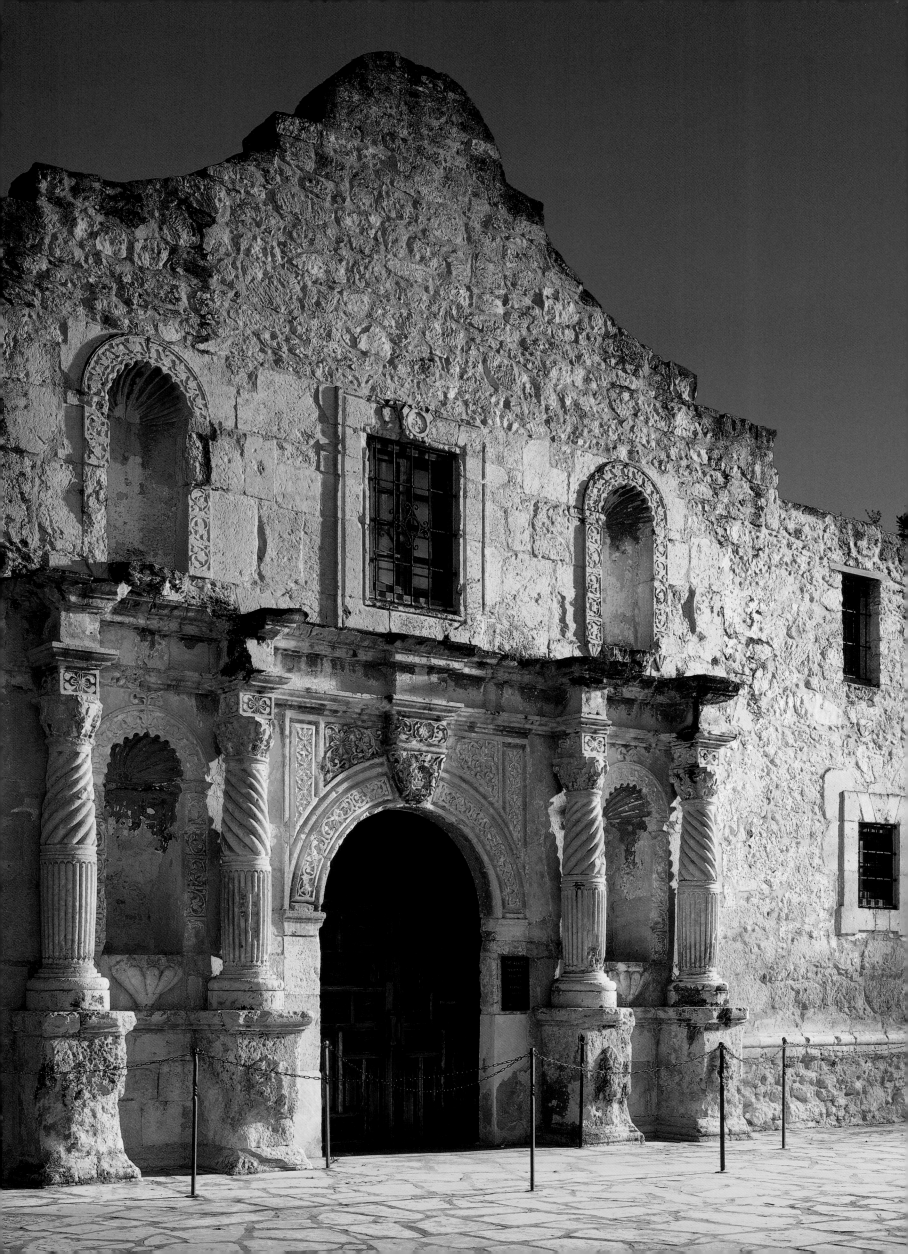

The Alamo, first of five Spanish missions founded on the San Antonio River, is best known for the defeat of Texas rebels at the hand of General Santa Anna. Occupied by Texas troops, the Alamo was placed under siege by Santa Anna's army. Although the Texans were outnumbered forty to one, they held out for thirteen days until the Mexicans breached the walls on March 6, 1836, and killed every one of the defenders. *Remember the Alamo* became a rallying cry of Texas' revolution. ◄ Bluebonnets and huisache trees brighten a Goliad County pasture. ▲

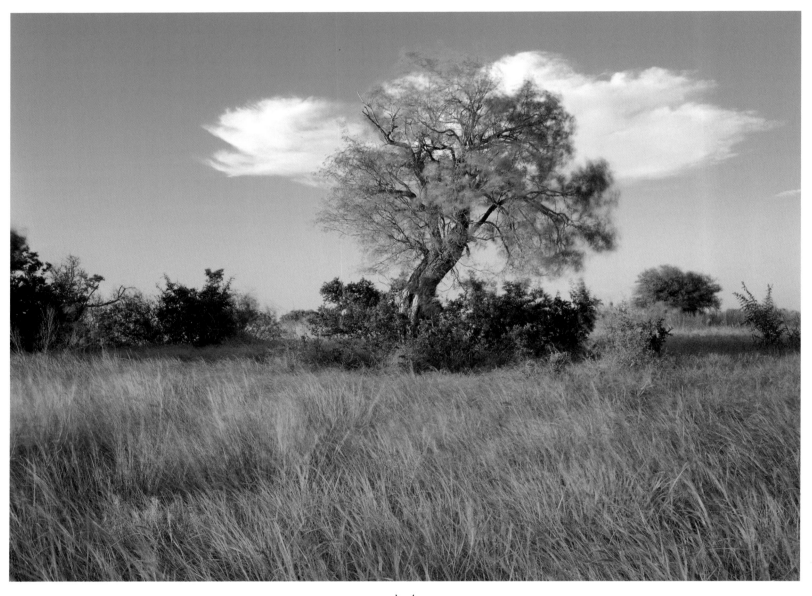

Mesquite trees, such as this one at Choke Canyon State Park, are a common sight in South Texas. ▲ An agave grows in front of the reconstructed Mission Espiritu Santo church in Goliad State Historical Park. Nearby is the Spanish fort, Presidio la Bahia, notorious as the site of the Goliad Massacre. On March 27, 1836, 342 Texas rebels under Colonel James Fannin were executed at the order of General Santa Anna a week after they surrendered to Mexican troops at the Battle of Coleto Creek. ▶

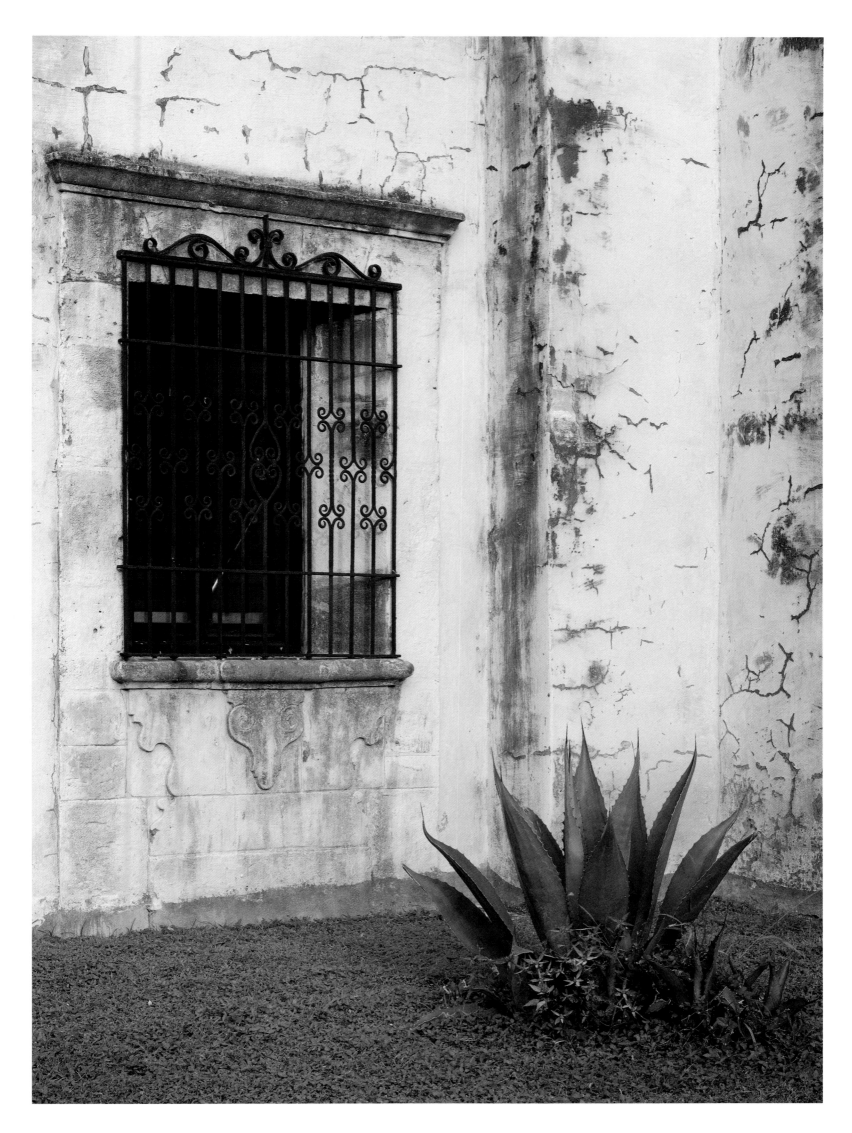

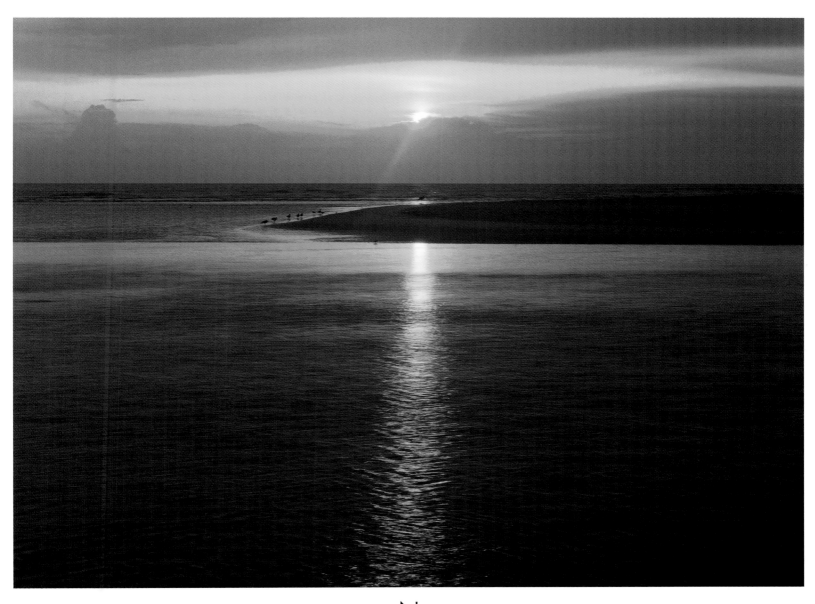

Near Brownsville, a subtropical forest grows at Audubon's Sabal Palm Grove Sanctuary. The thirty-two-acre palm forest is one of the last remnants of a unique habitat that once covered thousands of acres of the Rio Grande delta. ◄ The Rio Grande, now much shrunken by both agricultural and urban uses, flows into the Gulf of Mexico at Boca Chica Beach. ▲ The goat-foot morning glory is a common ground cover at sandy Boca Chica Beach and other Texas shorelines. The hardy vine is very salt-tolerant and a common colonizer of beach dunes. ► ►

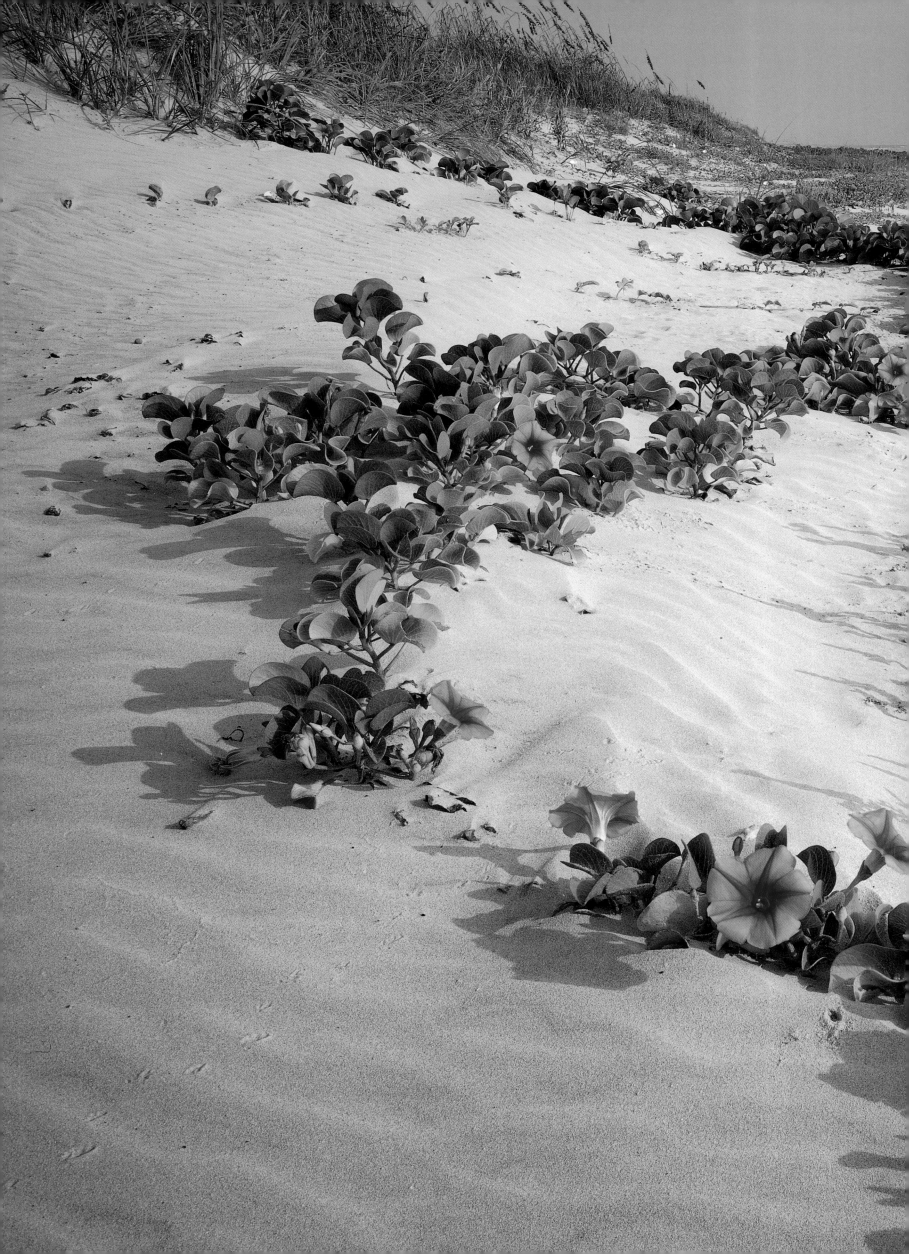

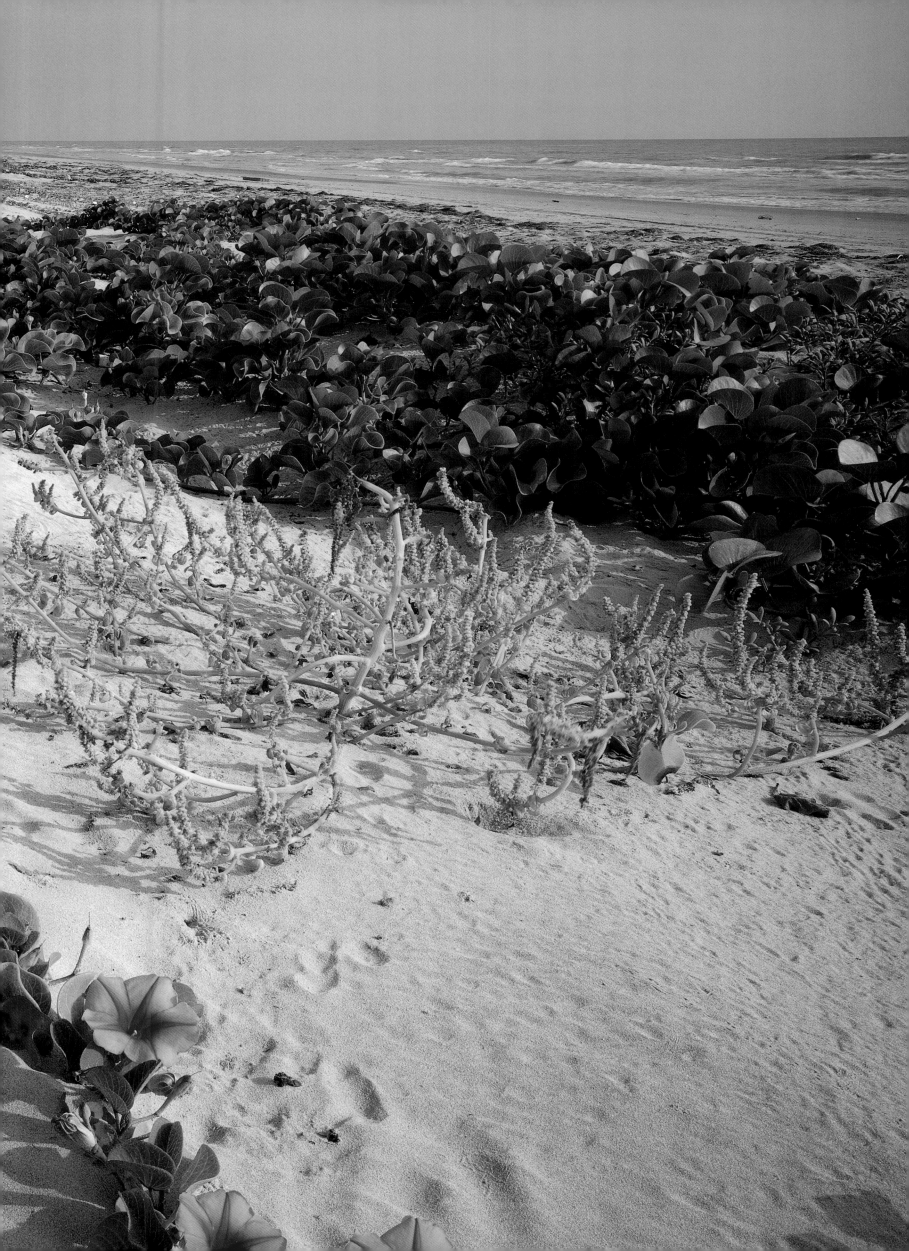

Live oaks were once more common on Padre Island, but today only a few trees survive in the salty environment. The 110-mile-long island stretches from near Corpus Christi almost to the Mexican border, broken only by a man-made cut at Port Mansfield. The barrier island, of which the middle eighty miles is a national seashore, protects the Texas coast from storms. ▲ Built in 1852, the Port Isabel Lighthouse was used, with a few interruptions, until 1905. Nearby, on May 13, 1865, in what is thought to have been the Civil War's last battle, Confederate troops captured 113 Union soldiers one month *after* Lee surrendered at Appomattox. ▶

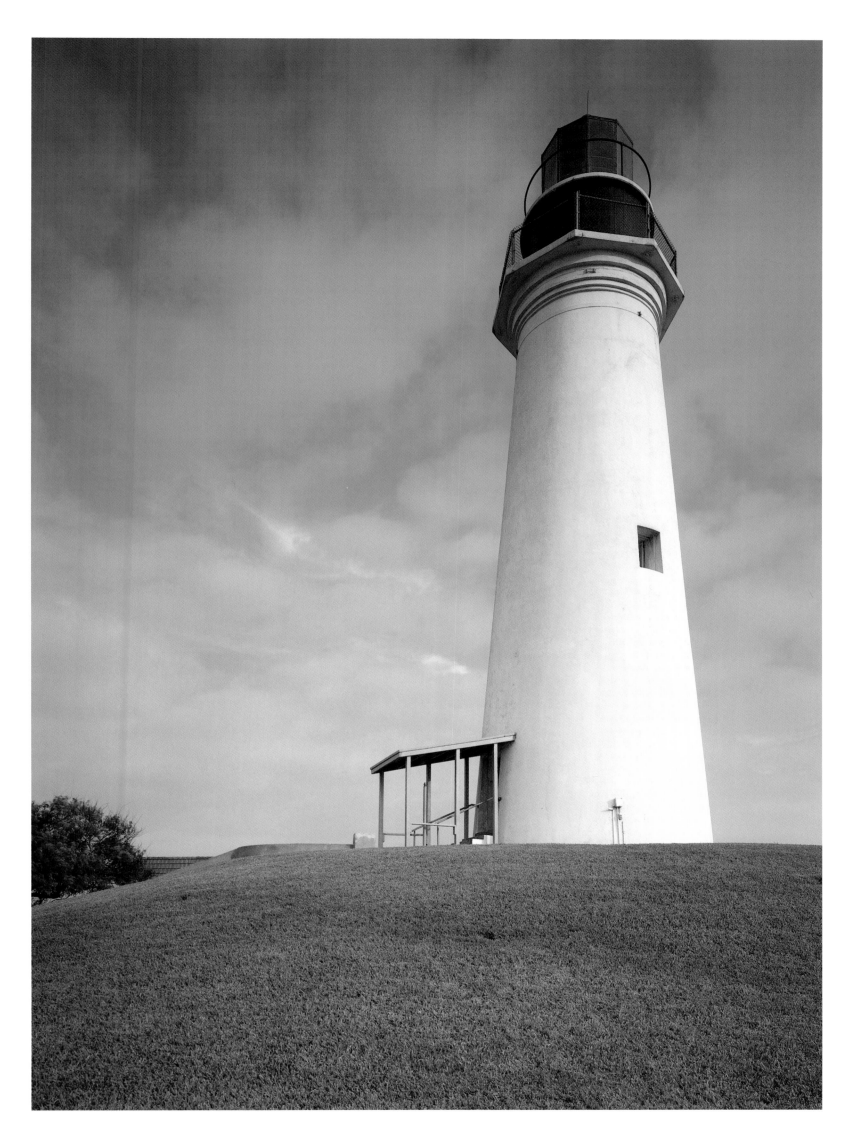

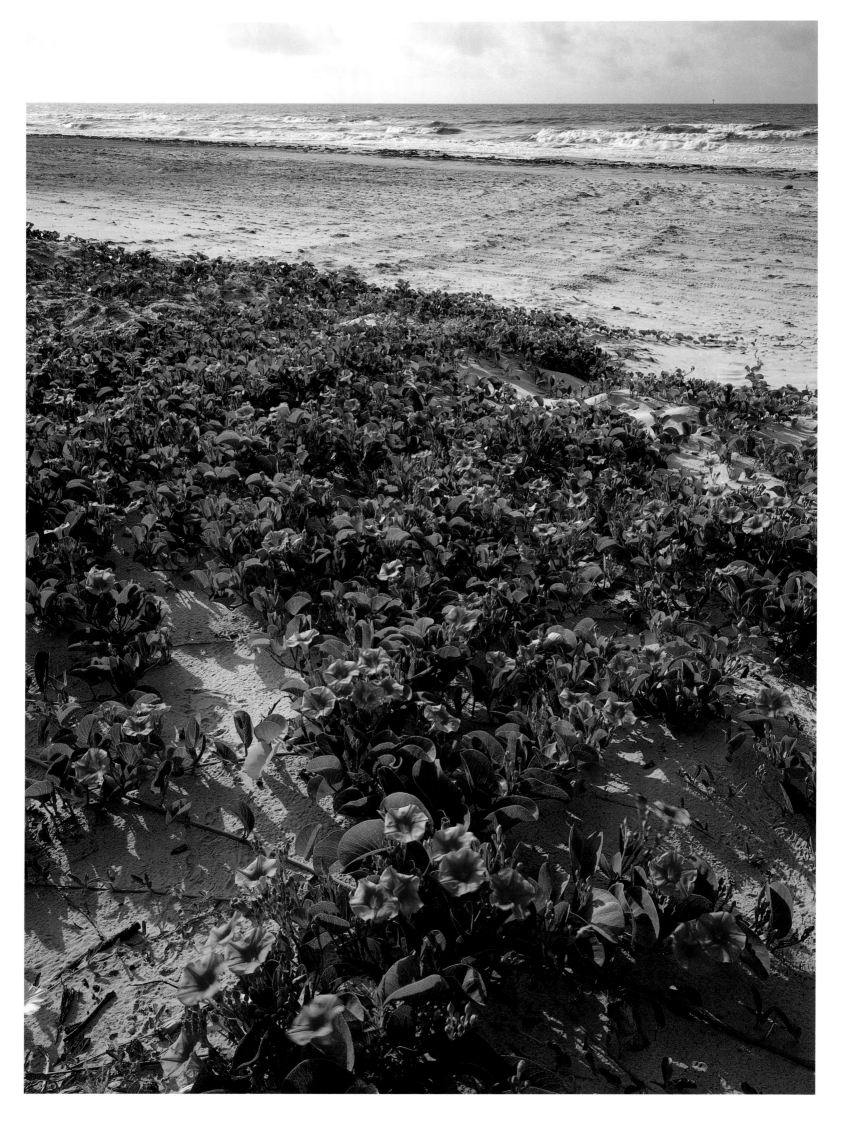

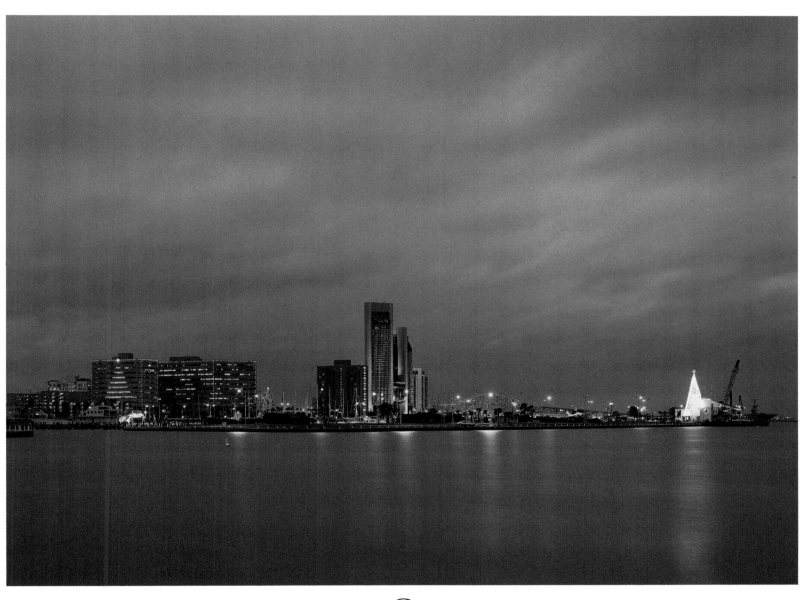

Goat-foot morning glories bloom
on the shore of Matagorda Peninsula. The long, narrow peninsula
is connected to the mainland only by small strips of land. Like the
many barrier islands along the coast, the peninsula was formed by a
combination of ocean currents and the action of wind and waves. ◄
Downtown Corpus Christi fronts Corpus Christi Bay, which is shel-
tered from storms by Mustang and Padre Islands. Although Spanish
explorer Piñeda discovered the bay in 1519, settlement did not begin
until Colonel Henry Kinney established a trading post in 1839. ▲

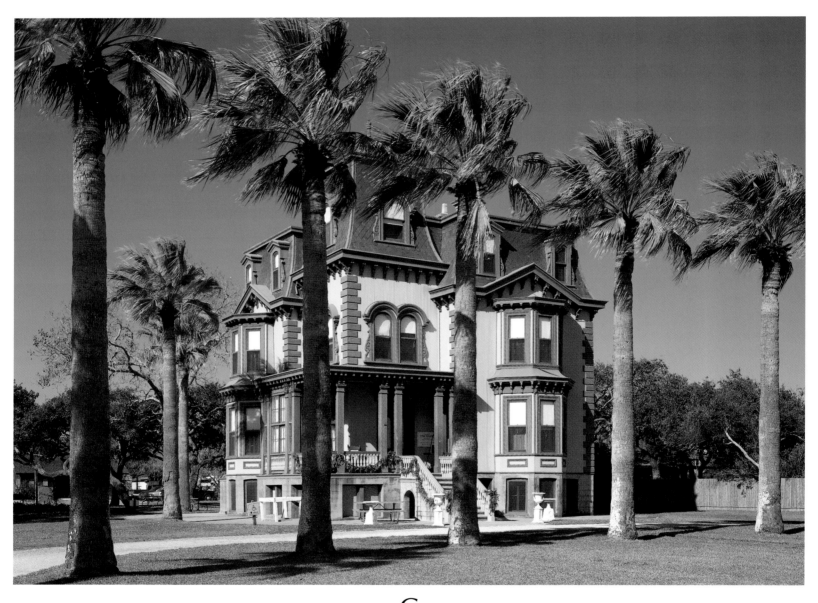

Construction of Fulton Mansion was begun by George Fulton and his family in 1874 beside Aransas Bay. The 6,200-square-foot structure was built very strongly to withstand hurricanes. Most materials were shipped at great expense from New Orleans and the East Coast. For its time, it was very modern, with central heat, running water, flush toilets, and gas lighting. ▲ Sea oats flourish on beach dunes of Matagorda Island. The island, one of two on the Texas coast accessible only by boat, has little development. It is managed by state and federal governments, largely as a wildlife refuge for the whooping crane and other species. ▶

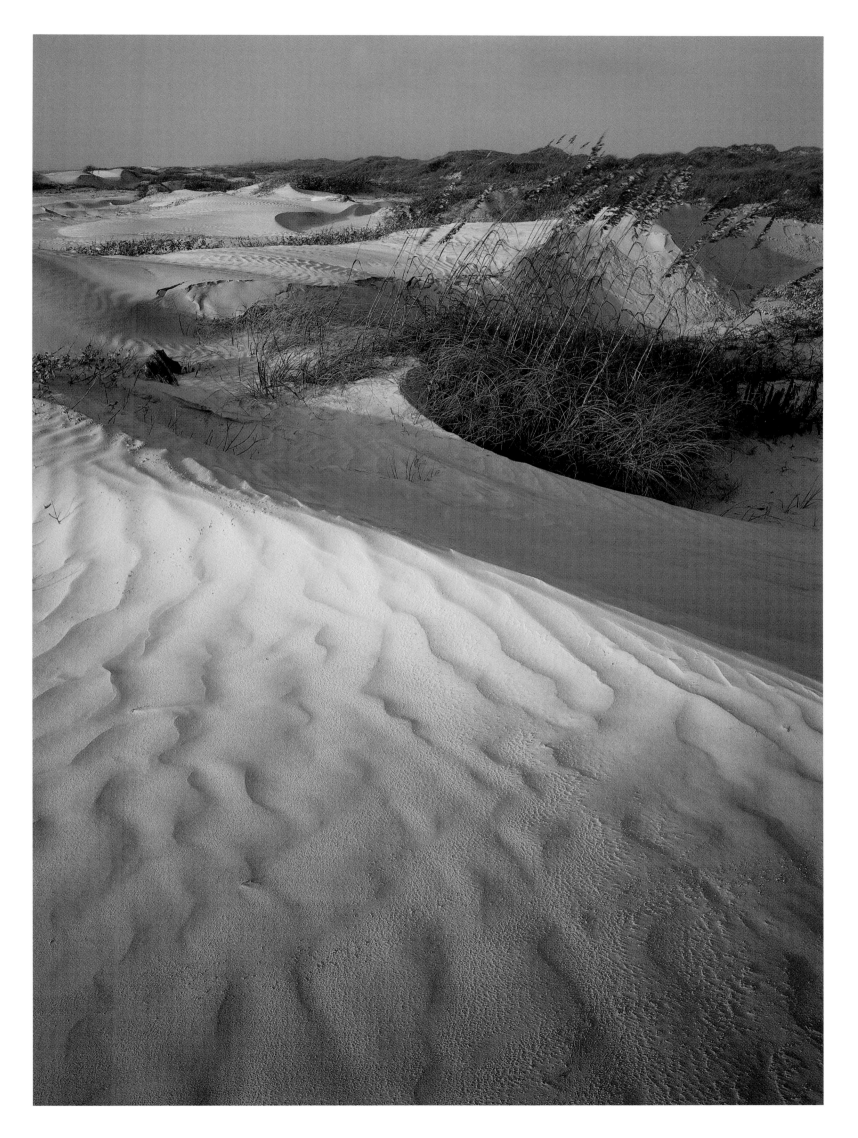

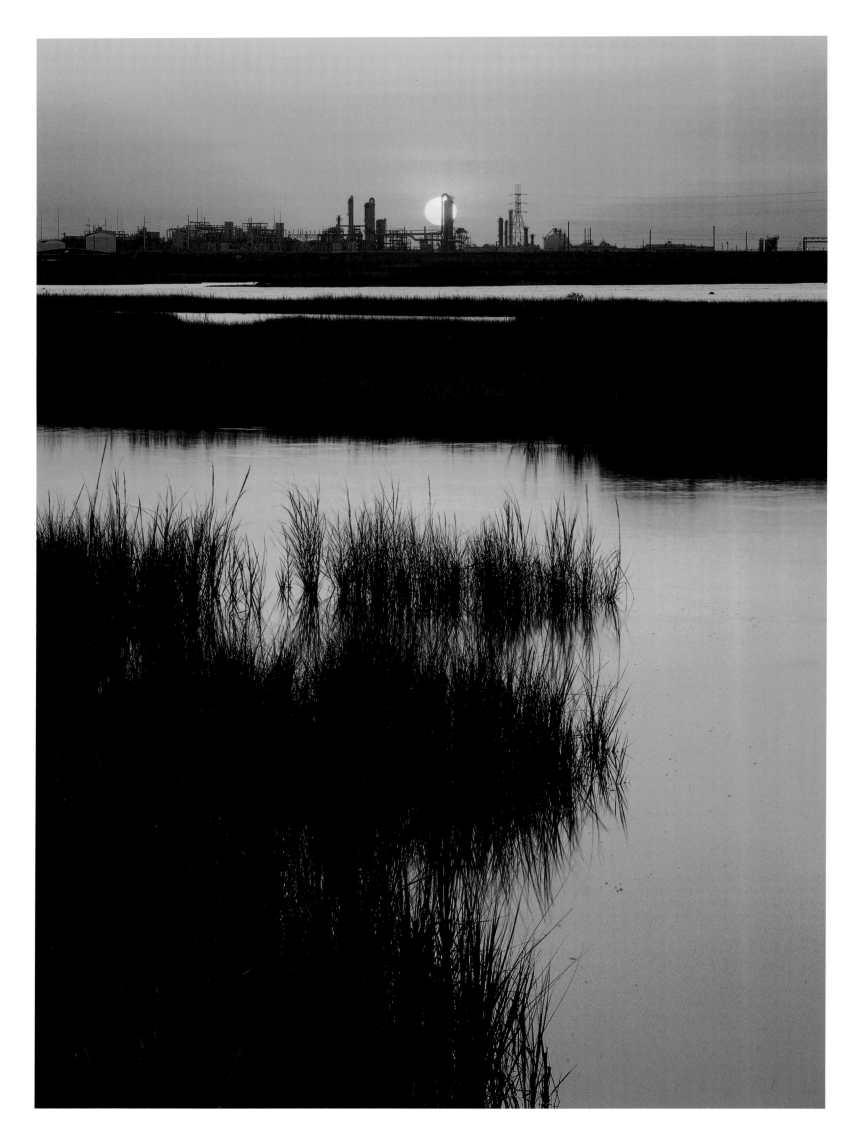

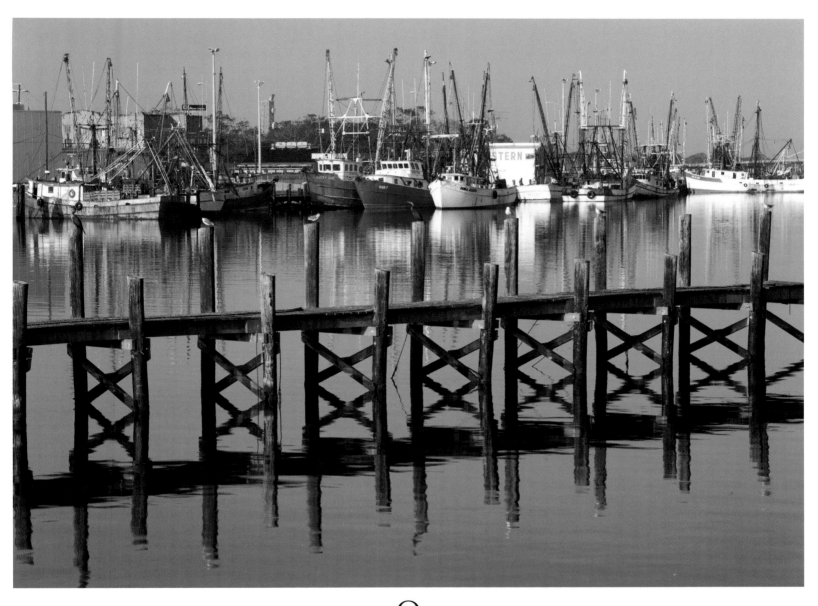

One of the country's largest petro-chemical complexes lies on the coast in the Lake Jackson-Freeport-Clute area. Here, Dow Chemical and other companies manufacture a huge number of products commonly used in everyday life. ◄ Numerous shrimp boats are based in Freeport Harbor. Freeport is noted not only for its shrimp catch, but for its high bird counts. Two national wildlife refuges and a location on migratory routes invite abundant avian life. Freeport often ranks tops in the nation for number of species in the Audubon Society's winter bird count. ▲

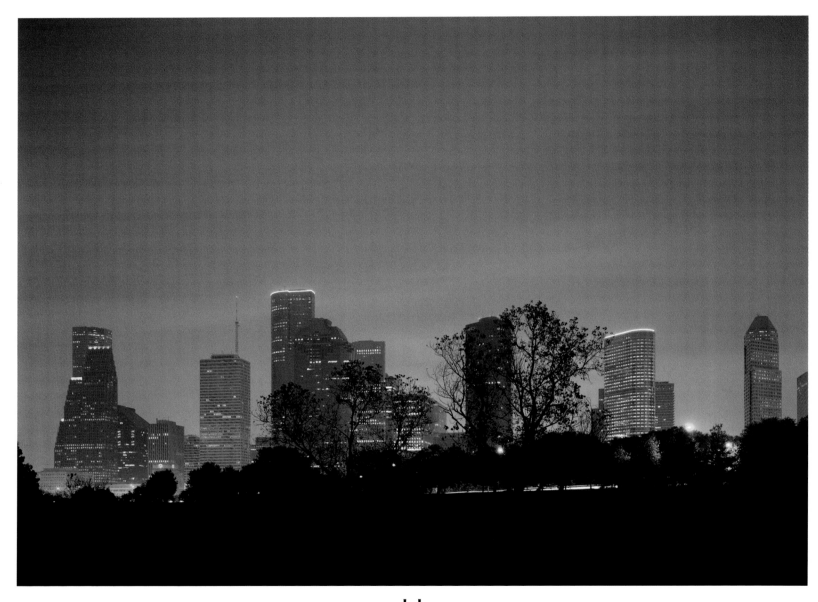

Houston, Texas' largest city and fourth largest in the nation, rises from flat coastal prairies along Buffalo Bayou. Started as a riverboat landing in 1836, the city grew into a major industrial and financial hub. It has one of the country's largest seaports and is still a major center of the world oil industry. The city was named for Sam Houston, head of the Texas army during the war for independence and a president of the Republic of Texas. ▲ Palmetto plants grow in moist, low-lying areas of Southeast Texas. ▶

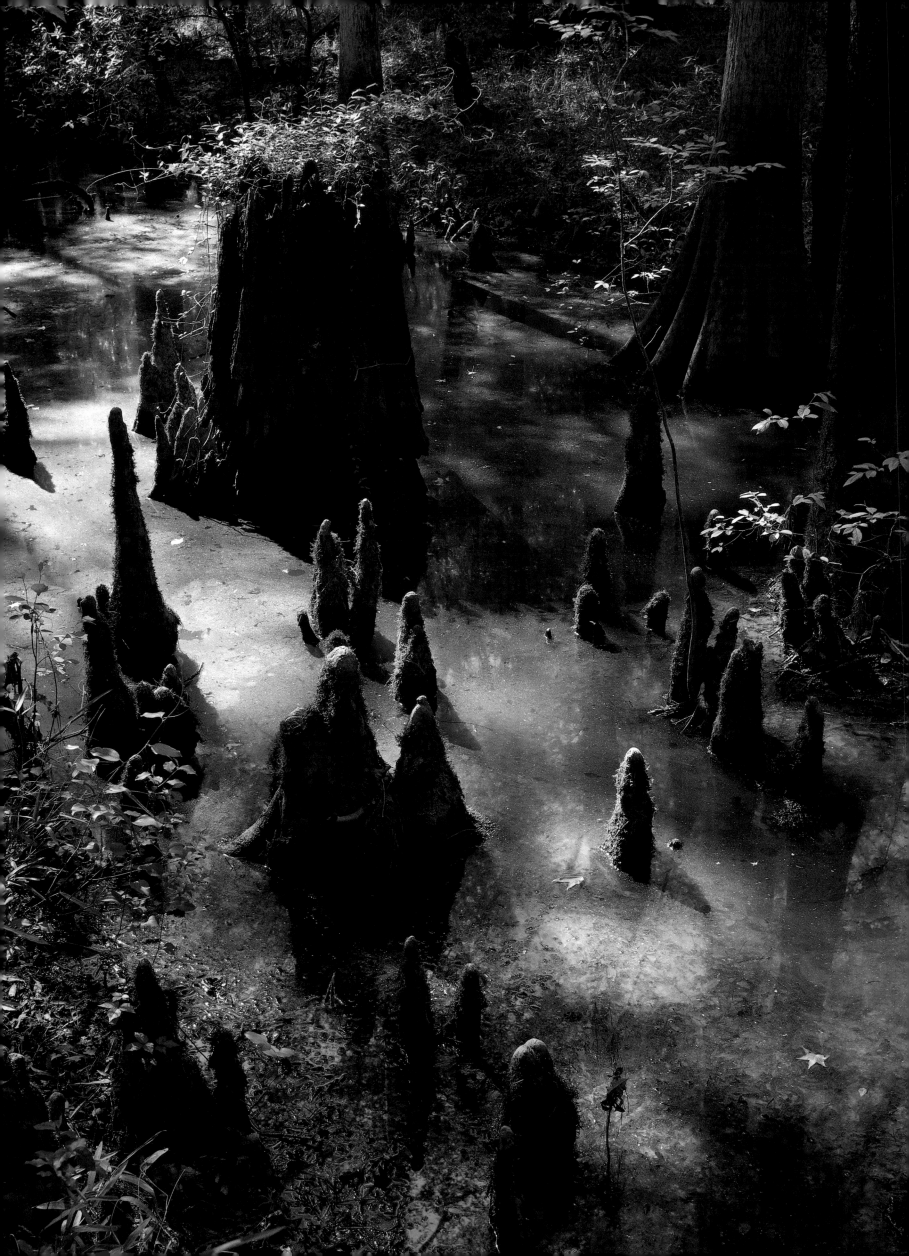

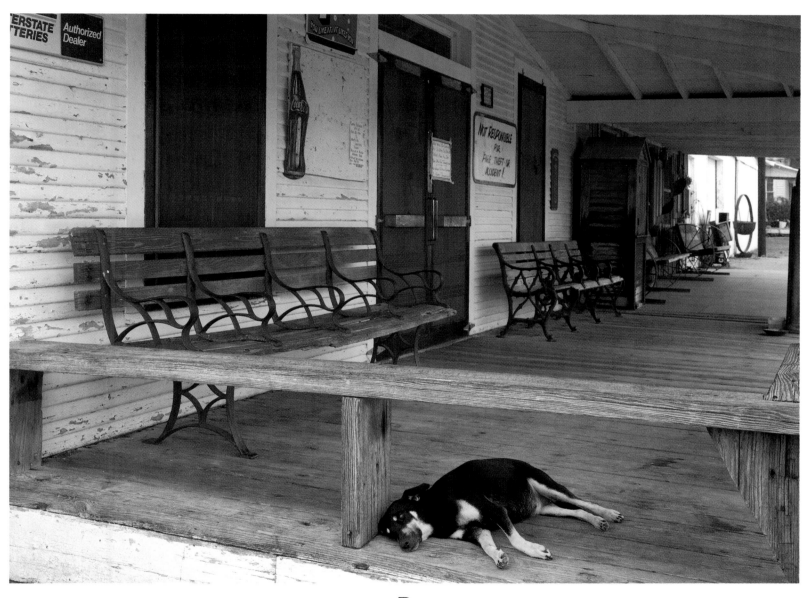

Bald cypress knees rise from a swampy slough in Big Thicket National Preserve. The tall trees were once heavily logged throughout East and Central Texas. Cypresses produce a durable, straight-grained wood that is resistant to decay. The trees do best in deep, moist soil along streams and rivers and in swamps. Although few large old-growth cypresses remain in Texas, the national preserve protects good second-growth stands of cypress, along with many other plant and animal species. ◄ An old dog rests on the porch of John's Country Store in tiny Egypt. ▲

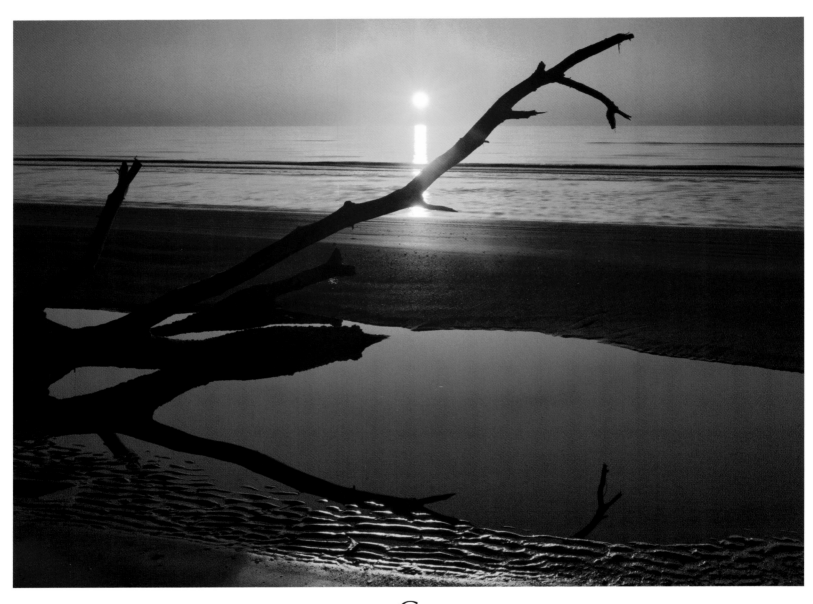

Gulf of Mexico currents carry driftwood and debris onto the shore at Bryan Beach State Park, at the Brazos River mouth, one of Texas' largest waterways. Its headwaters lie in the southern High Plains and eastern New Mexico. ▲

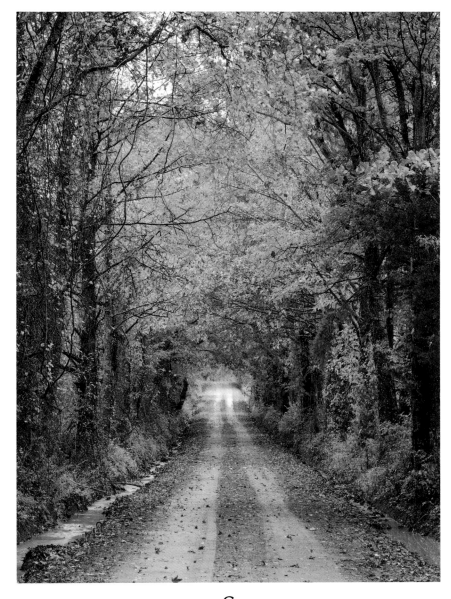

Sweetgums, hickories, maples, and a variety of other trees all bring fall color to Northeast Texas. ▲ Bald cypresses grow in the shallow waters of Caddo Lake. Although a dam now maintains a constant water level, primeval-seeming Caddo Lake is the only sizable natural lake in Texas. Steamboats once plied its waters on the way to Jefferson, a large port city at the time. ► ►

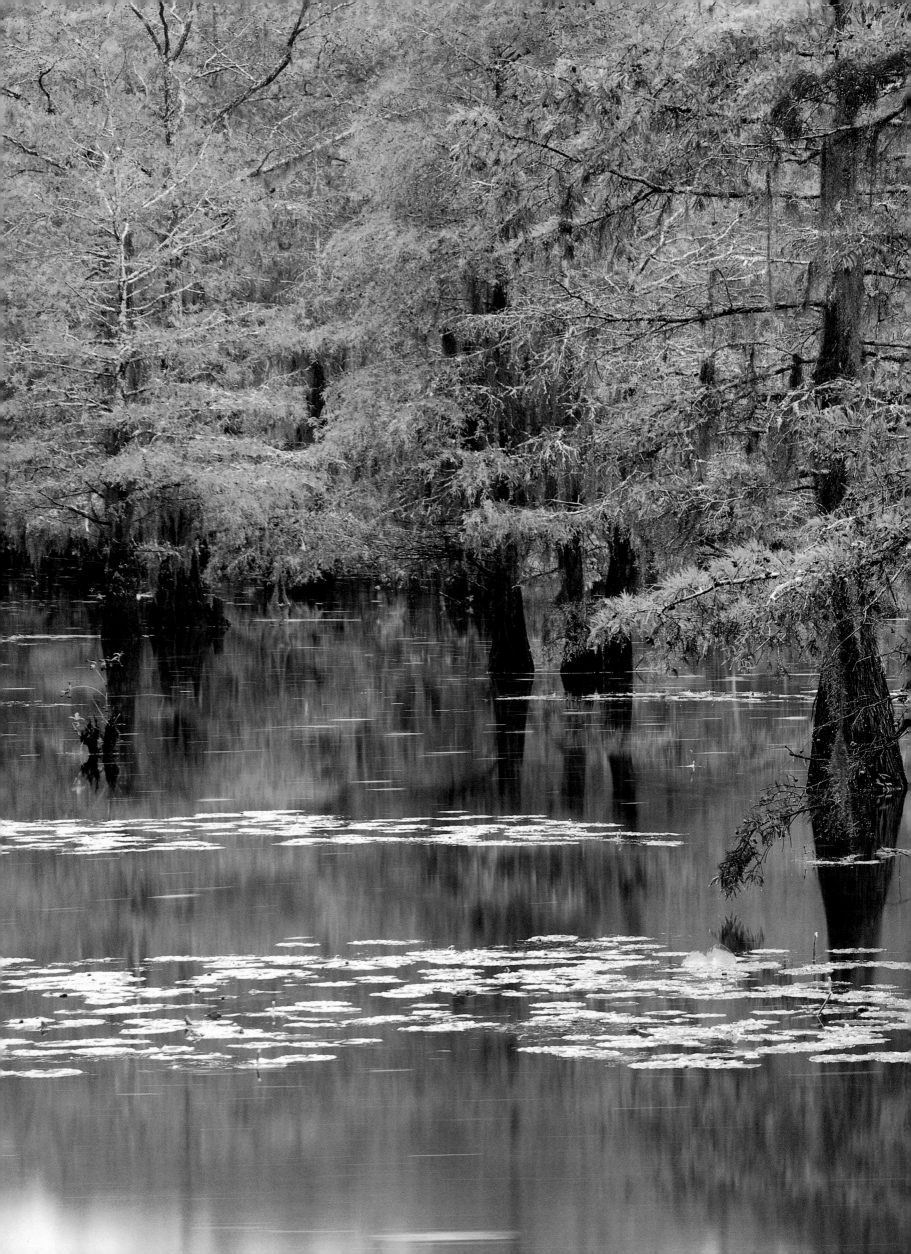

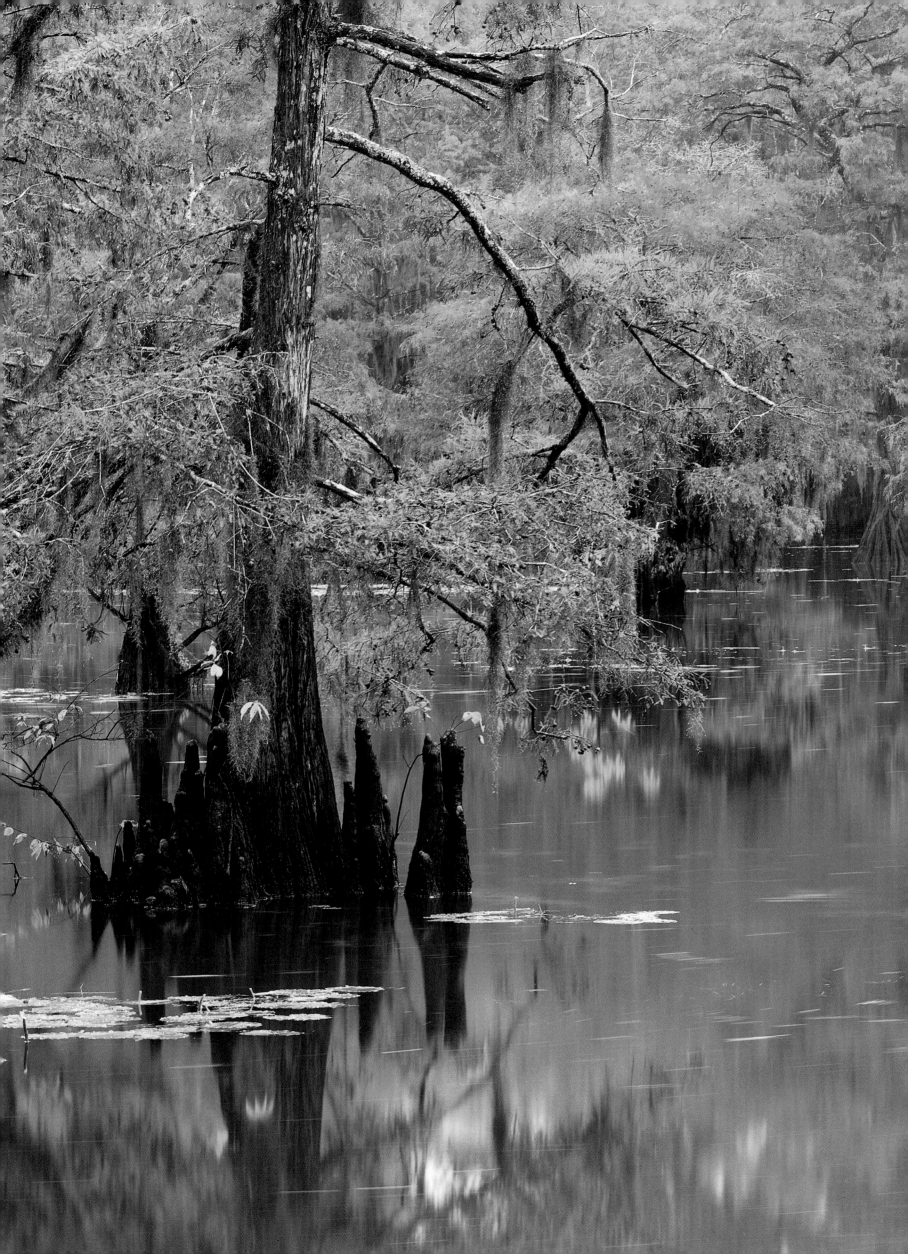

Vines climb an old building in Jefferson, once the second-largest port in Texas. A massive, 170-mile-long logjam blocked the Red River, forcing water back up into Caddo Lake and Big Cypress Bayou. Steamboats could travel upstream from the Mississippi to Jefferson until the Corps of Engineers blew up the jam, leaving the town high and dry. Fortunately, many historic buildings have been preserved and restored from the boom times. ▲

Tall loblolly pines hug Ratcliff Lake in Davy Crockett National Forest, one of four national forests in East Texas. The national forest is a popular retreat with activities that include hiking, fishing, camping, canoeing, and hunting. ▲

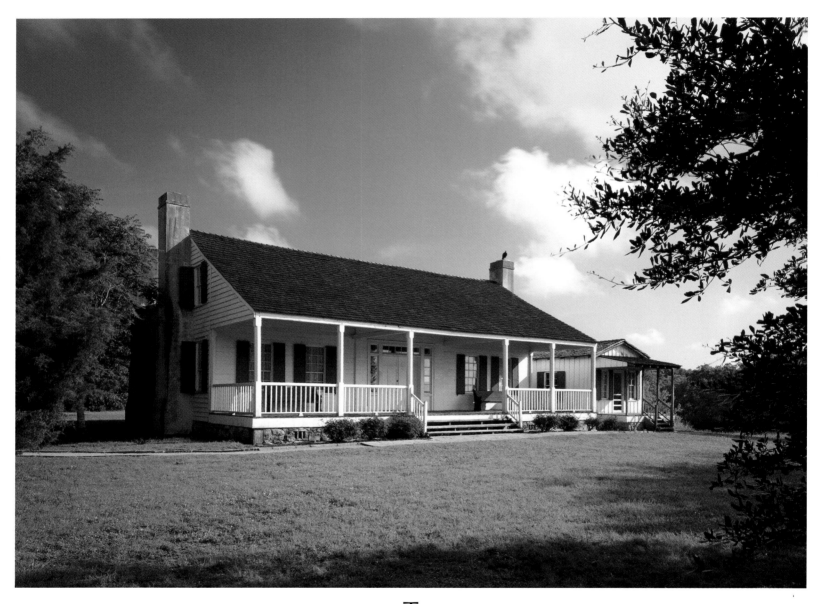

The home of Anson Jones, the last president of the Republic of Texas, is only one of several historic buildings and museums at Washington-on-the-Brazos State Historical Park. The ragged little town of Washington achieved prominence on March 1, 1836, when delegates convened in a small frame building and declared the independence of Texas. The new country's delegates then drafted a constitution, formed a government, and fled to the east ahead of the advancing Mexican army. ▲ In Caldwell County, bluebonnets, Indian paintbrush, and evening primrose are among the spring wildflowers that dress up Texas. ▶

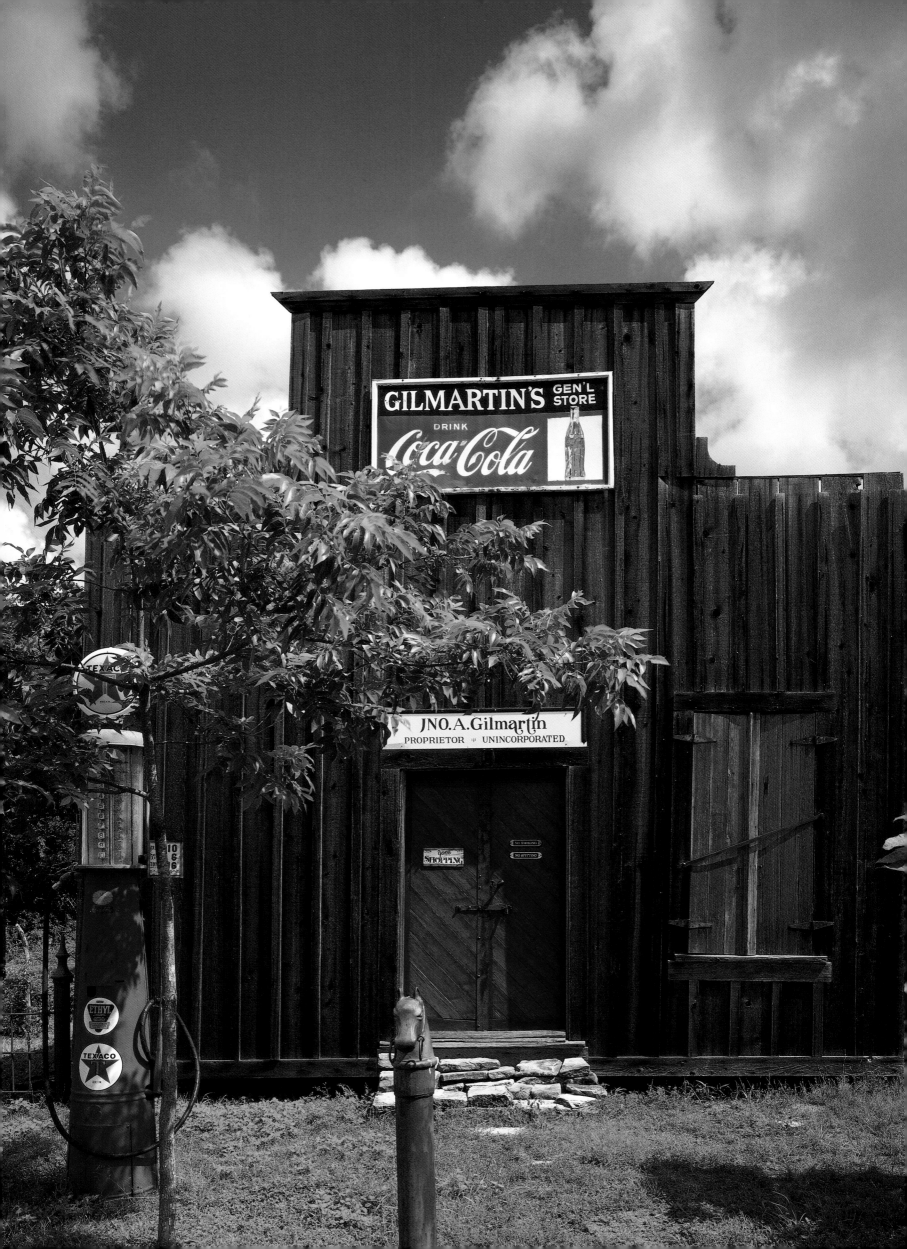

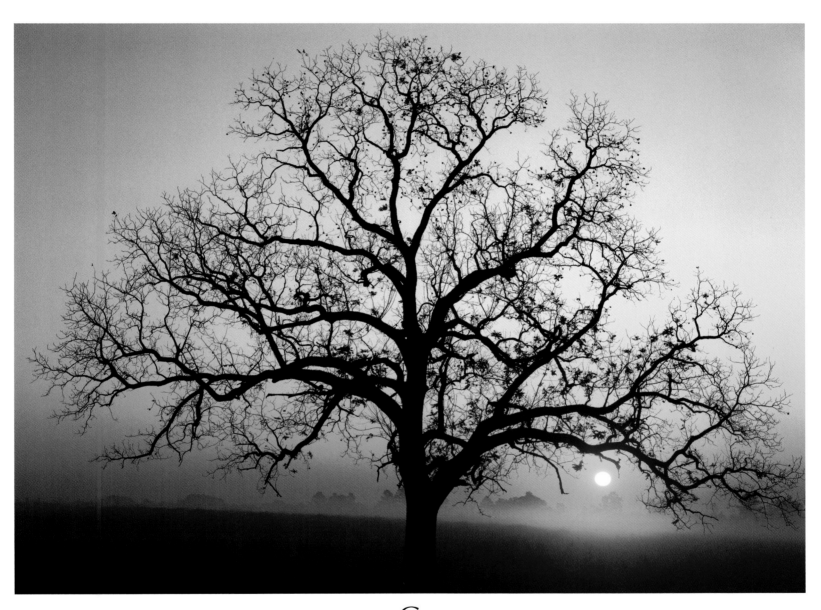

Gilmartin's General Store is one of several old buildings at Old Baylor Park, the site of Old Baylor University in Independence, the precursor of the present Baylor University in Waco and Mary Hardin-Baylor College in Belton. ◄ A lone pecan tree greets the sunrise in Davy Crockett National Forest. The 161,000-acre national forest was created in the 1930s when the government acquired land that nobody wanted. It had been heavily logged and depleted, requiring extensive reforestation efforts to bring it up to its much-improved condition of today. ▲

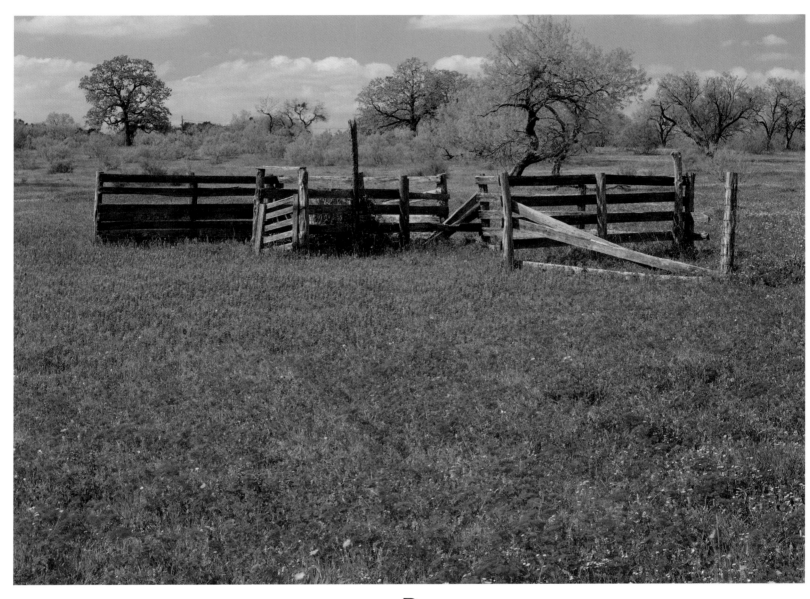

$P$hlox, bluebonnets, and other wildflowers blanket a pasture in Caldwell County. The spring displays in Texas usually start in mid-March and last through May. ▲ Bald cypresses thrive in a slough near Village Creek in Big Thicket National Preserve. Only remnants are left of the biologically diverse 3.5-million-acre Big Thicket of Southeast Texas. Logging, agriculture, and urbanization have left only about three hundred thousand acres, of which approximately 84,500 are within the national preserve. ▶

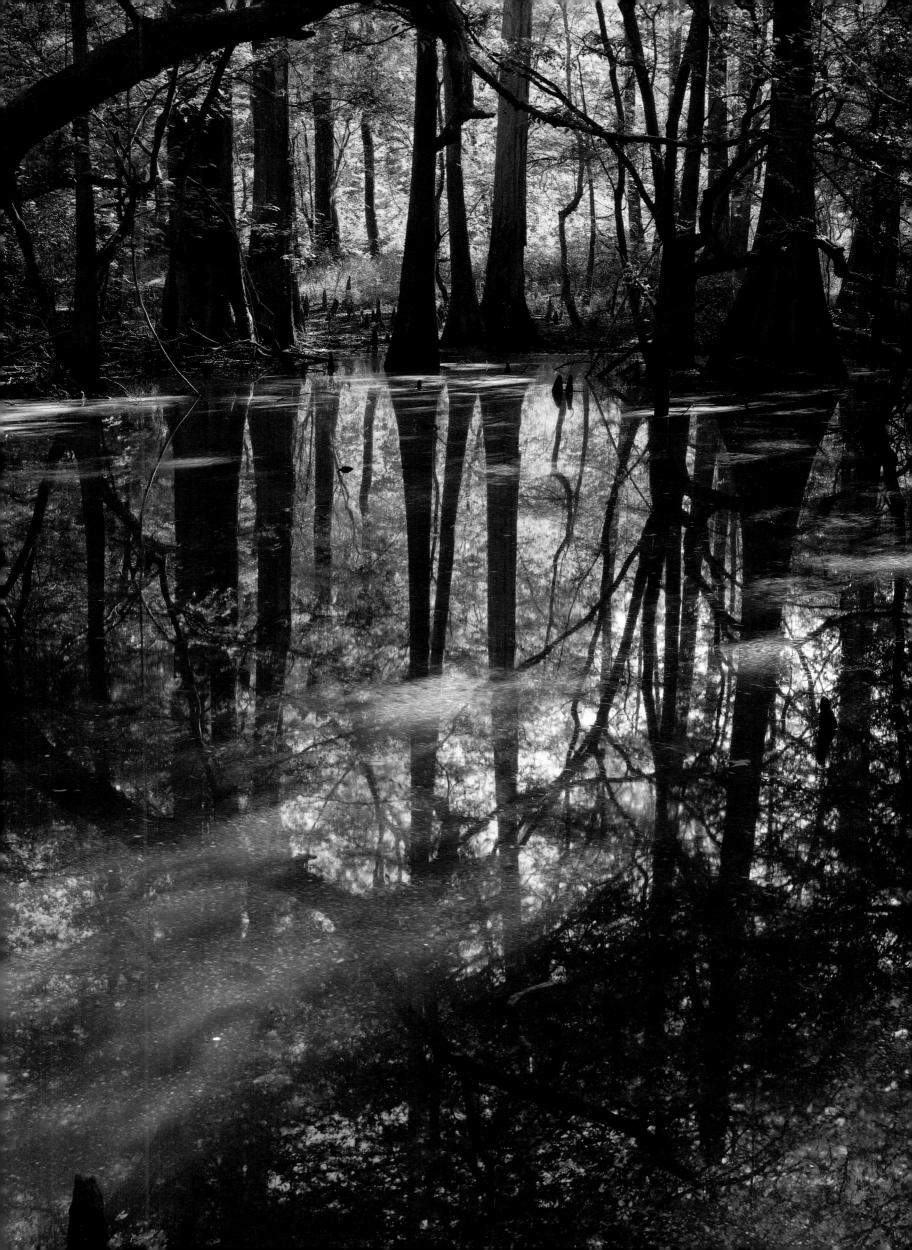

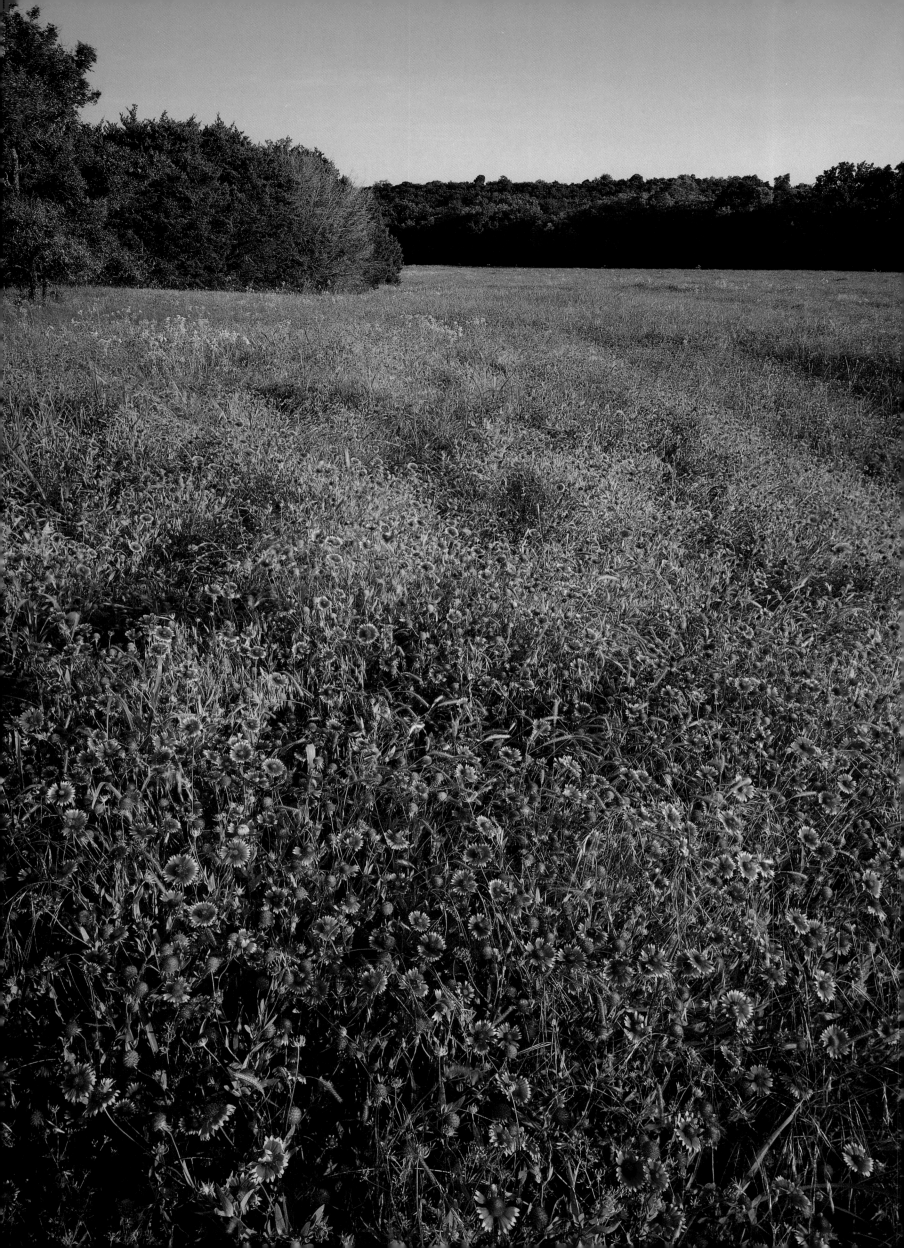

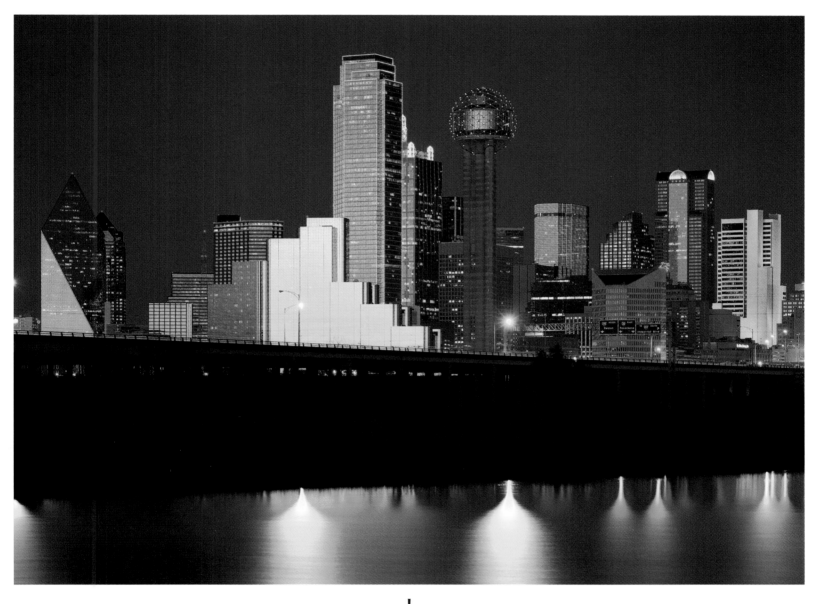

Indian blanket dots a meadow in Cleburne State Park, named for Confederate General Pat Cleburne. ◄ Downtown Dallas rises above the Trinity River. The city, second largest in Texas, has grown phenomenally from its humble beginnings. Dallas began as a single cabin in 1841 and had only grown to two cabins two years later. Growth slowly accelerated, and by the mid-1870s railroads had helped Dallas become a bustling business and market center. Today, a mix of oil, banking, insurance, fashion, and other industries provides the basis of the city's economy. ▲

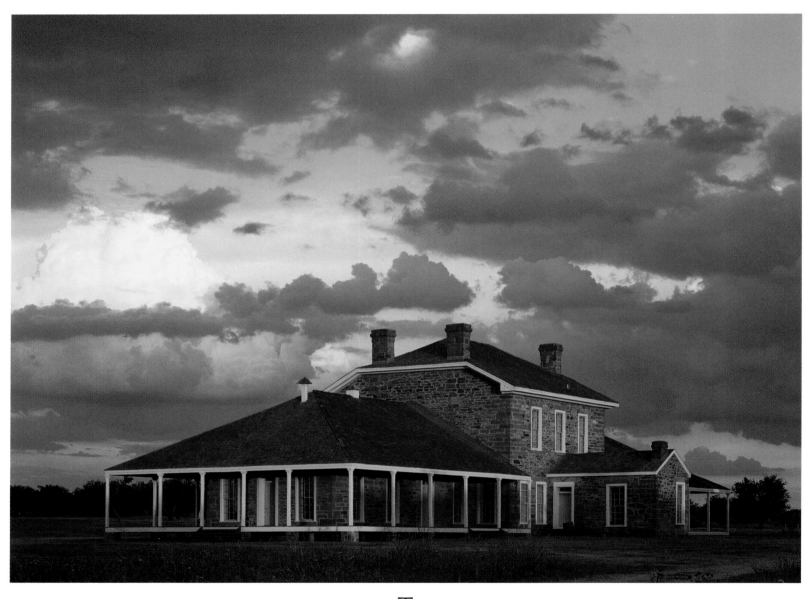

The post hospital is the most impressive of the seven original buildings at Fort Richardson State Historical Park. The fort was built after the Civil War on the prairies of North Texas to stop violence between settlers and Indians. Hostilities were relatively short-lived, and the fort was deactivated in 1878. ▲

$O$ld and new mix in downtown Fort Worth. The city was founded as a military post in 1849 on the Trinity River. After the Civil War, Fort Worth became a major shipping center for cattle, first by the trail drive, later by railroad. In the early 1900s, the Fort Worth Stockyards were among the world's largest. ▲

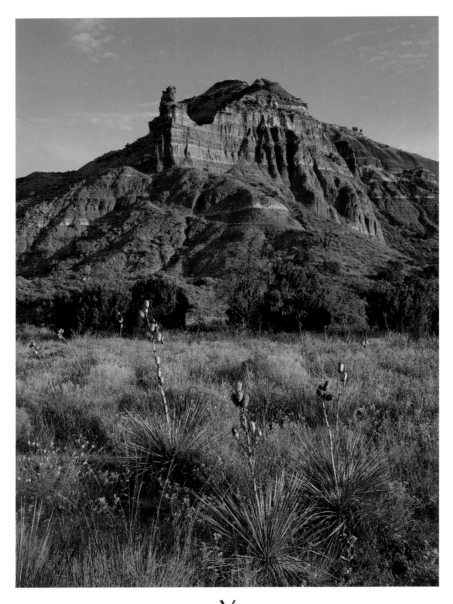

Yuccas are common in Palo Duro Canyon. Surprisingly, the deep red-rock canyon is surrounded by very flat, treeless plains. The Prairie Dog Town Fork of the Red River carved the canyon as it cut westward into the High Plains. ▲

Erosion has exposed the red rock that underlies the High Plains at Caprock Canyons State Park. The park lies at the point where the High Plains meet the much lower Rolling Plains. The boundary between the two is marked by a one-thousand-foot-high escarpment that is deeply incised by canyons. ▲ The red rocks of Palo Duro Canyon are the Quartermaster Formation, formed 250 million years ago at the edge of a Permian sea. ▶ ▶

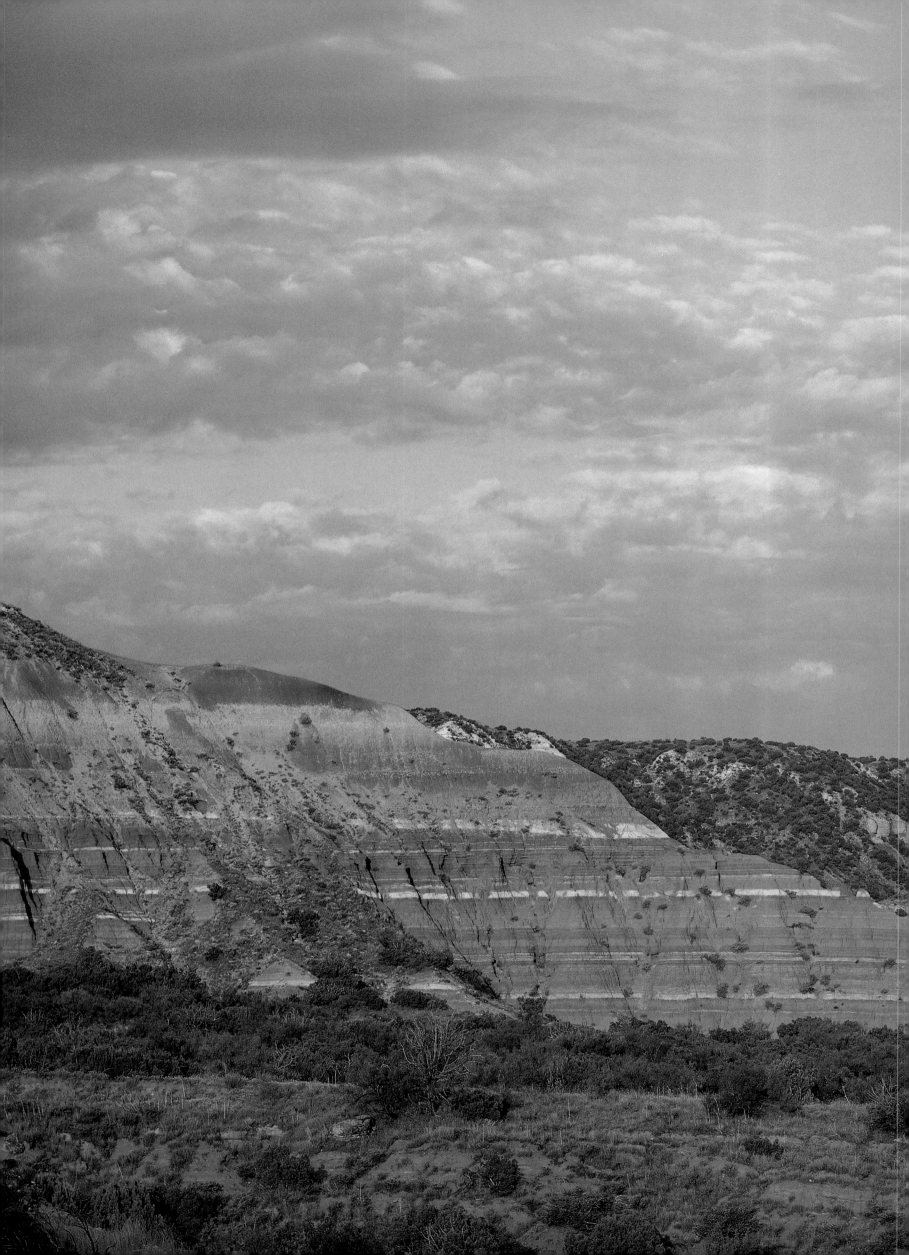

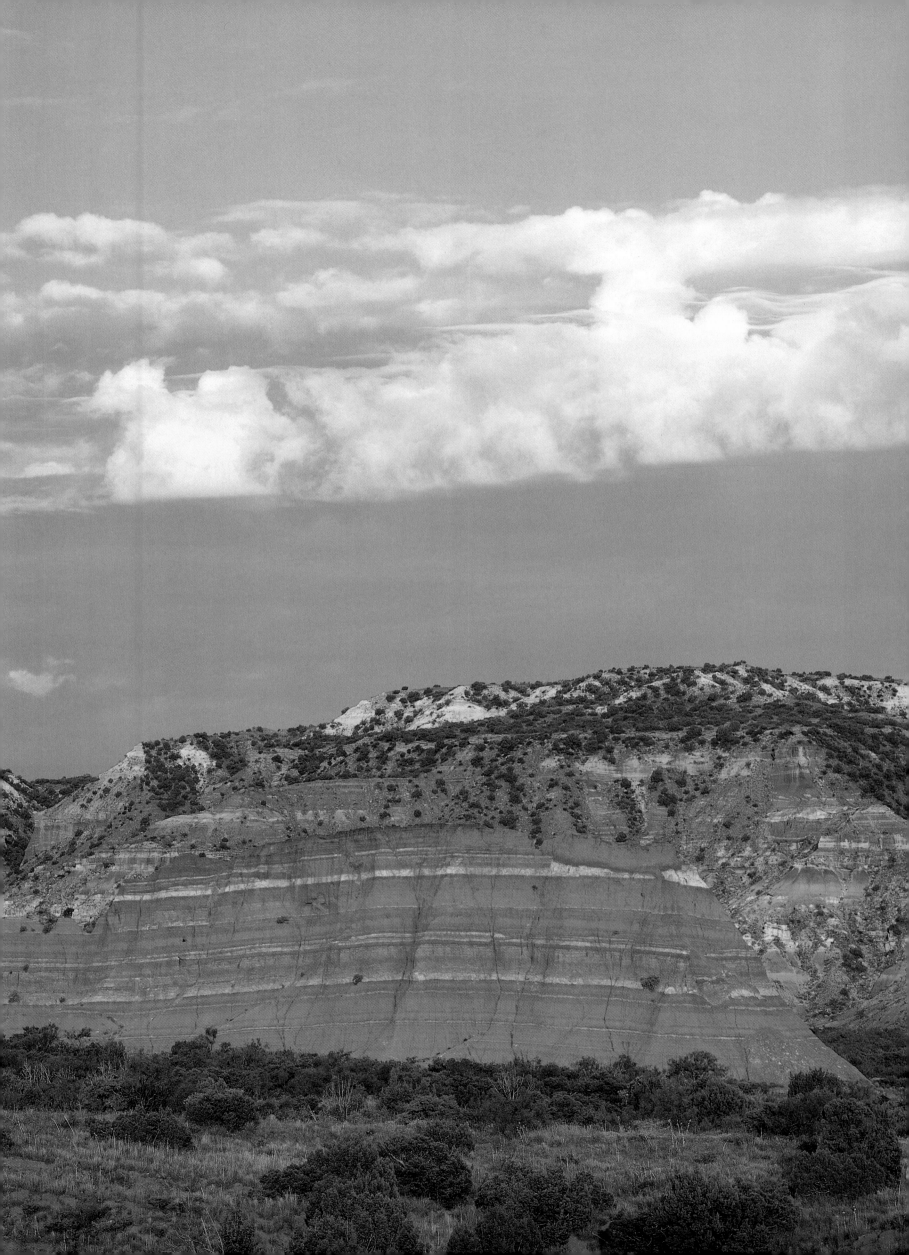

When the Canadian River was dammed, it created Lake Meredith National Recreation Area. The reservoir, the largest body of water in the Panhandle, is important as a water supply for several cities as well as for recreation. ▲ A petroglyph overlooks the Canadian River Valley at Alibates Flint Quarries National Monument. Indians have used the flint found at Alibates for making projectile points and other tools for at least twelve thousand years. The colorful, high-quality stone was traded widely and is readily identifiable by archaeologists nationwide. ▶

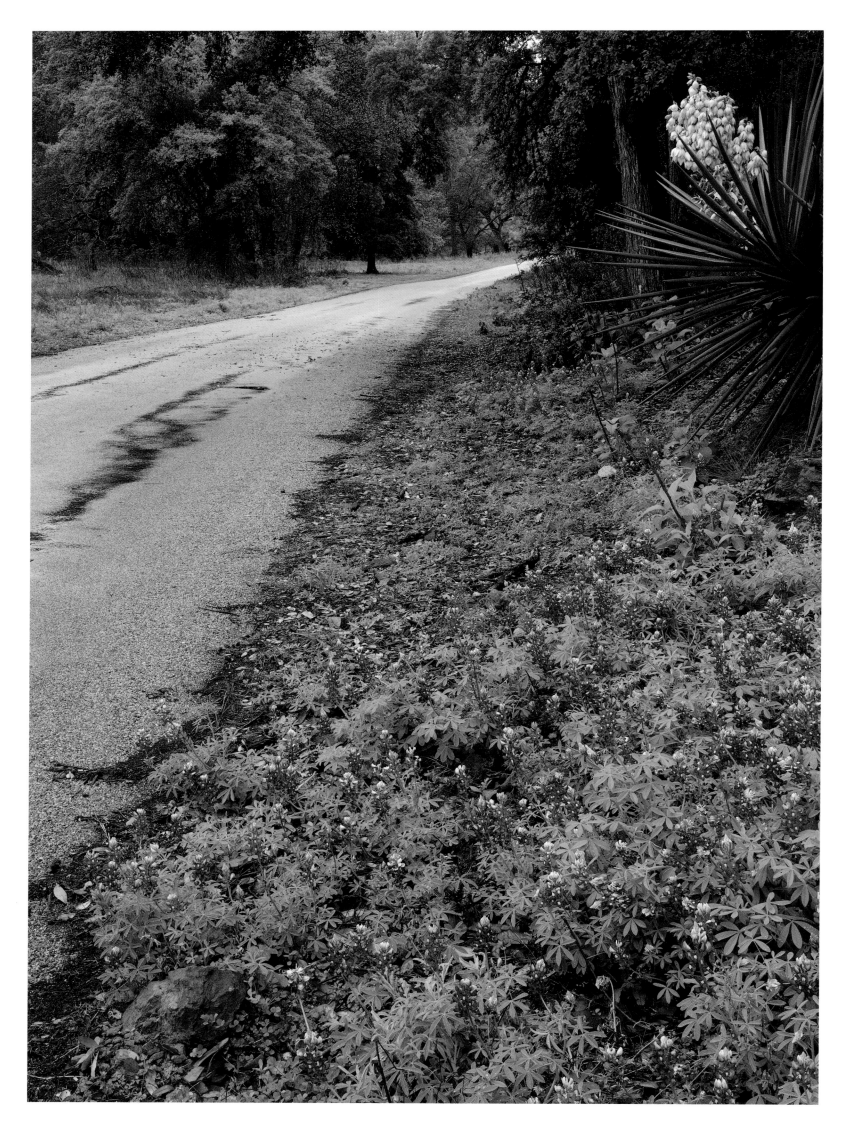

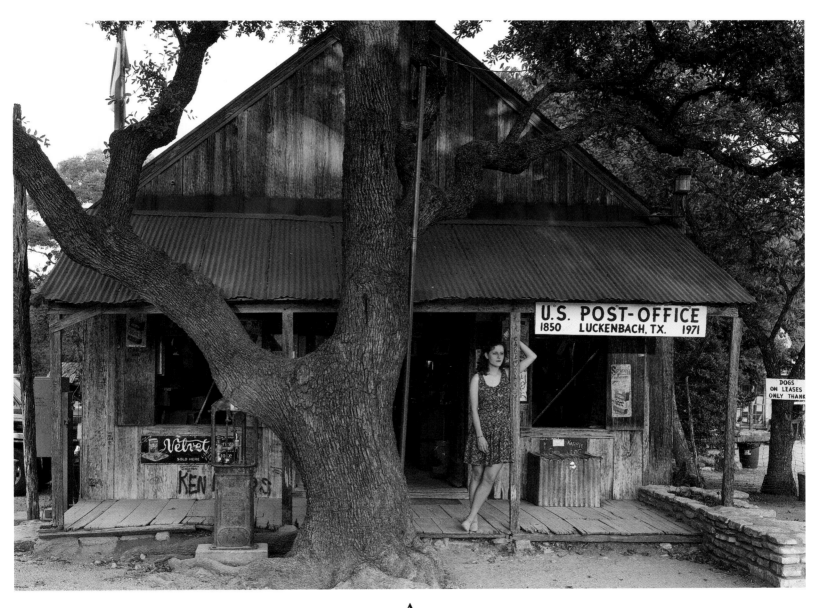

A county road winds through the Hill Country near Fredericksburg. In spring, bluebonnets, yuccas, and many other flowers bloom profusely in much of Central Texas. ◄ Elizabeth Johnston stands in front of the general store in Luckenbach, a small Hill Country hamlet. The town achieved fame in the 1970s when Willie Nelson and Waylon Jennings sang ". . . in Luckenbach, Texas, ain't nobody feelin' no pain." People still flock to the peaceful little town to drink a beer and listen to music under the live oaks. ▲

Dolan Falls, one of the largest waterfalls in Texas, is part of a large Nature Conservancy preserve. The falls lie on the Devil's River in a remote area at the western edge of the Hill Country. The river water comes from massive springs, some of which are only a short distance upstream. The river is so clean it is the benchmark by which other Texas rivers are measured. ▲ Except during heavy rains, Dolan Creek is usually dry in Devil's River State Natural Area. The large natural area includes part of the Devil's River and adjoins the Nature Conservancy's Dolan Falls Preserve. ▶

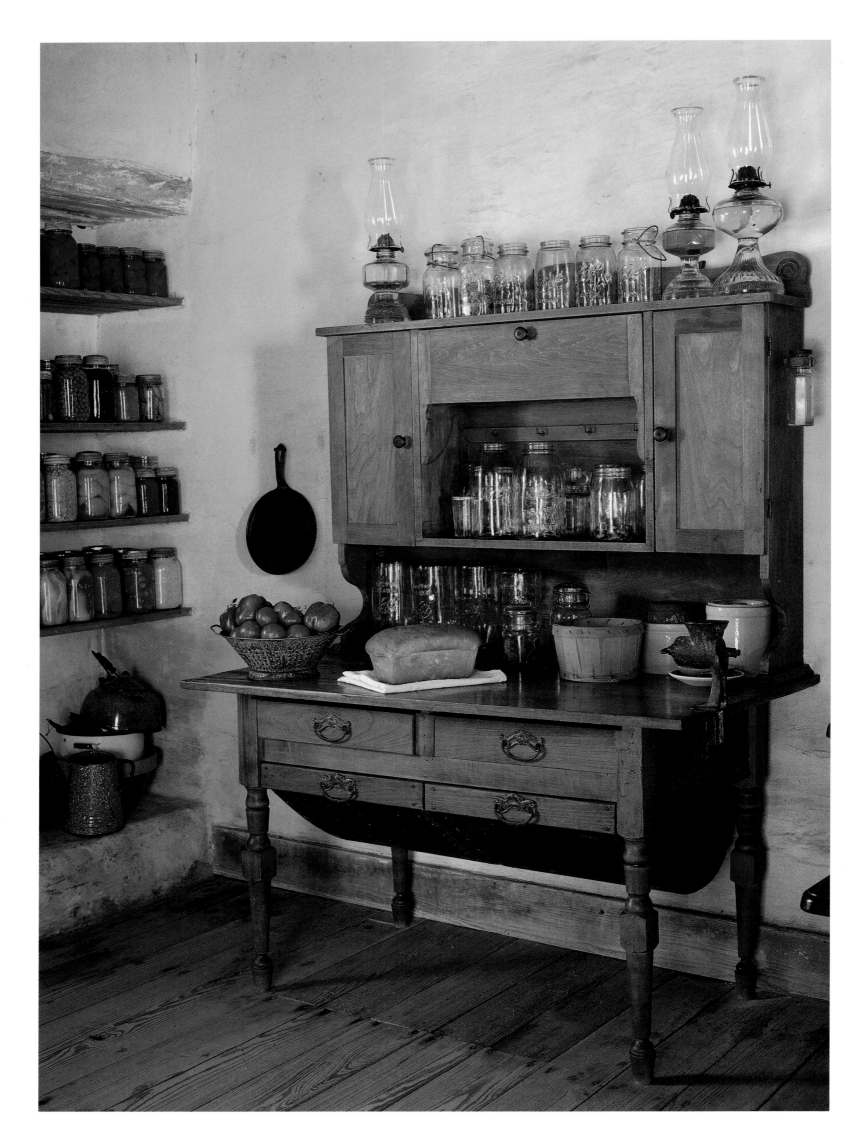

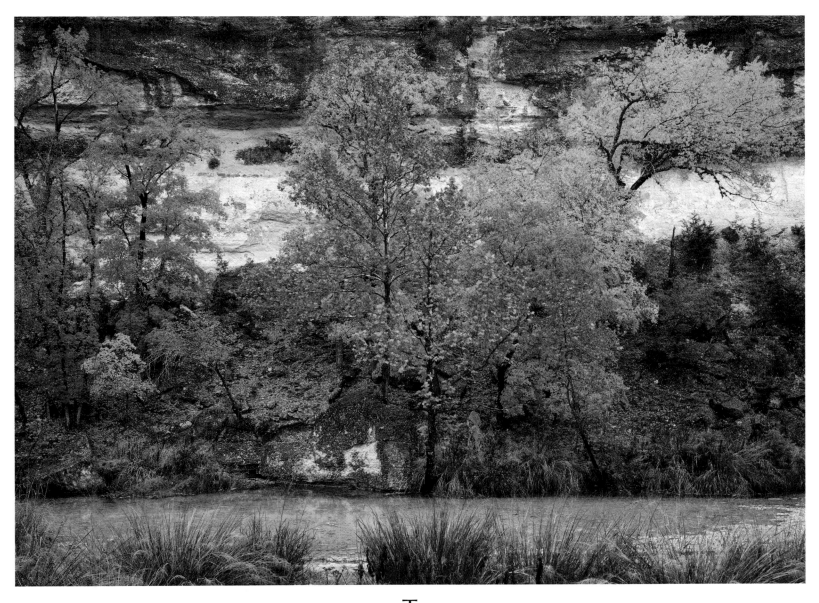

Turn-of-the-century life is preserved at Lyndon B. Johnson State Historical Park in the Hill Country at the Sauer-Beckmann Living History Farm. The park staff wears period clothing and operates the farm as was done long ago. ◄ Bigtooth maples and cherry trees display their autumn foliage along the Sabinal River at Lost Maples State Natural Area. The maples live in Texas only in a small area of the southwestern Edwards Plateau, Fort Hood, and a few West Texas mountain ranges. At the natural area, deep, moist canyons shelter the trees from heat and sun. ▲

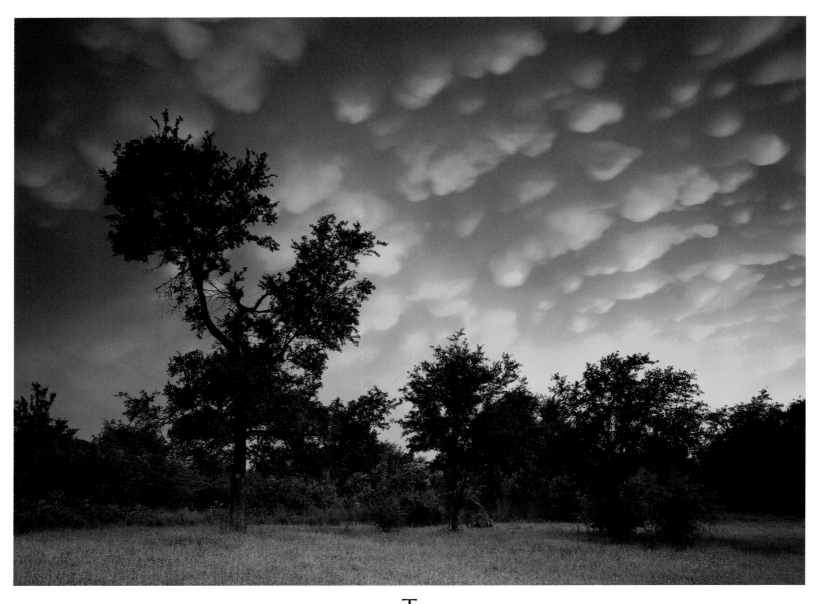

Thunderstorms, such as this one in Hays County, can strike in any part of Texas. *Mammatocumulus* clouds usually signify violent weather such as tornadoes and hail. This storm had heavy rain, strong winds, and a tornado watch. ▲ Austin underwent tremendous growth during the late 1970s and the first half of the 1980s. The increase in population was accompanied by an increase in area and much downtown growth. This Congress Avenue building was one of many office buildings constructed. ▶

100 CONGRESS

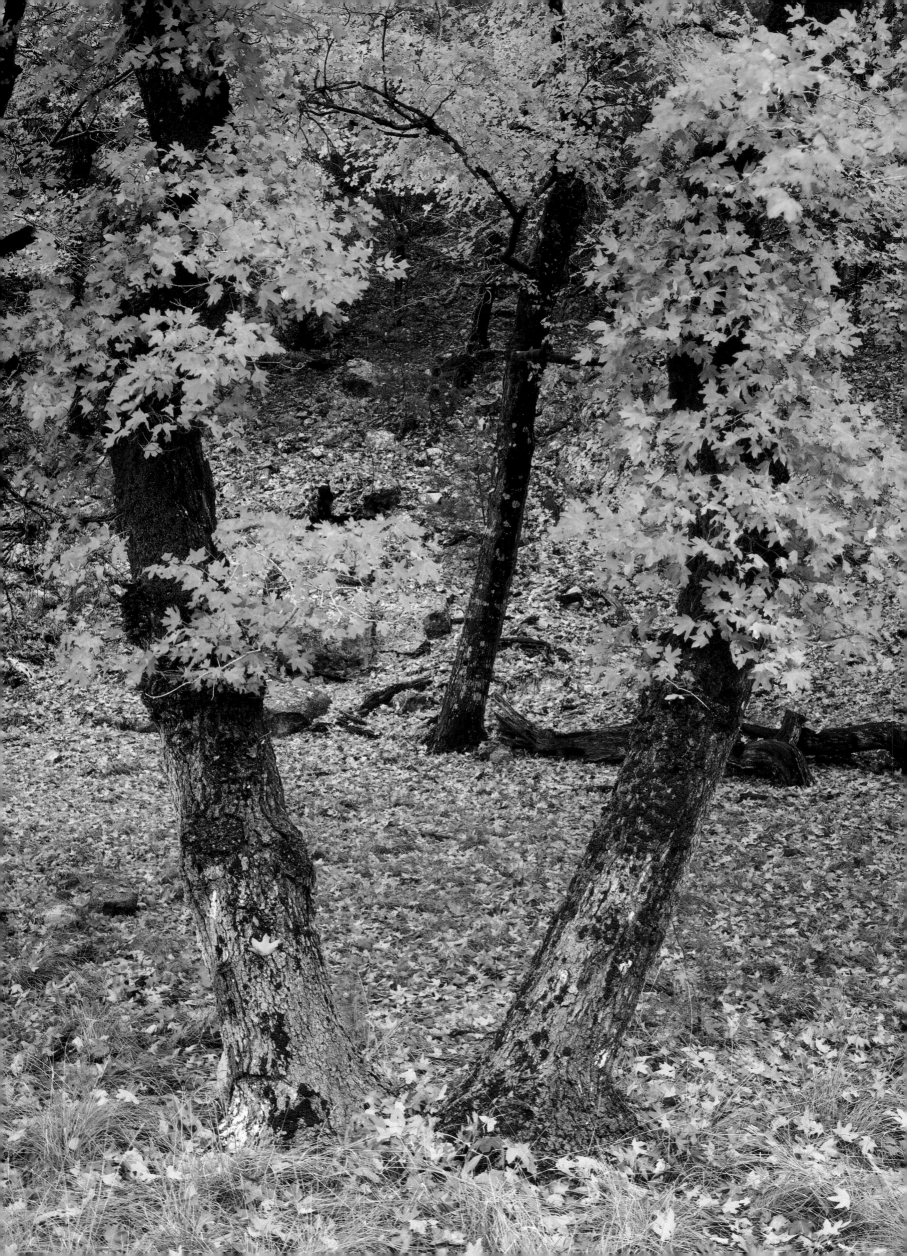

Bigtooth maples at Lost Maples State Natural Area provide some of the best fall color in Texas. When the Edwards Plateau was uplifted long ago, streams and rivers began cutting into its surface, creating hilly terrain that is now called the Hill Country. Along the southern margins of the plateau, the waterways cut especially deep canyons that today provide sufficient moisture and shelter for the maples to survive. ◀ On Austin's west side, the Loop 360 bridge spans Lake Austin, lowest of the Highland Lakes, a chain of Colorado River reservoirs. ▲

Cattle still range across the pastures of Lyndon B. Johnson's ranch at LBJ National Historical Park. ▲ Indian blanket and coreopsis flourish in much of the central and eastern parts of the state. These flowers usually add their colorful bloom in late spring after the bluebonnets have disappeared. ▶ The pink granite dome of Enchanted Rock looms above the valley floor north of Fredericksburg. The dome, one of the largest in the United States, is only a small part of a sixty-square-mile batholith of billion-year-old granite that is now exposed to the surface. ▶ ▶

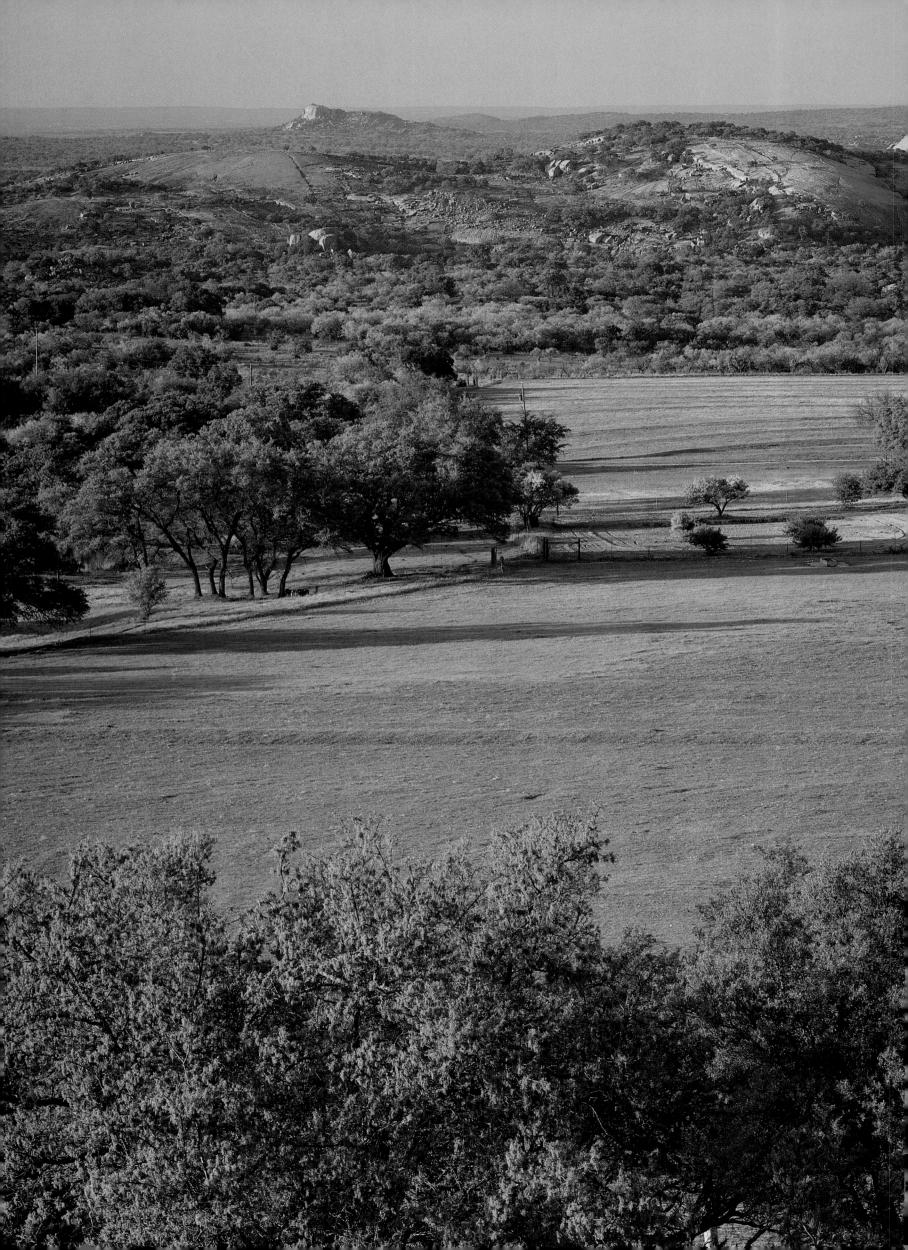

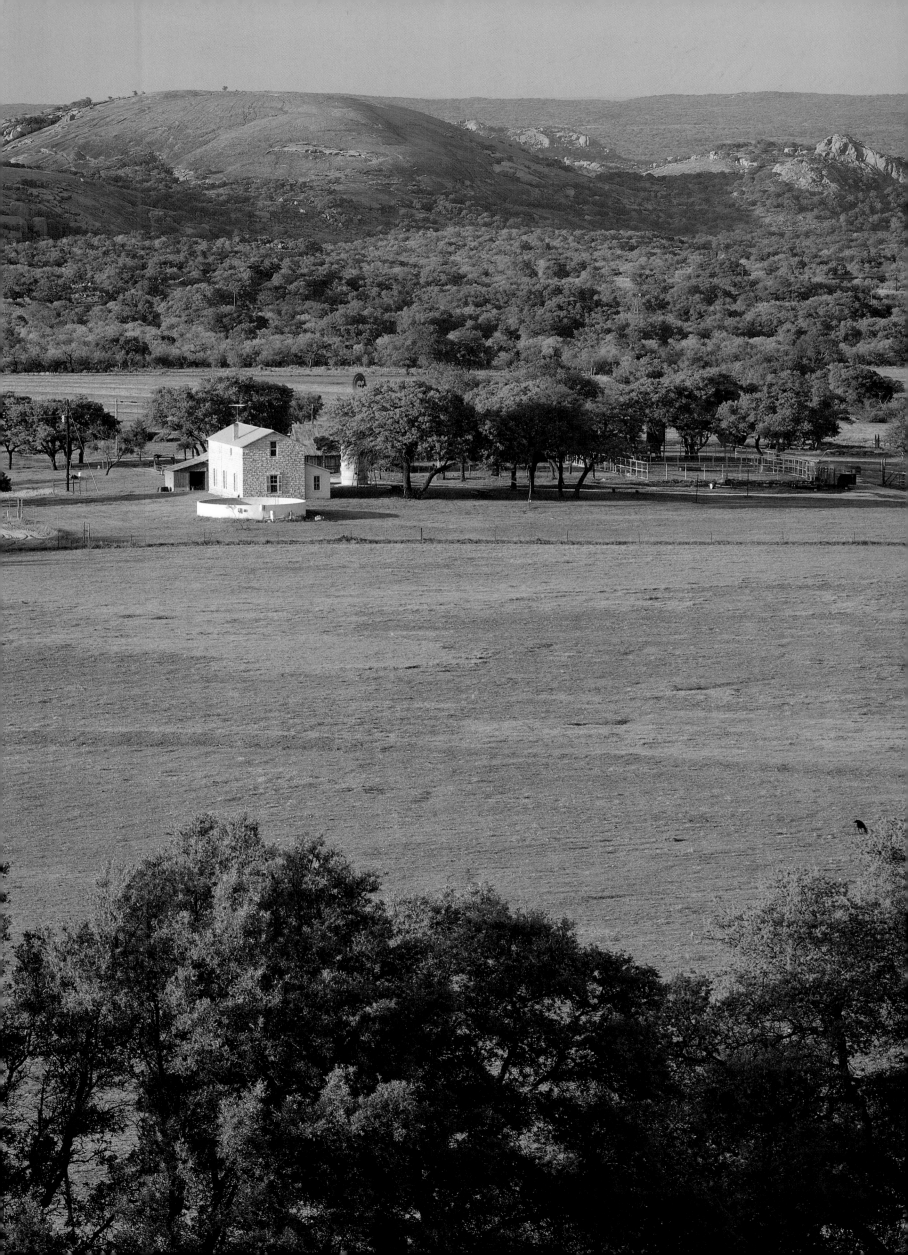

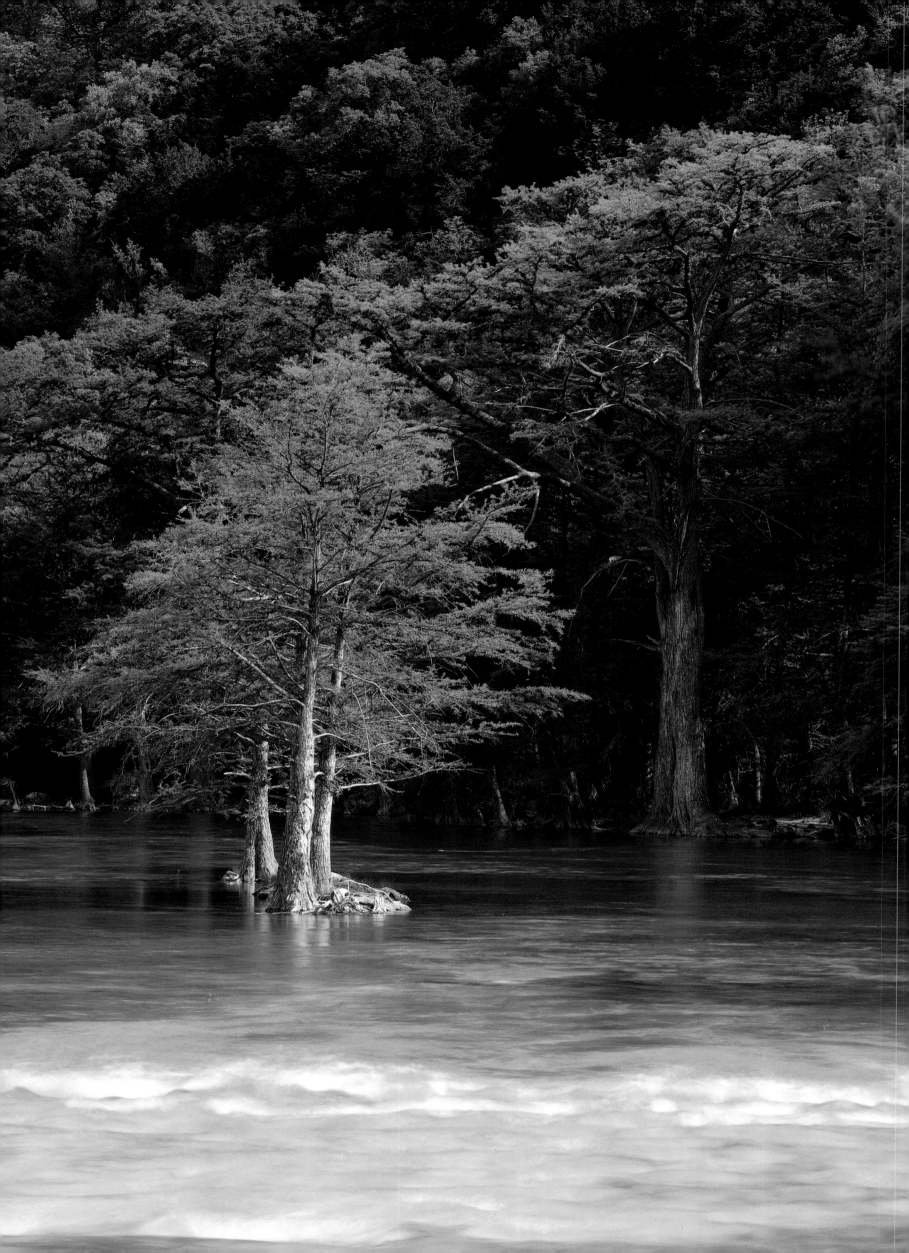

The Frio River is one of many spring-fed rivers that start in the uplifted terrain of the Hill Country. North of Uvalde, the Frio flows through some of the most rugged terrain in Central Texas. The river's clear, cool waters make Garner State Park one of the most popular places in this part of Texas. ◄ A large fountain decorates the front of the Lyndon B. Johnson Library on the University of Texas campus in Austin. The library houses a museum that includes exhibits relating to Johnson and to the office of the president, along with archives from his presidency. ▲

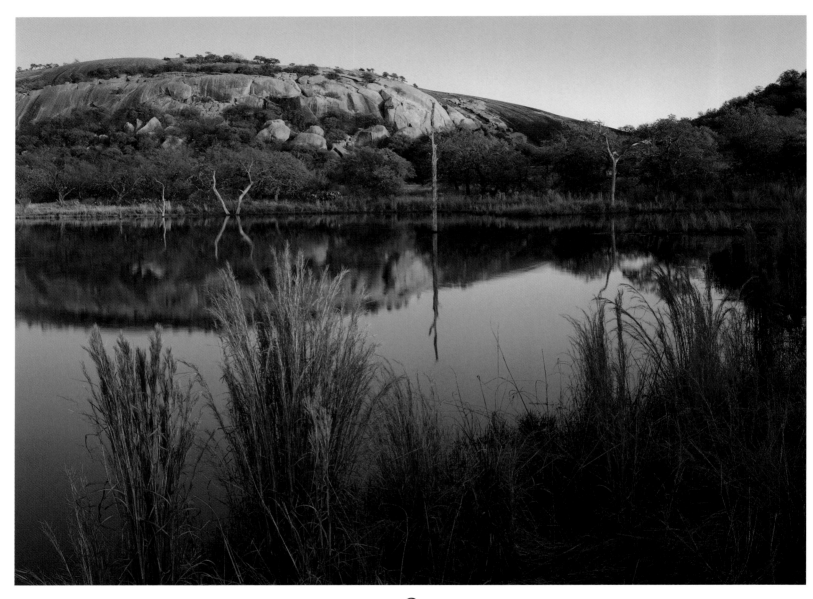

$S$mall Moss Lake reflects the large granite dome of Enchanted Rock. The granite is a hard, durable rock that, combined with its many sheer rock faces, attracts rock climbers from across the state. In nearby areas, the granite is quarried and shipped all over the country for construction purposes. ▲ Icicles hang from the roof of a collapsed grotto at Hamilton Pool. The weather is seldom cold long enough to create such icicles. In summer, the pool is a popular swimming hole in western Travis County. ▶

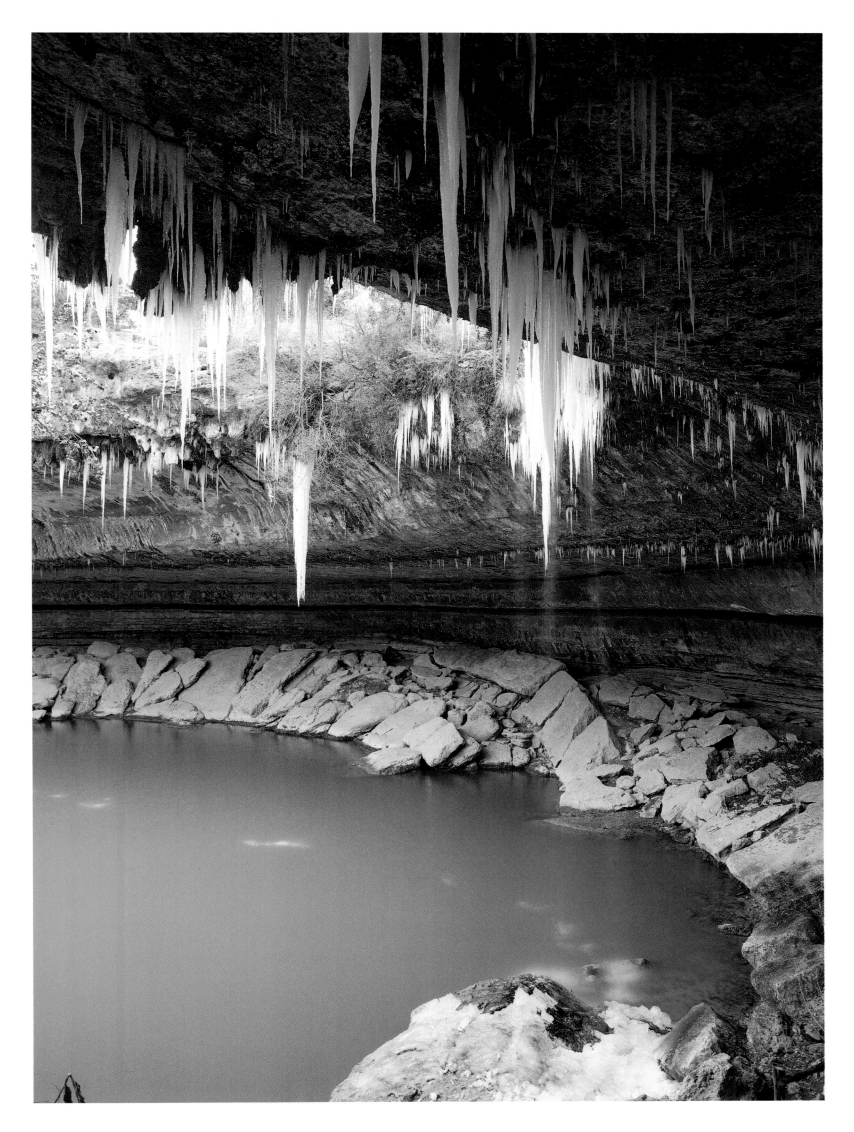

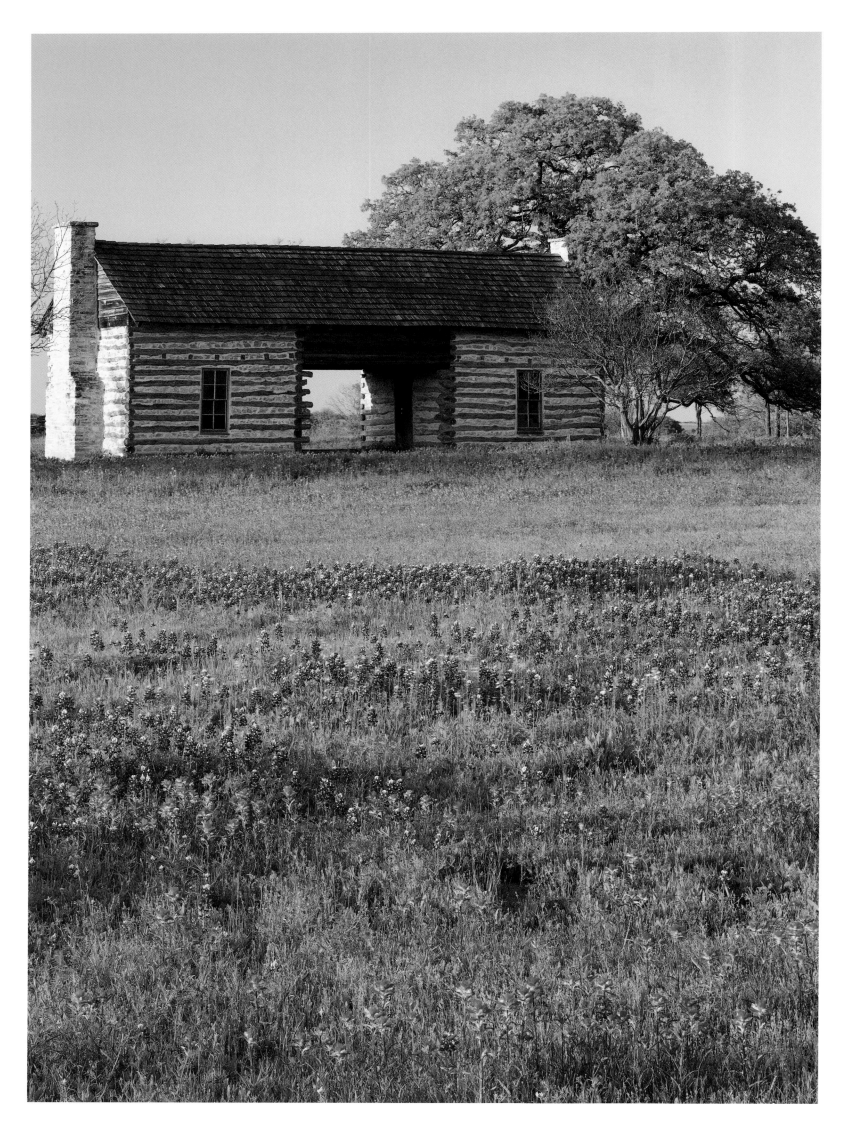

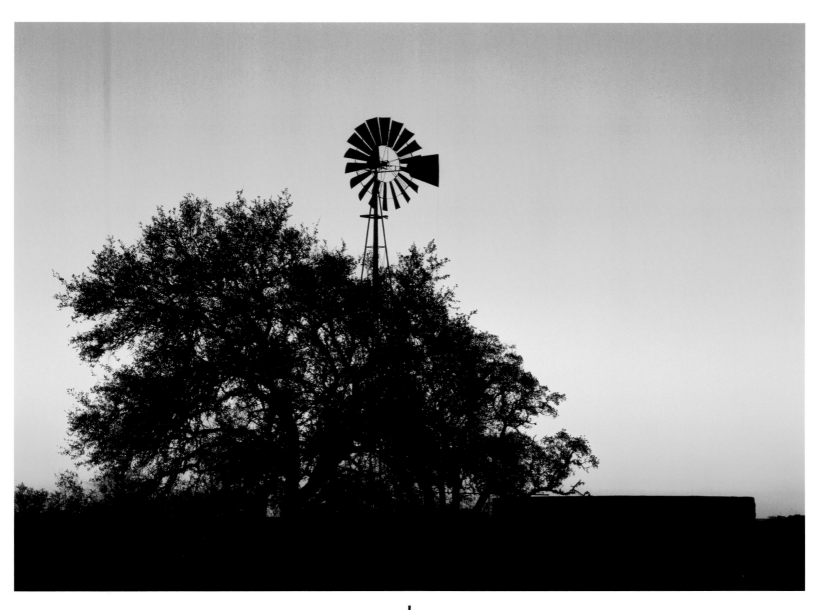

Indian paintbrush, bluebonnets, and phlox surround the Casper Danz cabin in LBJ State Historical Park. Often called a dog-trot cabin because of its split style, the home was built by Danz in the mid-1800s. He was one of the first German immigrants who settled in the Texas Hill Country. ◄ Windmills were vital for settlers in the Hill Country and other areas of Texas. They powered water pumps for livestock and homes far from permanent streams, rivers, and springs. Many are still used today, rather than installing expensive electric pumps and powerlines. ▲

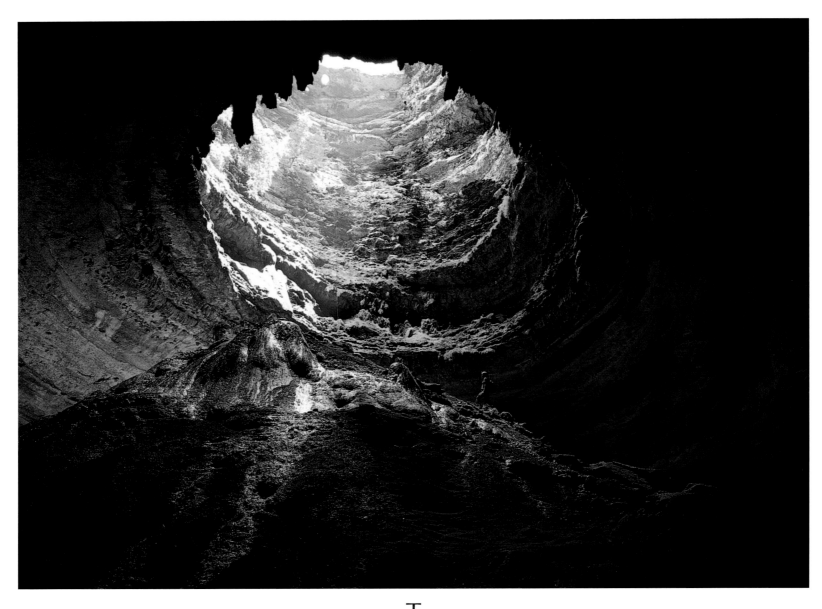

The Devil's Sinkhole is a large, underground cavern that is entered by a deep, vertigo-inducing pit located on a flat hilltop near Rocksprings. Because of the sinkhole's unique character and a large colony of more than a million Mexican free-tailed bats, the 350-foot-deep pit is a state natural area. ▲ Shaman pictographs are tucked into a remote rock shelter near the Devil's River on the Hill Country's western edge. Because of protection from sun and weather, they have survived for millennia. ▶

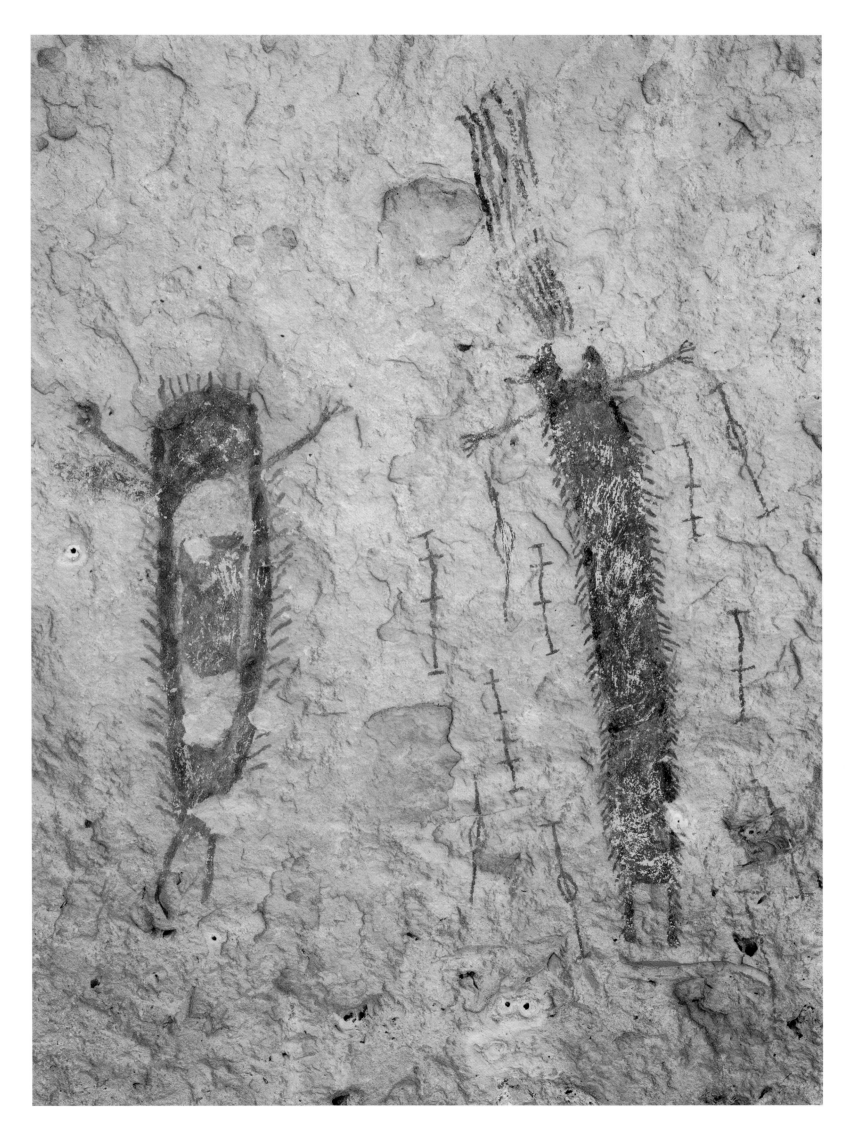

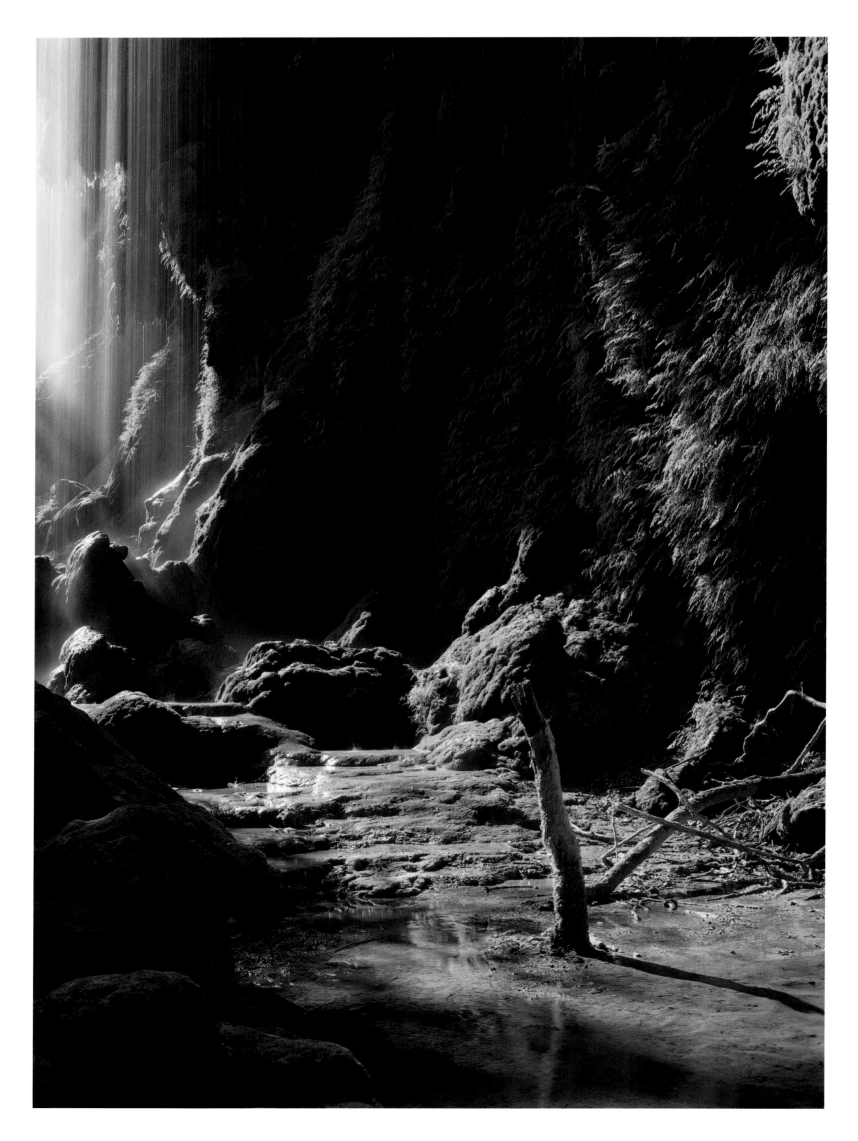

A spring-fed stream tumbles over Gorman Falls at Colorado Bend State Park. The mineral-laden water deposits travertine on a bluff overlooking the Colorado River and encourages a lush growth of maidenhair ferns and moss. ◄ Sam Johnson and his wife Eliza moved into this cabin at LBJ National Historical Park in 1867. Until cattle prices fell, Sam and his brother made a living by rounding up cattle and driving them to Kansas. ▲

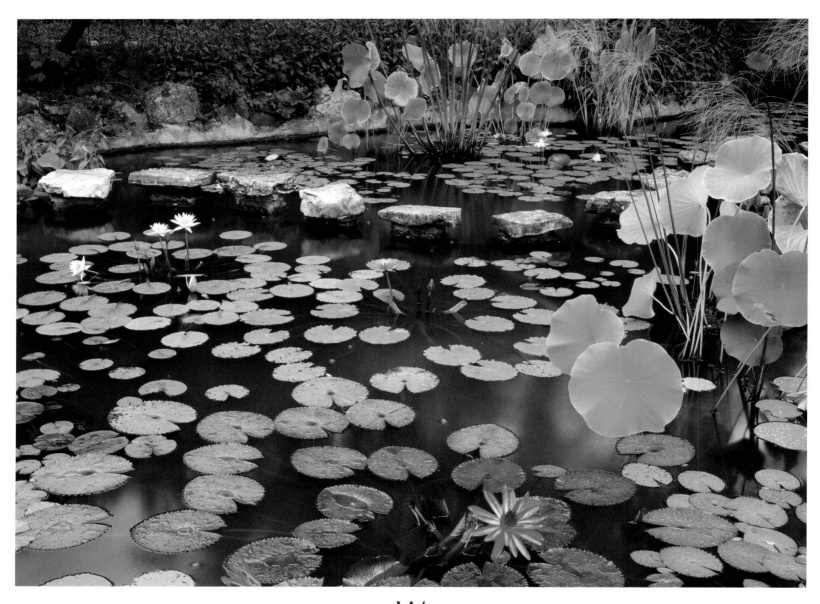

Water lilies float on the surface of a pond in the Oriental Garden at Zilker Park in Austin. The garden is only a small part of the city's centerpiece park on the shores of Town Lake. Zilker Park includes other gardens and Barton Springs, as well as running trails and acres of soccer fields. ▲

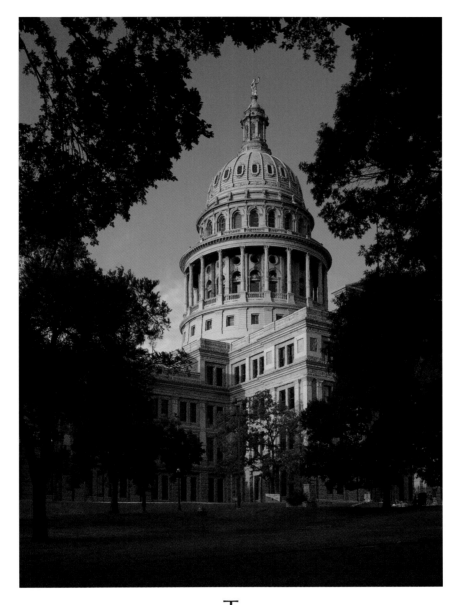

The State Capitol is the most imposing structure in the city of Austin. To finance its construction, the state gave Chicago investors three million acres of land in the Panhandle. Construction required fifteen thousand railroad cars of pink Hill Country granite and literal forests of fine hardwoods. In true Texas fashion, it was built to be taller than the nation's capitol. ▲

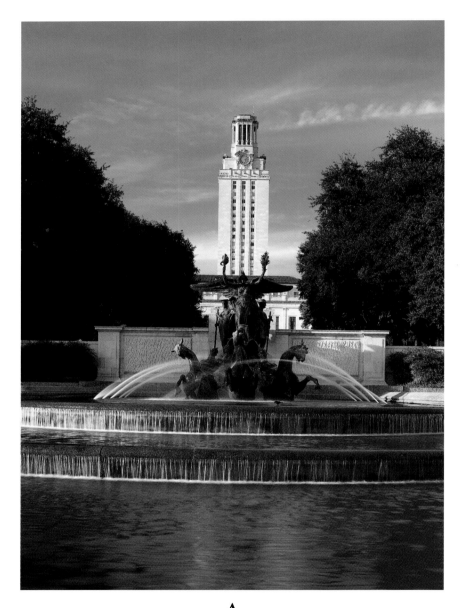

$A$long with the Tower, Littlefield Memorial Fountain, built in memory of graduates who were killed in World War I, graces the campus of the University of Texas at Austin. Classes began at the university in 1883; since that time, it has continued to grow and is now one of the state's flagship universities. ▲

$A$t night, the lights of downtown
Austin are reflected in Town Lake, a long, narrow reservoir on the
Colorado River that snakes through the very heart of the city. ▲
Inks Lake State Park lies along the shoreline of Inks Lake, one of
the smallest of the Colorado River lakes in the Hill Country. ▶ ▶

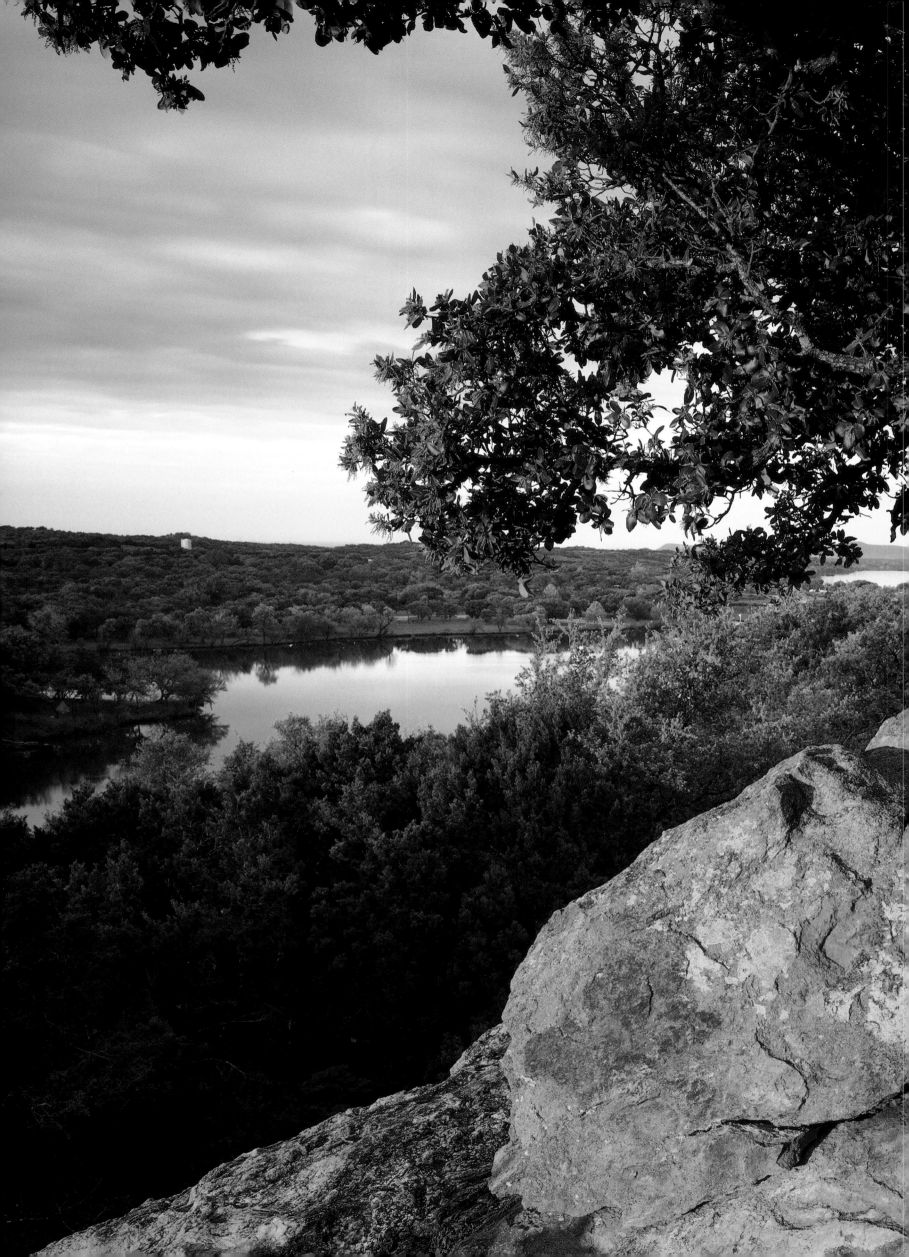

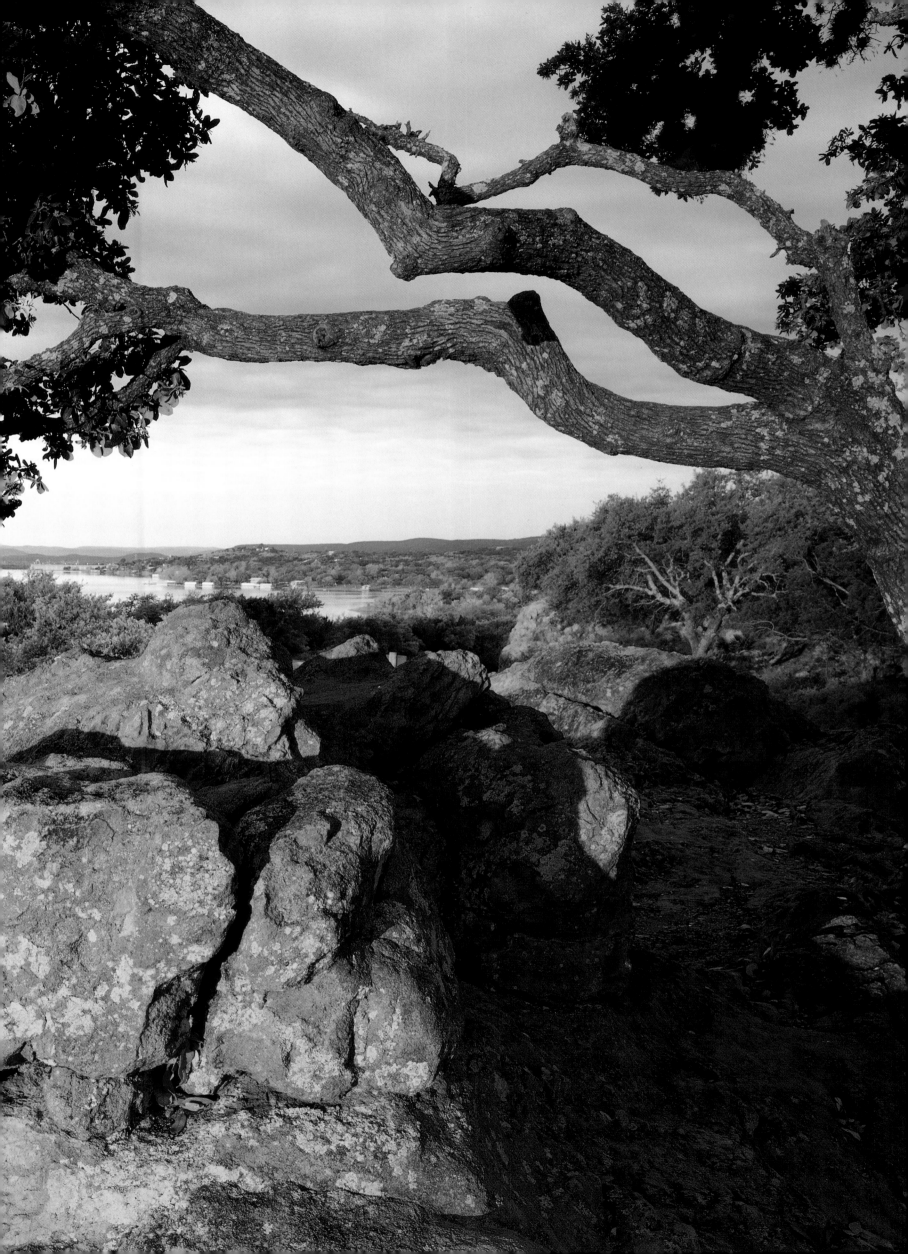

Some of the most rugged terrain in the Hill Country is found at Lost Maples State Natural Area on the southwestern edge of the Edwards Plateau. Beginning in mid-October, the park's bigtooth maples show off some of the state's best fall color. The park is very busy then, especially on weekends. ▲ The crystal-clear waters of the Devil's River cascade over Dolan Falls at a remote Nature Conservancy preserve north of Del Rio. The free-flowing river is an undeveloped oasis fed by springs that lie in the dry country on the western edge of the Hill Country. ▶

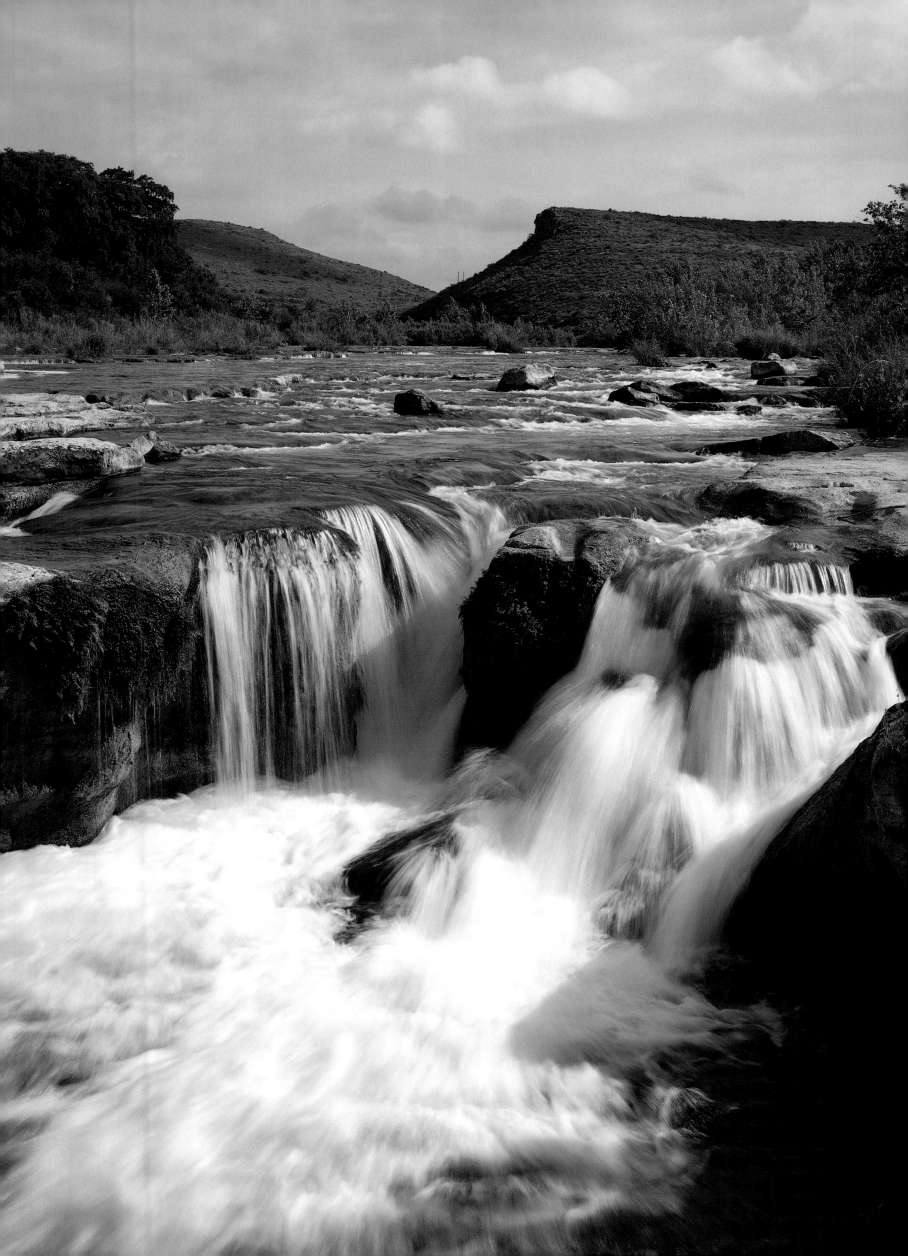

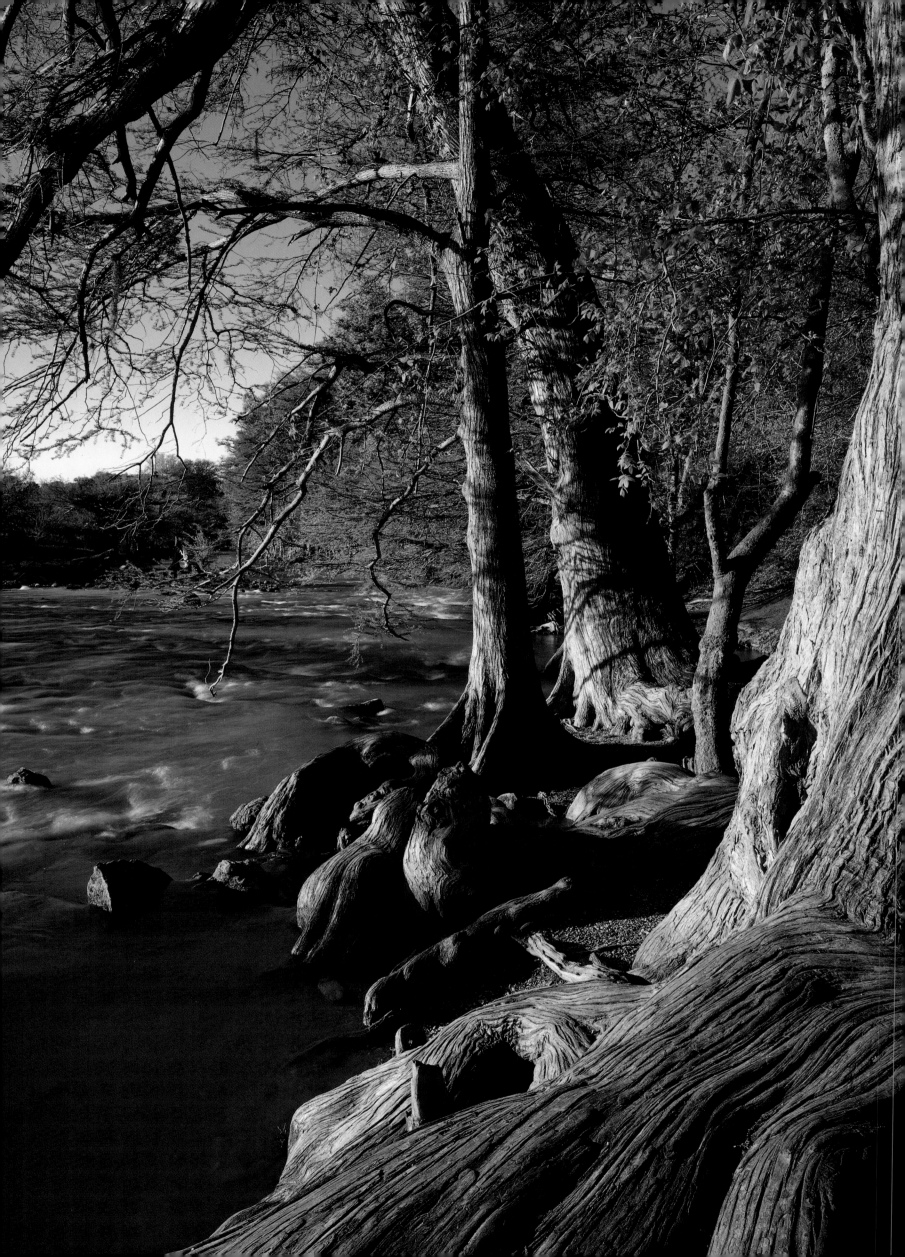

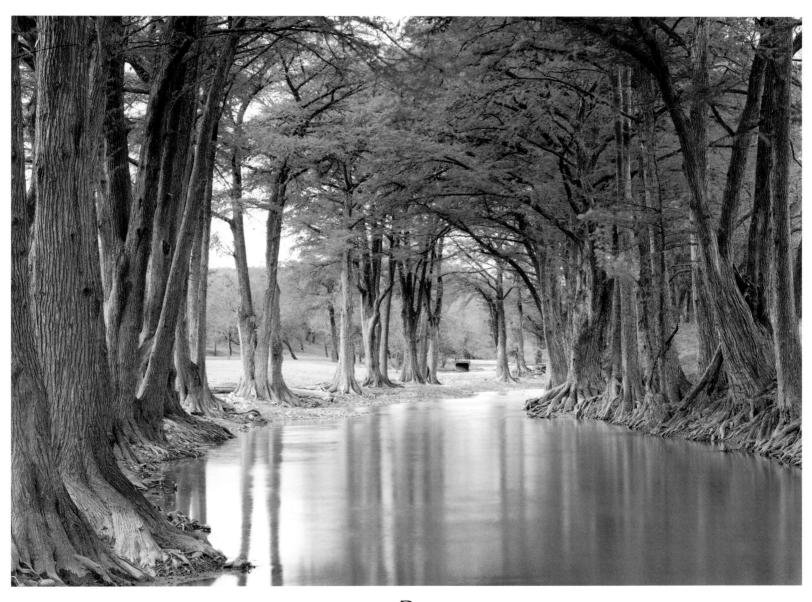

Bald cypresses line clear river waters in Guadalupe River State Park. Unlike the heavily dammed Colorado River to the north, most of the Guadalupe still flows freely and attracts thousands of canoeists and rafters every year. The state park is a popular site for camping, swimming, and boating. ◄ Cypresses along the Guadalupe River and other areas of Texas turn an attractive burnt orange color in the fall. Cypresses growing along the Guadalupe are sometimes swept away during its notorious floods. ▲

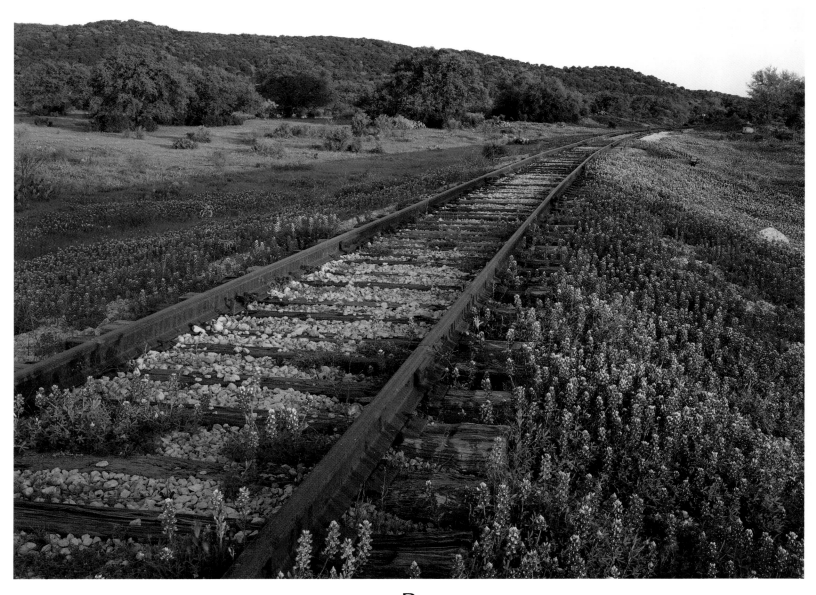

Bluebonnets thrive on the railroad tracks between Llano and Burnet. Once used to haul quarried granite as well as mining and agricultural products, the tracks see little use today. A connecting segment of track, leading from Burnet to Cedar Park on the north side of Austin, is currently being used to carry passengers on a historic steam train, the Hill Country Flyer. ▲ In good years, the bluebonnet can blanket hills and valleys in central Texas and perfume the air with a sweet, pleasant fragrance. Not surprisingly, it was selected years ago to be the state flower. ▶

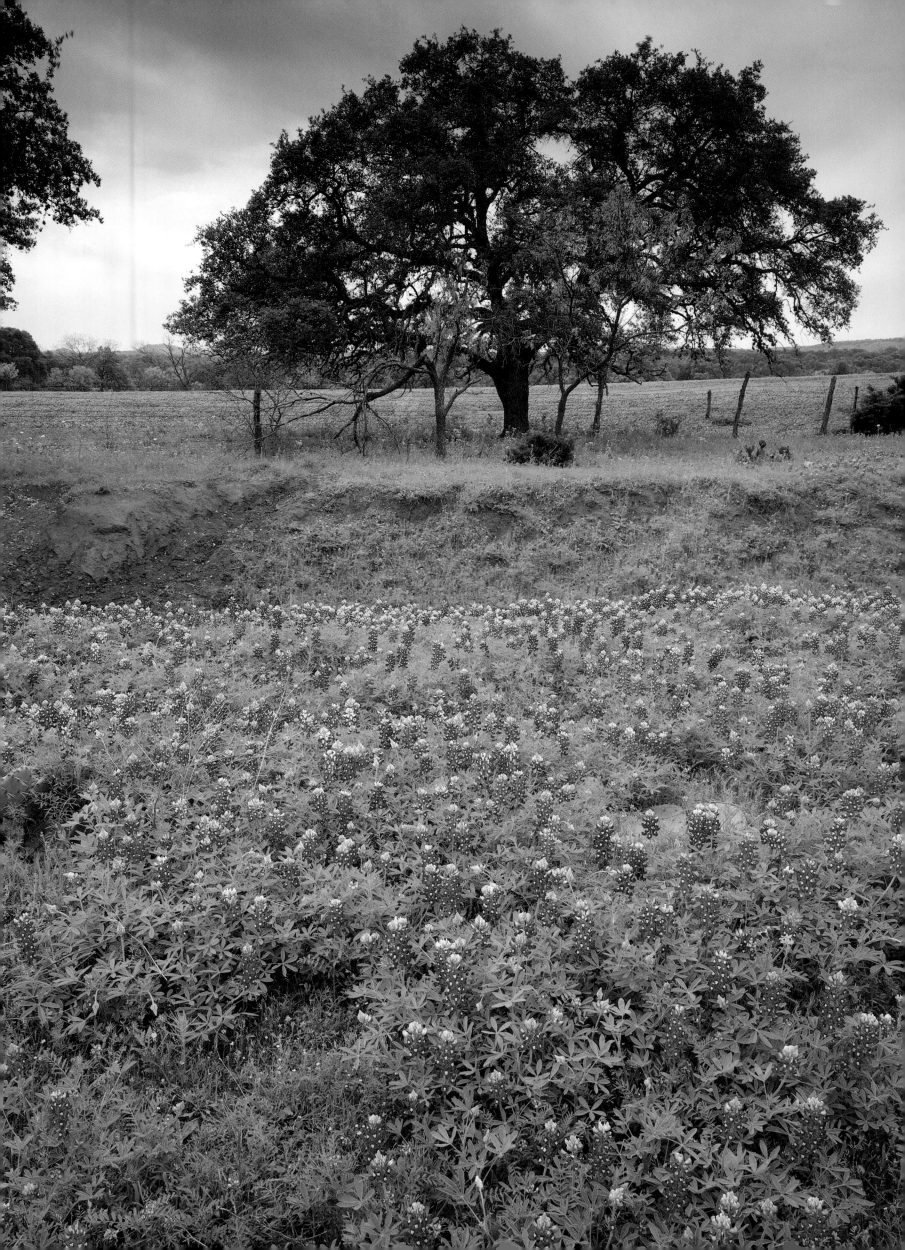

*Photographer's*

## ACKNOWLEDGMENTS

Special thanks go to Susan Gibler, who put Graphic Arts Center Publishing™ and me together for this book. Many people helped with this book in obtaining photos, including photo editors Mike Murphy and Bill Reaves, saddlemaker Lance Broussard, Clare Scherz at the Texas Capitol, Floyd and Tricia Davis and their longhorns, and the staff at the Salt Lick Barbecue. Many others helped in everything from offering hospitality to appearing in photos, including Pat and Jay Caperton, Elizabeth Johnston, Dale and Delilah Linenberger, Katy and Joe Cator, David Anderson, and Jacque Hopkins.

Many people at state and federal parks assisted me in many ways. Particularly helpful were Bill and Paula Armstrong, Mike Fleming, Wayne Haley, Larry Henderson, Deirdre Hisler, Valerie Jacoby, Carl Robinson, Dave Stuart, and Jerry Yarbrough.

LAURENCE PARENT